SKETCHING
THE BASICS

BIS Publishers
Building Het Sieraad
Postjesweg 1
1057 DT Amsterdam
The Netherlands
T +31 (0)20 515 02 30
F +31 (0)20 515 02 39
bis@bispublishers.nl
www.bispublishers.nl

ISBN 978 90 6369 253 7

"What you always wanted to know but never got explained in a simple and efficient way."

KOOS EISSEN AND ROSELIEN STEUR

SKETCHING
THE BASICS

BISPUBLISHERS

This book is aimed at people who want step-by-step guidance in learning how to sketch. But we could not resist including examples from designers and design offices around the world. By looking at how they work we link theory and everyday practice, and we hope that these case studies inspire young designers.

We wish to thank all the designers who were kind enough to find time in their busy schedules to send us these brilliant and inspiring projects and quotes for our book.

Thanks also to Rudolf, Bionda, Menno, Wimer, Sara, Eveline, Billy and Sandra, all of whom helped us to make this publication.

We hope that we have succeeded in encouraging students of industrial design to use sketching as an effective skill in conceiving and communicating their designs.

And to our little daughters Eiske (age 3) and Keke (age 1), we promise to not immediately jump into another big project.

Roselien and Koos, April 2011

www.sketching.nl
www.SketchingForDesigners.com

Preface

SKETCHING
THE BASICS

Sketching: *Drawing Techniques for Product Designers* was first published in 2007. Intended as a reference guide, it was aimed at designers and design students, and has since been translated into different languages. We combined educational drawings, photographs and case studies from design practice to highlight various aspects of drawing, tips and theory, and also the position and use of freehand sketching in product design. In short, the theory as presented in design drawing education, and its implementation in practice, outside education. We chose for design showcases from designers educated in the Netherlands, from small independent practitioners to leading players in global firms, promoting 'Dutch Design' along the way.

Within a short time it became a much-used book by students all over the world (50,000 books were sold within two years) as an extension to their drawing education. It also argued the necessity of learning to draw for designers, and showed a variety of way that sketching is used in the design process, and a variety of examples taken from our beloved field of work.

This book can be regarded as the 'prequel' to our first book, and it is intended to be used in an integrated manner in drawing education as part of product design studies. It contains many step-by-step guides to how drawings are produced. Drawing an object or idea is not a rigid process but a lively interaction. Often it is essential to show the drawing when finished in relation to how it started. That's why we chose to show a lot of step-by-step drawings. Doing so enabled us to reveal certain drawing decisions and their impact on the final result. We also show the impact of different choices made during these steps. We based the chapters in this book on the choices and difficulties encountered by a beginning designer or student while drawing.

Design drawing is embedded in a process involving many colourful aspects. Therefore we do not wish to hand out a recipe for 'good drawing', for such a thing does not exist. The field of sketching is both lively and changing, and the importance of drawing in relation to the design process is manifold. The first chapter discusses various drawing matters in relation to the design process. In general, we make no distinction between drawing on paper and drawing with the computer using a sketch tablet. Both methods stimulate receiving and sharing ideas, which will in many cases will aid the further development of those ideas. To visualise an idea is to present it for discussion.

The design of a product is a process in which several people work together and contribute to. To keep the whole process manageable, these contributions need to be recorded. Sketching can be a major part of the documented design process. For a client, drawings have another relevance: they enable him or her to stay involved with the design process, to keep an overview, and to know his or her moments of input and choice.

Drawing is an excellent way of expressing the emotional character of a product, especially drawing by hand or tablet, using the designer's personal signature. But most of the drawings made during the design process are at least partly or totally based upon communicating information about shape. We will start our focus on this aspect of product communication in the following chapters. How to draw a product in a way that its shape is most clearly 'legible'.

We will show examples from design professionals based on the essence of drawing in its context. There should always be a reason behind a drawing or sketch.

Our aim in making this book can be expressed thus: What you always wanted to know about sketching but has never yet been explained in such a simple and efficient way.

GALLERY

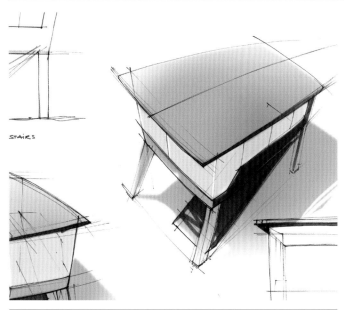

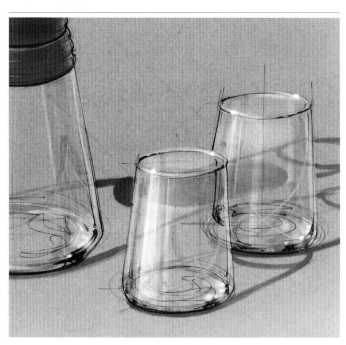

Material Expression
Transparency and Metal
Chapter 5, pages 130 and 134

Choosing Viewpoint
Bird's Eye Perspective and Eye Level Perspective
Chapter 3, page 70

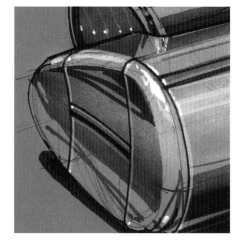

Sketching Progress
Rounding
Chapter 4, page 90

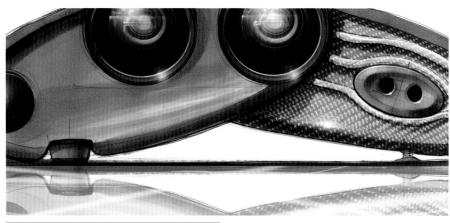

Choosing Viewpoint
Side-View Drawings
Chapter 3, page 61

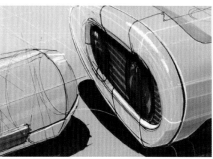

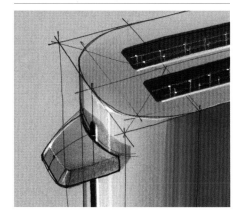

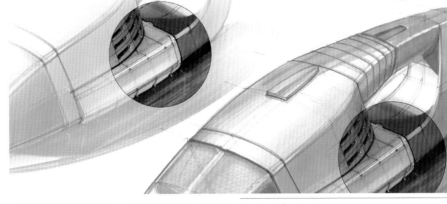

Product Context
Emphasizing Part of a Product
Chapter 7, page 192

Product Context
Hands and People
Chapter 7, page 182

Fast and Fearless
Intuitive Sketching
Chapter 6, page 162

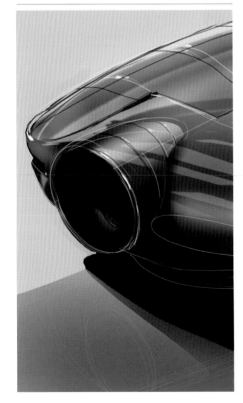

Fast and Fearless
Drawing freely, shape optimising
Chapter 6, page 153

CONTENTS

Chapter 1

SKETCHING IN DESIGN

This is a book about drawings in the context of the design process, and whether or not a drawing is effective within this process. This may mean that a product is sometimes visualised in a clear way, and in other cases that the drawing itself should be convincing or persuasive. There is no one criteria for a drawing to be 'good' or 'bad', and before you judge, it is important to always know the goal and context of a drawing. So making a 'beautiful' drawing is not the main purpose of this book.

We will leave a lot of the (pre) design process out of our discussion. What is important here, is that there are certain recognisable moments in the process of design in which drawing and sketching can play a major role. This chapter focuses on these moments only. Although every design may be different, there are some generally recognisable phases in every design process. These various design phases can of course overlap, and may differ a little in each situation. Each of these phases demands different things from a drawing or a sketch.

In this chapter we will discuss different kinds of drawings within the design process.

' ... the beauty of design; it is like music; you do not need to speak the language to be able to work somewhere. So I could work in Italy without speaking a word of Italian, I could go to Japan without speaking Japanese. As a designer you can communicate through drawing. So you're not dependent on language or origin to establish your place....'
—Laurens van de Acker, Director of Design at Renault

1.1 IDEATION/BRAINSTORM

Whether you brainstorm together, with others or alone, it is important to keep the flow of ideas going, fresh and free of judgement, with room for changes in the proposals. It is not important to present products in correct perspective or with shading. It is more important that the ideas themselves are clear and either context related or context driven. This may mean a lot of schematic and archetypal line drawings in, for example, side view or a page full of line drawings as shown here. In this process of visual thinking, words on post-its or inspiring pictures could be added to tell a story.

Some typical drawings in this phase are referred to as 'doodles' and 'thumbnails', both quite small. Small drawings are justified at this stage of design because there is no room for detail. However, we do encourage drawing larger, if possible, and using a 'blunt' medium such as a marker, instead of a fine liner or colouring pencil, to create the same effect regarding details.

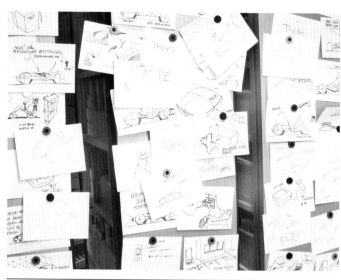

Initial brainstorm - design case FLEX/the INNOVATIONLAB®

Some designers like to keep a booklet in which to sketch ideas. With this sketch book you can do ideation whenever you like, anytime and nearly everywhere. Making an initial ideation sketch may lead to producing another sketch, improving the first or drawing another idea. One of two things may occur with this first sketch: either something comes up that was not detected while the idea was still in your head, or this idea was already there in a different sketch, as the sketch book works like a visual recollection. Do not criticise these sketches yet, as it is important to keep the flow of ideas going; criticism will take place later.

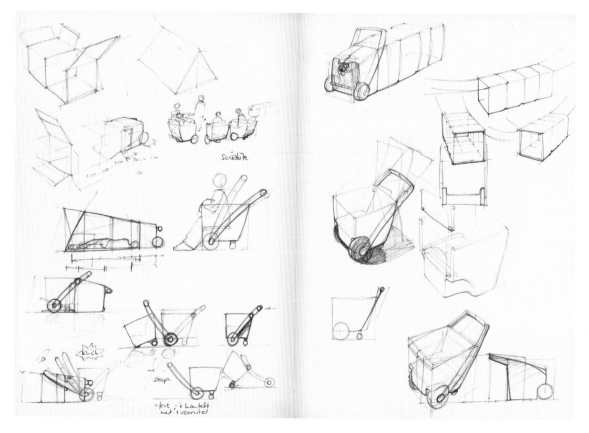

Sketches by Robert Bronwasser, SMOOL

In the ideation phase it is important to generate many ideas, explore several variations, and end up with a range of ideas. The ideation phase will conclude with a selection of these ideas with which to continue. These are the potentially good ideas that may grow into a real proposal or concept.

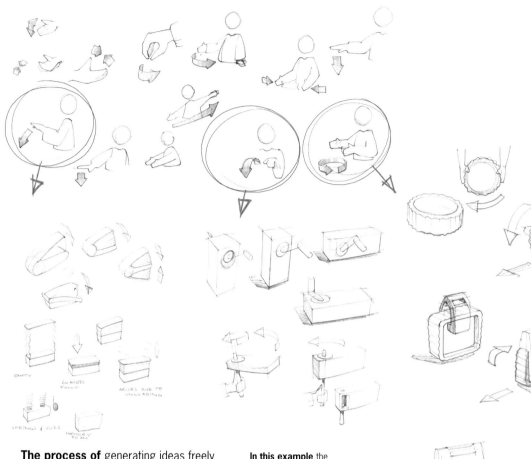

The process of generating ideas freely and evaluating and choosing them is a repetitive action in the design process. Visualisation plays an important role in this iteration. Each phase starts with the generation of many ideas, and concludes with one or a few 'end' results. These results form the input for the next phase, where problem solution or optimisation requires you to again first generate many solutions, and then evaluate them. The further along in the design process, the more uncertainties will be overcome. As a logical result, this will be reflected in the more definite character of the drawings.

In this example the starting point was to create more awareness for energy consumption. It was chosen to come up with a product idea in which human power plays a key issue.

We started with a human power brainstorm; a collection of hand-and-arm movements that can be used to generate (electrical) power. We then chose 3 movements we found 'interesting' and made a first investigation in charging mechanisms in terms of their shape. This generating of ideas was done largely by association, and that is how the sketch with the toy car suddenly 'popped up'.

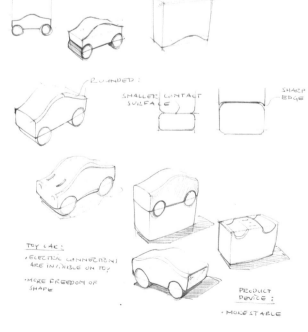

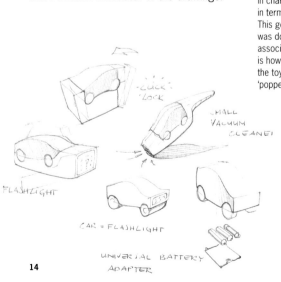

1.2 SKETCHING AND DESIGN PHASES

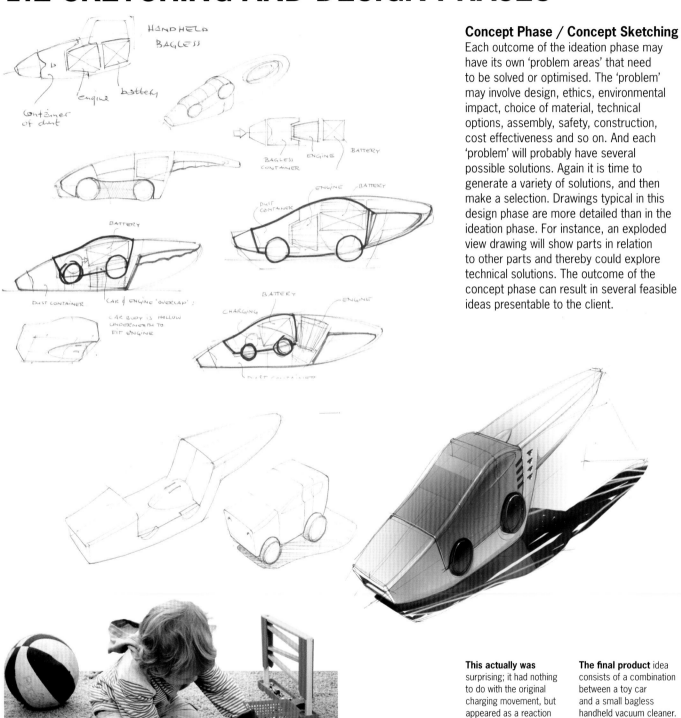

Concept Phase / Concept Sketching
Each outcome of the ideation phase may have its own 'problem areas' that need to be solved or optimised. The 'problem' may involve design, ethics, environmental impact, choice of material, technical options, assembly, safety, construction, cost effectiveness and so on. And each 'problem' will probably have several possible solutions. Again it is time to generate a variety of solutions, and then make a selection. Drawings typical in this design phase are more detailed than in the ideation phase. For instance, an exploded view drawing will show parts in relation to other parts and thereby could explore technical solutions. The outcome of the concept phase can result in several feasible ideas presentable to the client.

This actually was surprising; it had nothing to do with the original charging movement, but appeared as a reaction to the existing drawings. This key sketch was then picked up and used for further exploration, again generating several variations and ideas. Still early in the design, the final product idea is seen in the coloured drawing.

The final product idea consists of a combination between a toy car and a small bagless handheld vacuum cleaner. Inside the toy car is an alternator which charges a battery through the movements of the playing child. This is the power source of the vacuum cleaner.

15

Choosing Concepts

Choosing a concept can occur internally, with co-designers or management for example, or externally with a client. At this point you should present the different ideas in similar ways. Make sure an honest choice can be made, and not be blurred by the use of different handwriting or drawing styles. Presentations should be alike.

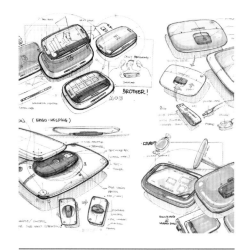

Design case chapter 4
Idea Dao Design

Presentation

Sketches and drawings can be used for presentation during several stages of design. Presentations can be in-house, among designers that work together, or externally. In each case different issues may be important.

A client, such as a producer outsourcing the design of his products, has of course knowledge of his field of products, his market and the technical details, and may want to compare the design with existing products and production techniques.

A professional from outside the product field or design, such as a sponsor, manager or user, requires other aspects of the drawings. He or she is usually unaware and not interested in the underlying technical details of the design, and may wish to have a clear and inspiring image of what the implications are of this product on a person's daily life.

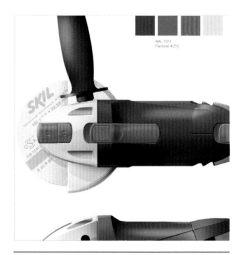

Design case chapter 1
FLEX/the INNOVATIONLAB®

Pitch / Contest

A pitch or contest requires a specific type of presentation. During a pitch your idea should look its very best and reveal the context of the design. A pitch takes place with competitors, and your goal is to get the assignment or win the contest. So when pitching together with other designers, make sure your drawings tempt and convince the viewer.

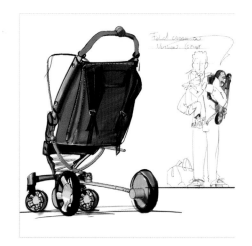

Design case chapter 1
TurnKey Design

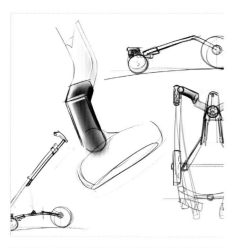

**Design case chapter 1
TurnKey Design**

Detailing

In this phase, all details are decided upon, such as the exact surface finish and size of a product. Several close-up drawings may be required, in combination with side views and perspectives. A variety of drawings usually works best to visualise both detail and its impact on the product as a whole.

Design and Communication

From the developed concepts, one final idea is chosen. This idea is further developed for realisation. In this phase details are being decided upon, engineering is done, and production is being prepared.

Problems are met, solved, optimised and communicated with various parties. An ideal situation would be for the designer to use the same drawings for design as for communication.

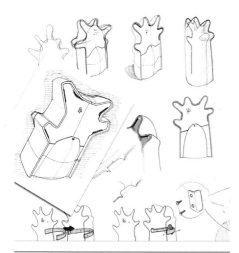

**Design case chapter 1
Art Lebedev Studio**

Shape Optimisation

Since an idea is never 'ready', a drawing is a good tool for developing something further in a short time, as sketches can be made quickly and suggestively. By using a technical drawing from engineering or a photo of an existing product as an underlay, you can quickly generate variations in shape. Pictures taken from a (foam) model will do the job as well.

In any case, if the proportions of the shape allow, it is worthwhile to make an underlay, side views and perspective, and take time to optimise the object's form, as the emotional aspect of the product is often dependent on this.

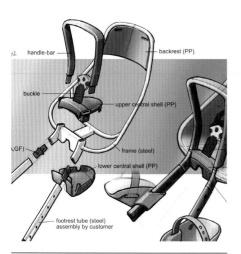

**Design case chapter 4
Van der Veer Designers**

Pre-Engineering

When communicating with construction engineers just before the actual engineering begins, so called 'pre-engineering sketches' are made. These can be principle sketches of (partial) technical solutions, possibly made during an engineering meeting. Rough side view technical drawings and exploded views are commonly used drawings in this phase. Exploded views show components in relation to each other, and can give direction in assembly methods. Pure product information is important during this phase.

During the communication process, the different parties require specific drawings, showing different aspects of the product. Here you will find the use of underlays such as CAD drawings, renderings, and pictures of (foam) models very effective.

So when making a drawing, beware of its role in the design process, or what it is you want to explore or show, and which parties are involved. This determines a lot of the drawing choices from start to end.

In ideation it is important that sketches keep your flow of ideas going and inspire you. A large amount of sketches with little or no detail can be more effective and inspiring here than a few 'beautifully' rendered products.

At other moments you may wish your client to choose from a few possible options. In such a case a large number of drawings can be confusing, whereas a few drawings in which the different concepts are emphasised may be better suited.

The various parties with whom you communicate are also of importance. Showing your initial ideas to an experienced client with knowledge of the product can be something completely different than showing the same ideas to a sponsor, who may only be interested in his return of investment.

All these aspects determine whether the drawing can be a quick sketch or should look precise. Be aware if a drawing's context in design solves questions such as: Can I use an existing sketch from ideation?, Or should I make another drawing for communication purposes?, What is the most important part of the drawing (or product) that I need to show?, Can I visualise it in one sketch, or do I need a side view or more sketches for clarity?, Do I show only the product or also its user context?. Moreover, the choice of drawing materials you use, the viewpoint of the drawing and even the direction of light can be a direct result of the sketch's role in the design, and largely determine the 'look and feel' of a sketch.

1.3 HOW TO PRACTICE

A way for you to quickly get a feel for the different kinds of drawings in the design process yourself is to (re)design a scooter for children. Start by drawing a scooter from memory. Questions like: How does the steering mechanism work?, and How are the front and back wheel attached to the chassis? call for a plan. Make quick sketches while researching; first draw different solutions and then choose the best one. After you have done that, make your final perspective drawing. In this exercise you will use sketching with different applications: first as a tool to locate and

analyse problem areas in the design, second to explore solutions, and finally to choose and communicate your solutions to others.

NB: You will need to know the direction of the ellipses of the two wheels. Keep the wheels parallel to keep from creating another drawing problem. See Chapter 2 for support.

ART LEBEDEV STUDIO, RUSSIA

Tetra Pak recycling containers, 2010
Client: Tetra Pak

Tetra Pak strives to be eco-friendly
and encourage recycling. They wish to
teach people that juice and milk cartons
shouldn't be thrown away, but collected
and reprocessed. The campaign includes
lectures, flyers and posters explaining why
cartons are useful and should be recycled.
Schools and offices would need containers
to hold cartons before they are taken
to recycling centres. We designed the
containers, devised names and slogans for
the campaign, and created a set of logos.

CASE

'...Sketches, for us an essential part of the design process, are used to present, share and develop the ideas within the team. As a rule, we do not show these to clients. Sketches are made at every stage of the project to help us select and refine designs, from an overall concept to the smallest detail.

Here are some drawings illustrating different stages of the Tetra Pak recycling container project. We started with a series of concept sketches and picked out the cheerful monster idea...'

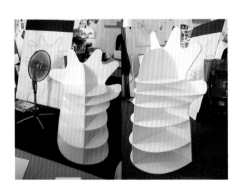

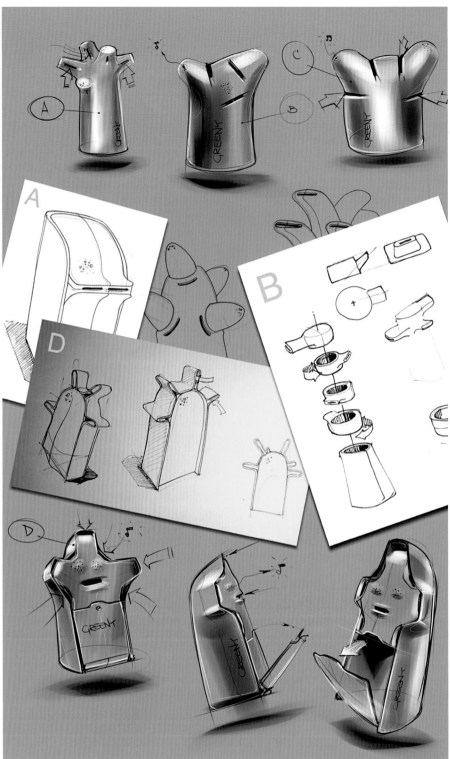

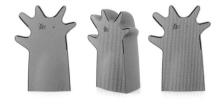

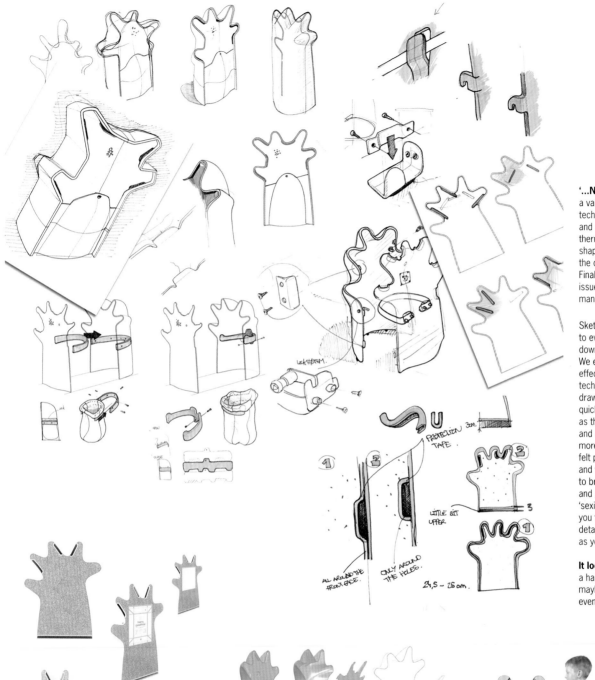

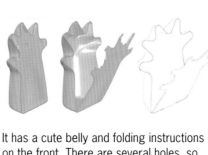

'**...Next, we explored** a variety of production technology options and set our choice on thermoforming. Then the shape was refined and the details elaborated. Finally, we addressed all issues related to industrial manufacturing.

Sketching enabled us to evaluate and narrow down the alternatives. We employ simple yet effective sketching techniques. Black ink pen drawings can be done quickly to visualise ideas as they are generated and evolve. When focused more on shape, we use felt pens to add colour and volume; it's a fast way to bring out the shape and give the images a 'sexier' look. This allows you to go into as much detail about your design as you need...'

It looks like a tree, or a hand, or a splash, or maybe a shaggy head, or even an alien. Kids love it.

It has a cute belly and folding instructions on the front. There are several holes, so kids wouldn't have to queue, and their size is right for drink cartons folded flat, but small enough not to let any books in. With built-in speaker and light sensor, the monster thanks you for every received carton — its belly rumbles contentedly.

The design for the office container

CASE

FLEX/THE INNOVATIONLAB®, NETHERLANDS

A new brand language for Skil Europe B.V., implemented in a new range of power tools, 2006-2010

Sketch Phase

Several exploratory design sketches were made, using a simple BIC ballpoint pen, as both 3-D sketches and side view drawings, including a study of details and shape transitions. A second coloured BIC was used to make some details clearer. Some drawings were clarified with elementary colouring in Adobe Photoshop software.

These drawings are mostly used for internal communication; touched up (or at least cleaned and coloured) versions are used for communication with the client to explain basic concept or shape ideas. 'Pictures of quickly handmade foam models or existing designs can be used as underlays to help make a drawing with realistic proportions.'

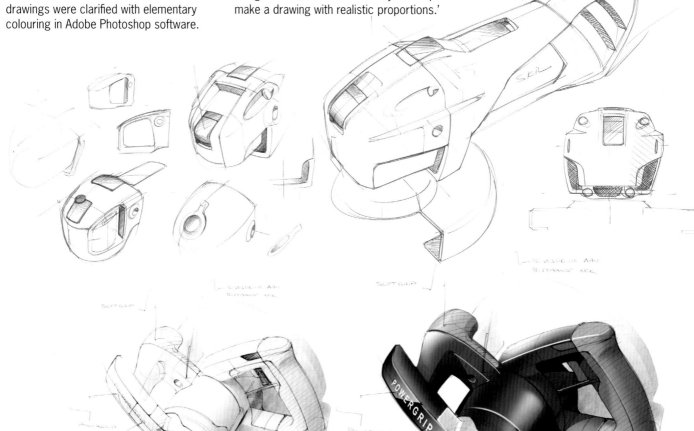

3-D Models

Volume models are extremely important for checking shape, surface and ergonomics. Any interpretative problems of drawings can now be resolved. Photos are perfect underlays for any new drawings to come and save heaps of time. Even quick models can be very useful if you want to get your perspective and proportions right.

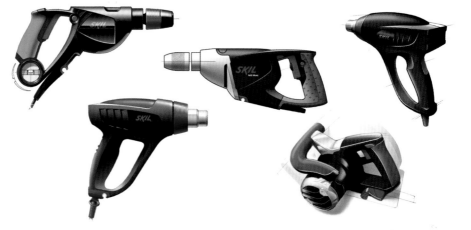

Choosing Concepts

A combination of a side view are presented to the client for concept choice. All these have an explanatory character.

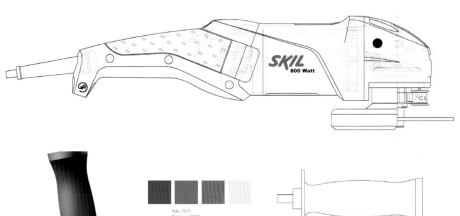

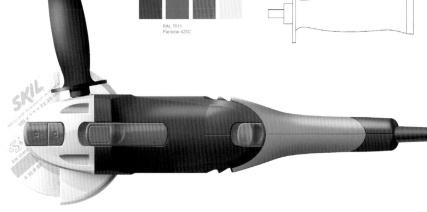

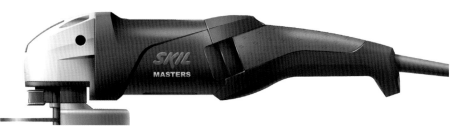

Design Phase

With Adobe Illustrator, lines are set and designed with respect to the internal components and other details like screw bosses, hand grip sizes, logos and labels. These clean line drawings are not only good to work with but also clearly communicate design aspects to the technical department of the client for final engineering.

Presentation

Finally Illustrator lines are imported to Adobe Photoshop for colouring. For extra realism branding, parting lines and screw bosses are added. Rubber parts have soft edges (see styling line in hammer drill), plastic has hard edges, and metal has subtle reflections. There is a subtle balance between realism and 'illustrating concept'; some material characteristics are exaggerated to clearly communicate the concept. These images were created for the marketing department of the client.

Review Images

First production samples are reviewed for final checks of shape, details, ergonomics, etc. '...For these images we use pretty much everything to communicate what we mean. Photoshop over a photo or sketch over a photo of a model to indicate the goal. Also, tracing a photo of a model can create a quick but very clear image when details are at stake. Clear communication is the key in this phase...'

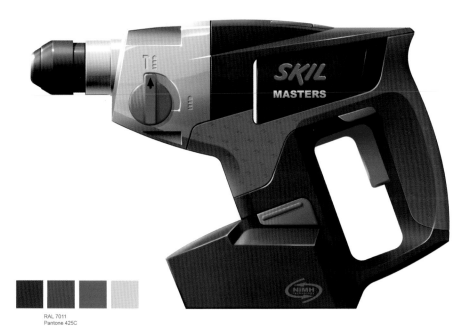

RAL 7011
Pantone 425C

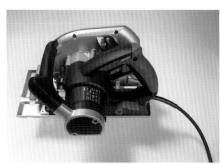

CASE

TURNKEY DESIGN, NETHERLANDS

A compact foldable buggy 2010
Designer: Imre Verhoeven

The main focus of this project was to try to combine a strolling buggy with the possibility of carrying the buggy like a backpacker.

'...**For the pitch** I used a variety of drawing materials. Not only do I like to use a ballpoint pen and photos, I also used a Wacom tablet and Alias SketchBook Pro and SolidWorks...'

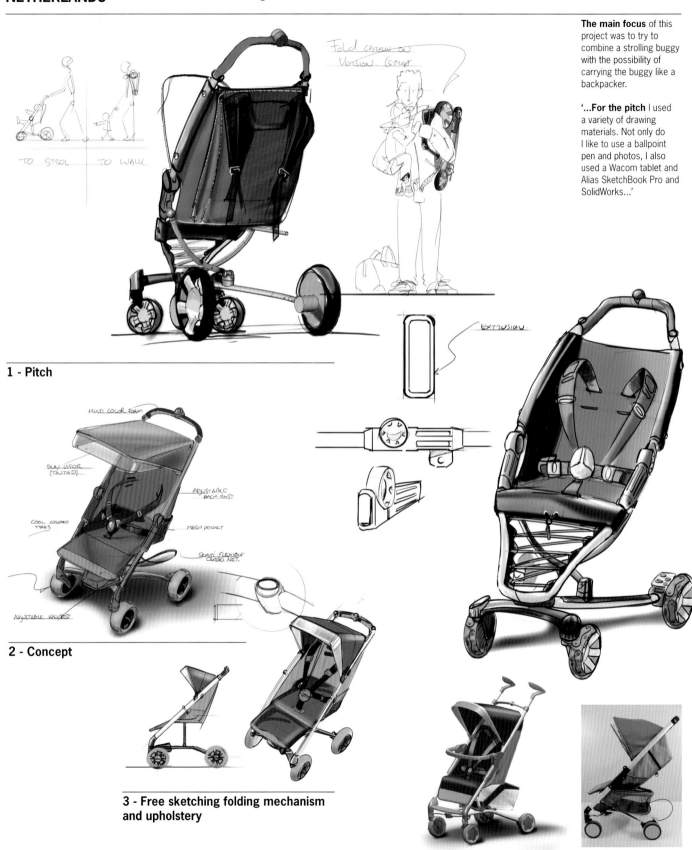

1 - Pitch

2 - Concept

3 - Free sketching folding mechanism and upholstery

4 - Cad

5 - Sample 1

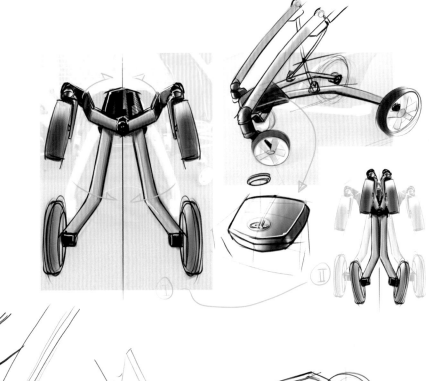

After TurnKey presented the pitch, the concept was picked up by the Chinese mother company. With a GO from the mother company, we delivered a concept sketch. In China a CAD model was developed. This process from pitch to concept, consisted of communicative sketches and scribbles, email, video conferences and discussions with our engineers in China.

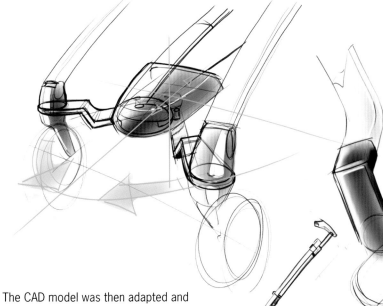

The CAD model was then adapted and approved by us, and a sample (working prototype) was made for further judgement.

This first prototype was then redesigned at Turnkey, with the final prototype as the result. This final prototype was then tested and judged by potential customers. Also in this process informative sketches, with the CAD model and photos of the sample used as underlays, are used as a means of communication. In the example here you see adaptation of the curvature of the lower frame, sketched over photos of the first frame sample, and the compact bumper bar concept, sketched over a CAD model.

The complete design from initial sketch to final sample took place at high speed, within two and a half months.

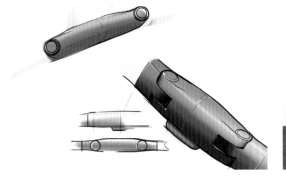

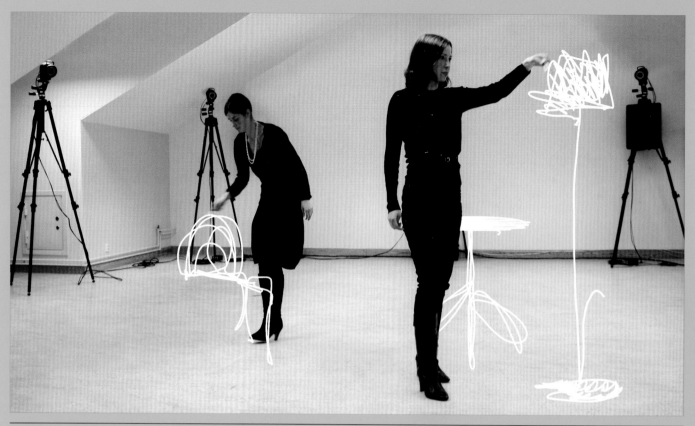

Sketch Furniture by FRONT

Is it possible to let a first sketch become an object, to design directly onto space? The four FRONT members have developed a method to materialise freehand sketches. They make it possible by using a unique method where two advanced techniques are combined. Pen strokes made in the air are recorded with Motion Capture and become 3D digital files; these are then materialised through Rapid Prototyping into real pieces of furniture.

Chapter 2

DRAWING APPROACH

This method is based on starting with a basic shape such as a cube, cylinder, cone, sphere or plane. In this chapter we will use this strict division of shapes for clarity, whereas in reality various situations can occur. This approach, however, will encourage you to think 'spatially', and to analyse shapes, and to distinguish overall appearance from details. You will find that after a while you will draw more intuitively; you will 'estimate' more instead of 'construct', and you will be more able to improvise and correct.

Experience has taught us that this will only lead to good results when these estimations are based upon a steady knowledge of things. This cannot be rushed. Eventually it will be all about the credibility of a drawing. It has to be convincing, and precision is not as important. So in short, basic knowledge and precision are necessary to start with, whereas later on making estimations will become more important.

'... Hand sketches are rather timeless and appeal to one's imagination.
It is the most direct way of expressing the designer's thoughts and pondering and reveal the artisan's skills...'
—Roy Gilsing, Designer

2.1 INTRODUCTION

We asked several non-designers to simply 'draw a chair' in perspective, with no specific purpose for the drawing. You will of course recognise a chair in all the drawings, but it is obvious that these drawings were made by people untrained in drawing, who are not designers. What is the striking difference between drawings by designers and non-designers? Non-designers in general will focus on a 'story', an archetype perhaps, or a history: this is a chair that I have, remember, know, etc.

A designer's drawing, however, will always have a specific purpose, and will in a lot of cases be about communicating an idea. Like a language, different rules apply to drawings that 'communicate'.

The designer is able to analyse, and can make a distinction between the overall shape and details, and will make a deliberate choice on where to put the emphasis in his drawings. In the concept phase, just after ideation, for example, the overall shape will probably need to be communicated in a clear way. To do so, a so-called 'informative' viewpoint is chosen, and aspects such as guidelines and shading are used.

Drawing of chairs by none-designers of various age and gender

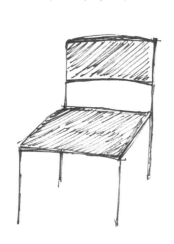

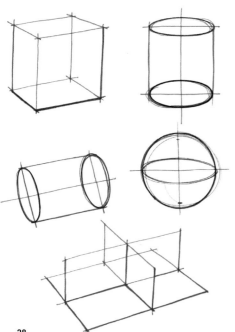

In the following chapters we will show a drawing method that will lead to informative, shape explaining drawings. In this chapter a quite bold division between shapes (products) is made by means of how they are drawn:

- starting with a block shape
- starting with a cylinder or cone
- starting with a sphere
- starting with a plane

In each of the above, the necessary aspects of lines, shading, colour and drawing materials will be explained.

We have chosen this division for specific reasons. Of course, not every situation can be described in such a bold way; a mixture of approaches will eventually be more realistic. But it is a simple way to start with learning how to analyse and draw shapes. Learning how to draw spatially and implementing it in design work are surely two different things at the beginning of your studies.

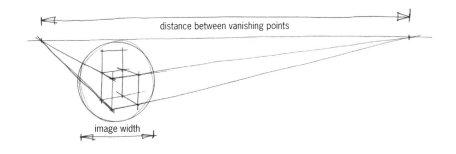

distance between vanishing points

image width

Basic principles of perspective

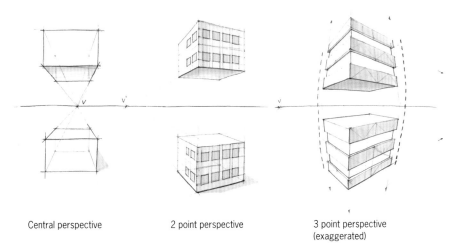

Central perspective

2 point perspective

3 point perspective
(exaggerated)

This drawing method requires no horizon and vanishing points on the paper. The reason for this is that in order to appear 'realistic' (without distortion), the vanishing points of a shape need to have a distance between them that is approximately 5 times the image width. In the case of a chair, for example, this means that the drawing will be very small in relation to regular paper size or needs a very large piece of paper.

Among the several 'kinds' of perspective, such as central perspective, 2-point perspective with 2 vanishing points, and 3-point perspective, we will mainly draw in 2 point perspective. This means that the vertical lines will have no vanishing point, no convergence, and therefore no foreshortening. This will ease things dramatically, while still maintaining a realistic appearance. In reality we will more or less perceive or notice objects having 2-point perspective, but if you take a picture of a product, you can immediately see 3-point perspective. Seeing with your mind instead of with your eyes explains this difference in perception.

As for the actual drawing itself, the main guidelines can be described as follows:

- Use long lines and draw with a definite medium such as a fineliner. A pencil and eraser will tempt you to keep erasing things and will not train you to be resolute in your decisions.
- Draw in a 'transparent' manner; for example, draw the lines of the main shape that you do not see. These lines will guide you regarding control and correction of the perspective and shading.
- Choose an informative viewpoint (See also Chapter 3)
- Start the drawing with a large basic shape, and work your way down to the details; save the details till last.
- Drawings are preferably in a size related to your hand size, preferably bigger and not smaller.
- Use guidelines; they not only enable you to draw easier, but they will also make the drawing more comprehensible (readable) for the viewer.

2.2 BLOCKS

2.2.1 Perspective in Lines

We start with drawing a cube. A vertical surface can be 'multiplied' literally by doubling it, as there is no vanishing point in this direction due to the 2-point perspective.

Thickness is added, and light direction is chosen from the top left. This means that all lines on the shaded side can be darkened a bit. This will add more clarity to the drawing, as well as spatiality and depth.

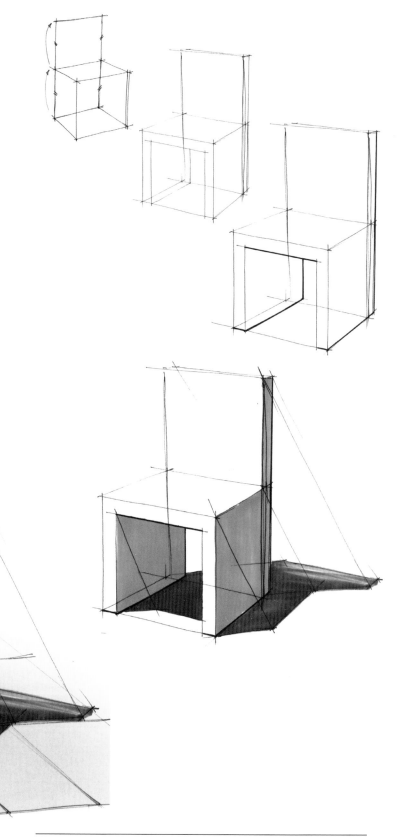

Tip

Adding just a quick suggestion of surroundings to the subject can add context, spatiality and can 'present' the object more attractively.

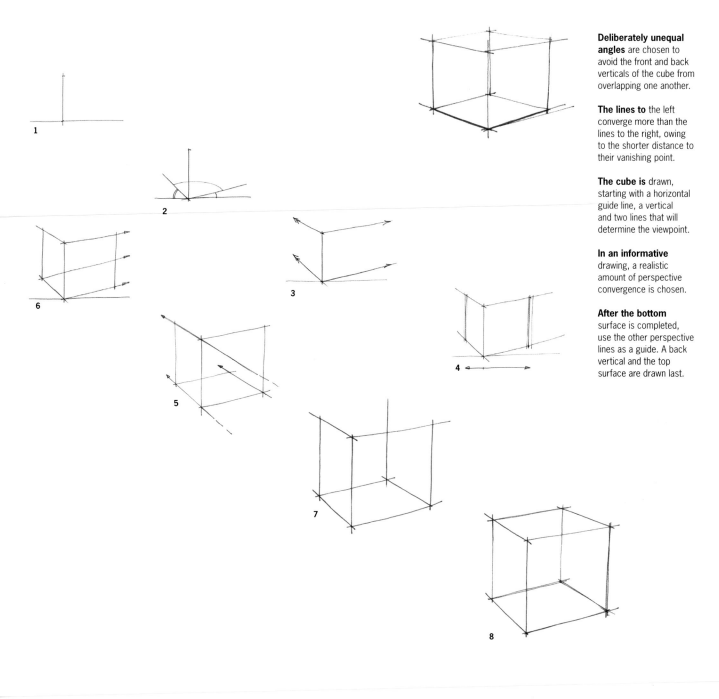

Deliberately unequal angles are chosen to avoid the front and back verticals of the cube from overlapping one another.

The lines to the left converge more than the lines to the right, owing to the shorter distance to their vanishing point.

The cube is drawn, starting with a horizontal guide line, a vertical and two lines that will determine the viewpoint.

In an informative drawing, a realistic amount of perspective convergence is chosen.

After the bottom surface is completed, use the other perspective lines as a guide. A back vertical and the top surface are drawn last.

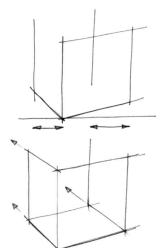

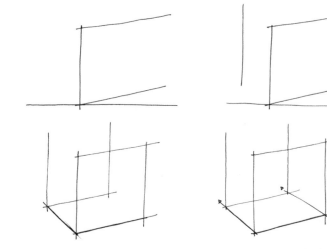

There are of course more ways to draw a cube; another way is shown here. In this sequence, there is an emphasis on the placement of the verticals. The placement of the back vertical is based upon the principle indicated with the added arrows. These dimensions are of unequal size, as illustrated on the next page.

To verify whether the cube you have drawn is in correct perspective or not, several quick checks can be made:

- Compare the shortening of the top surface with that of the ground surface; the top surface should be 'flatter', as it is closer to the horizon (see A, A').
- Check the two angles of the ground line with the horizontal line; they should differ, as should the width of the two vertical sides (see B, B').
- The most foreshortened vertical side (here on the left) should be much smaller that its opposite side (see C, C').
- Only in the case of a cube, the corner on the most foreshortened side should be 'higher' than that of the less foreshortened side.

When the block you have drawn is incorrect, it is important to find out why, and try to avoid making the same mistake again. Here are some common beginners' mistakes. Starting at the top left, there is a block shape (1) using parallel lines instead of perspective convergence, an axonometric image. Next to it is a shape (2) where the amount of convergence is estimated incorrectly. The vanishing point on the left is closer, so lines in that direction should converge more than those in the right direction, not the other way around. Block (3) shows a one-side frontal view, so it should actually be a central perspective, and not show the left side. It can easily be avoided using a horizontal guide line as you see next to it.

The last block (4) shows an incorrect perspective of the ground surface. It may help to extend and use the lines already there as a guide when you draw the ground surface.

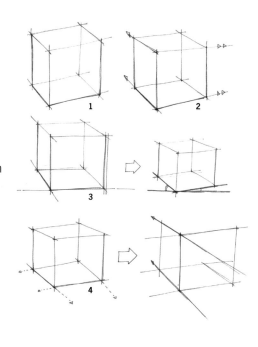

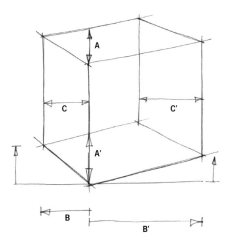

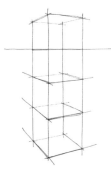

As horizontal surfaces of a column get closer to your horizon, the more foreshortened they become.

As vertical surfaces get closer to the vanishing point, the more foreshortened they become.

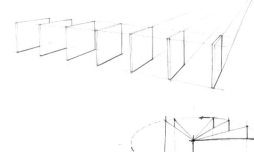

Learning to draw a cube at different angles will give enough experience to create a correct-looking perspective drawing. Keep this rule in mind: never exceed the measurement of the closest vertical. The width of the book's pages appears much smaller and foreshortened as the pages turn.

In this picture you see perspective distortion due to the fact that the third vanishing point is above the horizon, but also used incorrectly for every vertical below the horizon (see 3-point perspective rule). It is, however, subordinate to the spatial effect due to the effective use of perspective colouring and contrast.

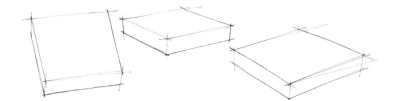

2.2.2 The Viewpoint

With the first lines of the drawing, the viewpoint is 'chosen'. Make sure all surfaces of the block are perceived well. These three viewpoints are dismissed owing to too much foreshortening on one of the surfaces. Or in the case of the shape on the right, the shape is drawn symmetrically, which may turn out confusing.

When drawing a typical block like this at the start, the drawing sequence of the block itself may differ slightly to that of a cube. Perspective rules and general sequence, however, stay the same. The basic idea behind this sequence of drawings is to show what to expect while drawing a little box. For example, to be successful in drawing the lid of the box, it is important to know possible solutions in advance. What angle suits best to create clear shape information?

Which lines could be stronger and what angle of light creates informative shading?

Finally, when the basis of perspective and shading are grasped, digital enhancement of the surface of the structure can give it a quick transformation in 'look and feel'.

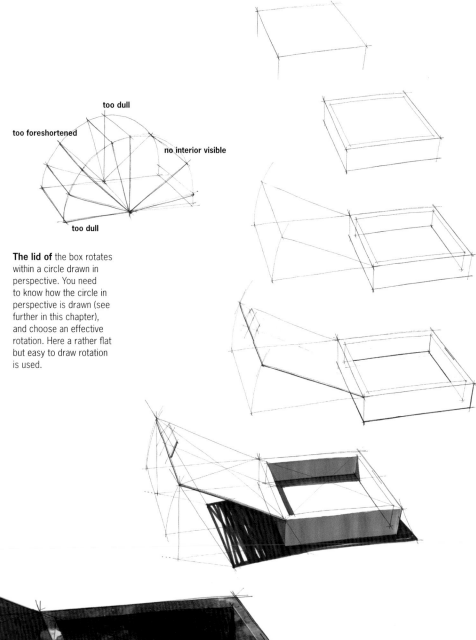

too dull

too foreshortened

no interior visible

too dull

The lid of the box rotates within a circle drawn in perspective. You need to know how the circle in perspective is drawn (see further in this chapter), and choose an effective rotation. Here a rather flat but easy to draw rotation is used.

2.2.3 Shading and Cast Shadow

Shading is used to emphasise the volume of an object, and to position it in its surroundings.

Shading refers to the differences in darkness of the object's sides, as related to a light source. Cast shadow is the projected shadow onto a surface.

In general, parallel light (sunlight) creates an effective cast shadow. One point light (lamp light) often does not show an appropriate cast shadow. It can create a shadow that is not related to the object's perspective. It is more difficult to construct and less predictable. Cast shadow from a parallel light source is easier to predict and perceived as realistic.

Choosing a direction of the light source is done by two lines: the actual light direction or 'slope' A, and the projected light direction B. Imagine a parallel light source just over your left shoulder. It will have a relatively steep slope A, and B will point slightly towards the upper right.

All the actual light directions (slopes A) in a drawing can be drawn parallel, and all projected light directions will slightly converge.

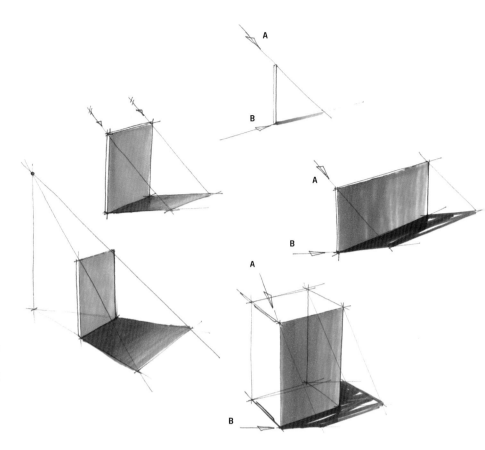

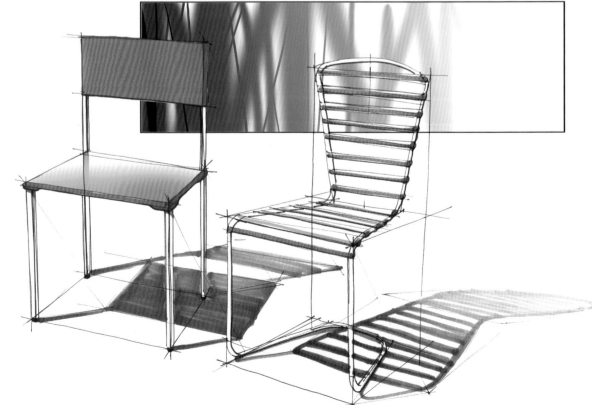

A lot of shape characteristics of an object can be seen by the shape of its shading, such as 'open' and 'closed' volumes, or edgy and rounded volumes.

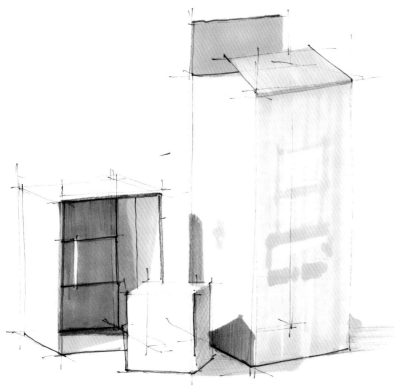

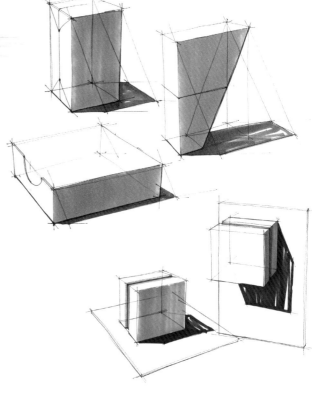

Constructing a cast shadow can be compared to projecting a shape on a surface, which means that rules of perspective for shading apply. The perspective of the cast shadow and that of its original converge toward the same vanishing point. The length of a line and that of its shadow are comparable in length.

The shadow of a block mounted on a wall and that of a block on a horizontal surface may actually have the same shape.

Backlight may only be desired to create a suspenseful scene.

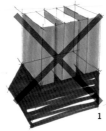

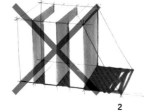

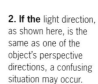

1

2

3

1. Choosing a light direction that comes towards you will not only put a distracting dark shape in front of the drawing, but more importantly, will leave no room for colour and contrast on the shape itself.

2. If the light direction, as shown here, is the same as one of the object's perspective directions, a confusing situation may occur.

3. If the slope of light chosen is too steep, the cast shadow will become too long and dominant.

In general, the direction of light is chosen in such a way that the most characteristic side of the object is the shaded side, and the cast shadow has a continuous shape. Perhaps the best option of the three chairs is that of the largest chair. The length of the cast shadow should be big enough to support the volume of the object, but not so large as to be dominant.

2.2.4 Marker Technique and Colour

Marker can be applied in several ways. The easiest way is to use parallel 'stripes' on a surface. Vertical stripes underline the vertical orientation of the surface. In the middle drawing the 'wet-in-wet' method is used. Marker direction is not important; just keep the paper wet. On the right block some lines are added on top of a wet-in-wet surface. This will suggest a gradient, and give the drawing a less static appearance.

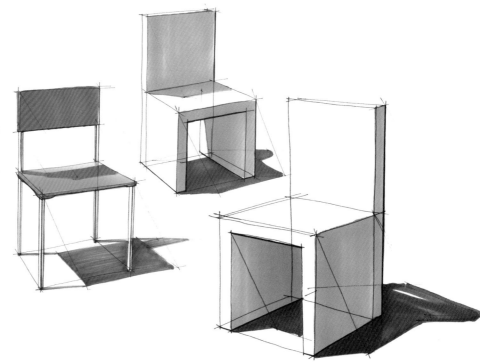

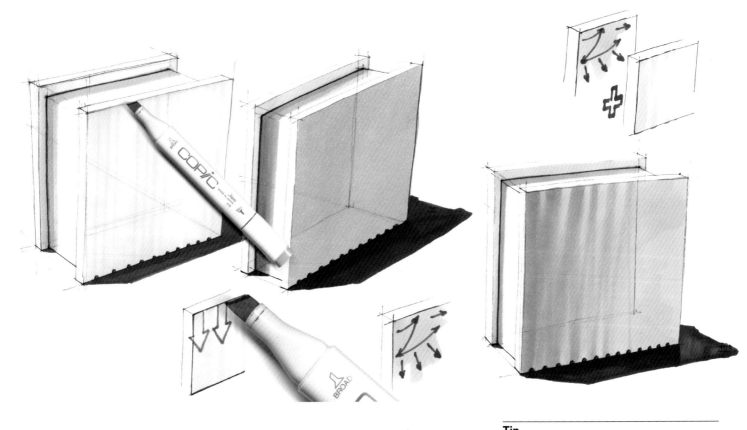

As the object and its cast shadow are further apart, the shadow will become lighter because of ambient light. This gradient in shading can be done with white pencil or marker.

Tip
Make sure that the flat side of the tip of your marker stays parallel to the border of the surface; this will make the drawn marker surface end in a neat line.

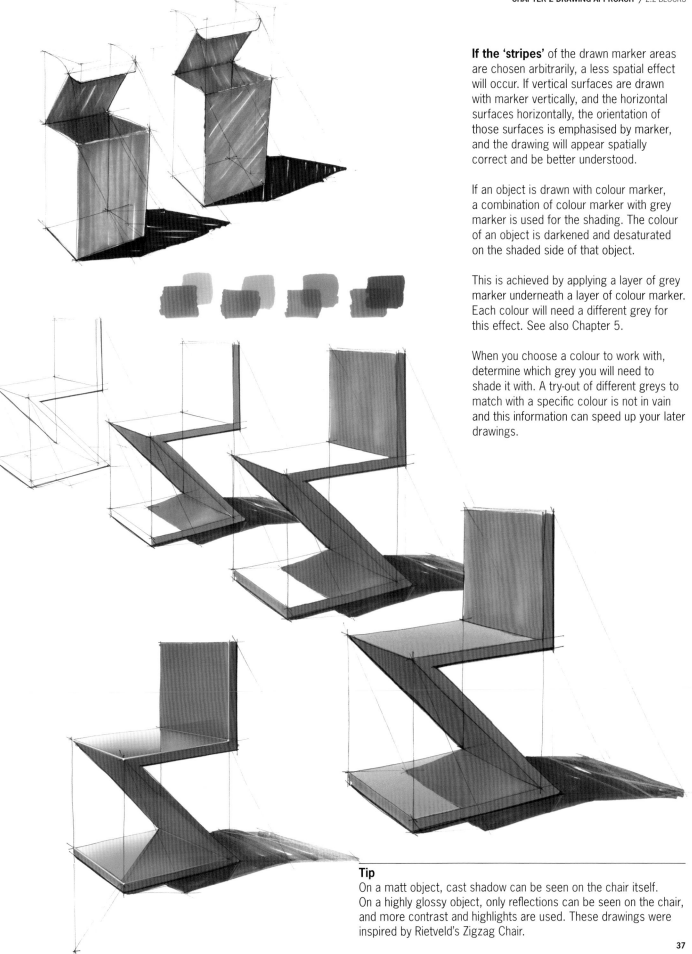

If the 'stripes' of the drawn marker areas are chosen arbitrarily, a less spatial effect will occur. If vertical surfaces are drawn with marker vertically, and the horizontal surfaces horizontally, the orientation of those surfaces is emphasised by marker, and the drawing will appear spatially correct and be better understood.

If an object is drawn with colour marker, a combination of colour marker with grey marker is used for the shading. The colour of an object is darkened and desaturated on the shaded side of that object.

This is achieved by applying a layer of grey marker underneath a layer of colour marker. Each colour will need a different grey for this effect. See also Chapter 5.

When you choose a colour to work with, determine which grey you will need to shade it with. A try-out of different greys to match with a specific colour is not in vain and this information can speed up your later drawings.

Tip
On a matt object, cast shadow can be seen on the chair itself.
On a highly glossy object, only reflections can be seen on the chair, and more contrast and highlights are used. These drawings were inspired by Rietveld's Zigzag Chair.

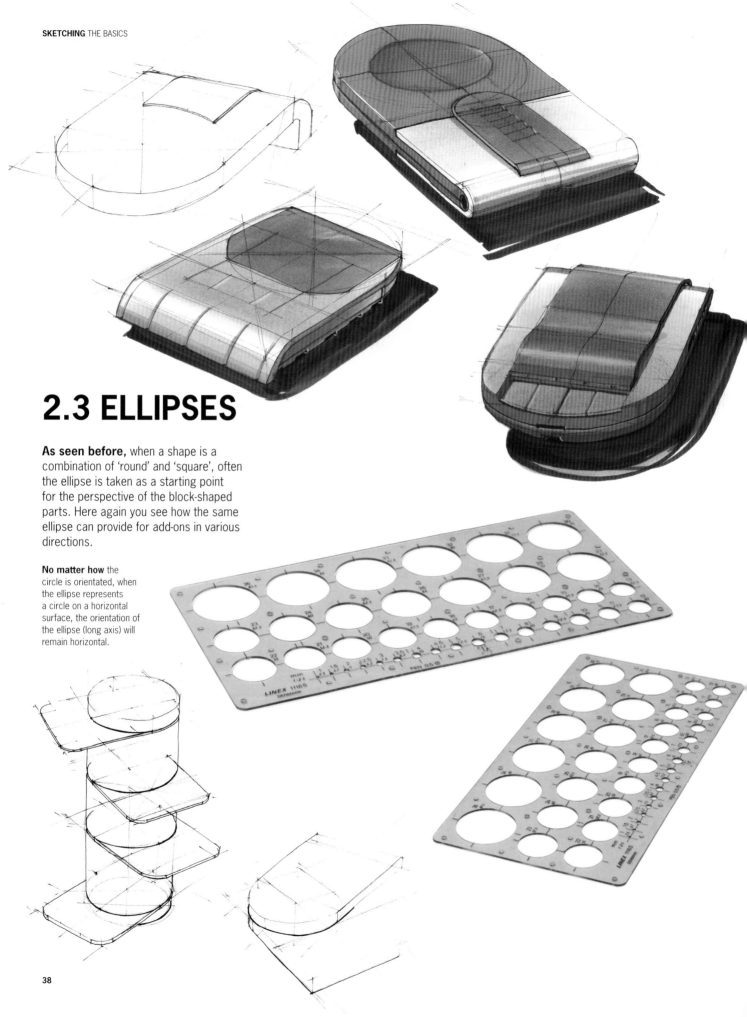

2.3 ELLIPSES

As seen before, when a shape is a combination of 'round' and 'square', often the ellipse is taken as a starting point for the perspective of the block-shaped parts. Here again you see how the same ellipse can provide for add-ons in various directions.

No matter how the circle is orientated, when the ellipse represents a circle on a horizontal surface, the orientation of the ellipse (long axis) will remain horizontal.

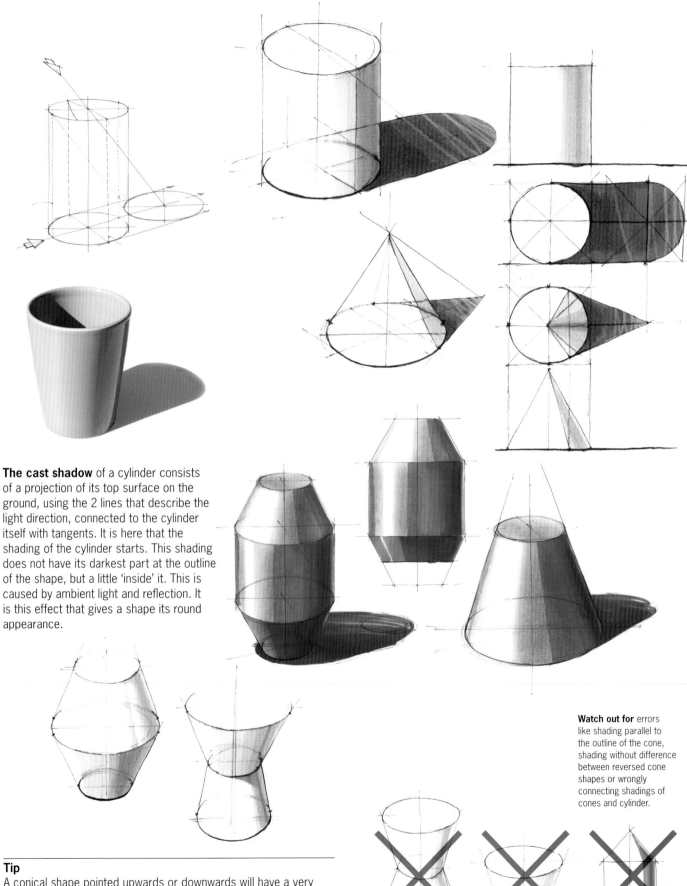

The cast shadow of a cylinder consists of a projection of its top surface on the ground, using the 2 lines that describe the light direction, connected to the cylinder itself with tangents. It is here that the shading of the cylinder starts. This shading does not have its darkest part at the outline of the shape, but a little 'inside' it. This is caused by ambient light and reflection. It is this effect that gives a shape its round appearance.

Watch out for errors like shading parallel to the outline of the cone, shading without difference between reversed cone shapes or wrongly connecting shadings of cones and cylinder.

Tip
A conical shape pointed upwards or downwards will have a very different shading from that of a cylinder. When these shapes are simply combined, without a smooth rounding transition, the shading of that object will have drastic 'jumps'.

2.4 UPRIGHT CYLINDERS

A circle drawn in perspective is represented by an ellipse, a mathematical shape. Useful rules are related to their axes. The major axis is the longest line possible, while the minor axis divides the major axis into two equal parts. The crossing of those two lines is exactly 90 degrees at the middle. Drawn in perspective, the perspective centre of the circle is of course not through this point, but, depending on the amount of convergence, somewhat behind this point, as shown in the example. If you cut a grapefruit in two equal halves you can see this difference.

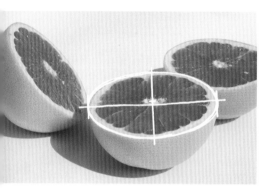

To draw a cylinder you need a centre line, two ellipses and two vertical tangents on the outside. The base ellipse will be rounder because of perspective. You may compare it to a block shape but you do not need to draw a block and construct a cylinder within this block.

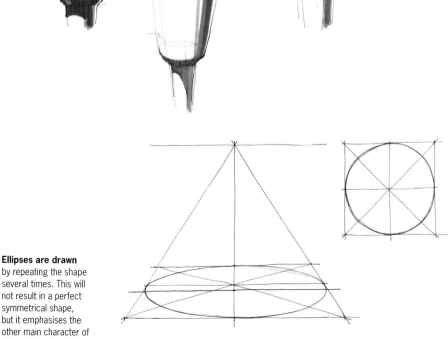

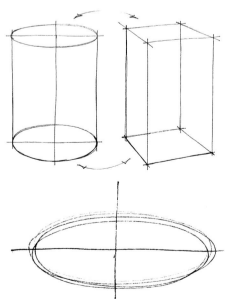

Ellipses are drawn by repeating the shape several times. This will not result in a perfect symmetrical shape, but it emphasises the other main character of ellipses: the fluency of the shape.

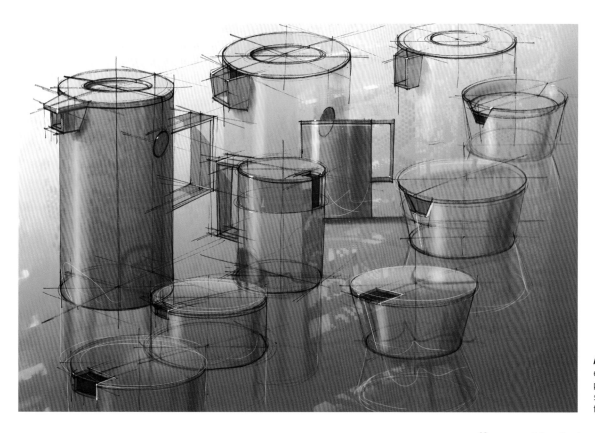

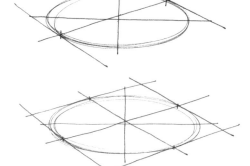

A tangent to the ellipse determines the perspective of other shapes combined with this cylinder.

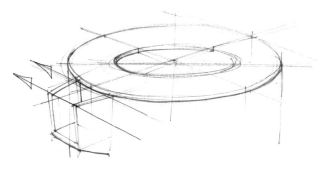

If you want to attach something like a handle or grip to a cylindrical shape, you will want to know its position and perspective in relation to the cylinder. Therefore you can use tangents.

The first line is a centre line through the perspective centre (and not through the crossing of the major and minor axes). If you then draw two tangents, step by step, you will get a square around the ellipse. The two directions drawn 90 degrees in perspective to each other is the result.

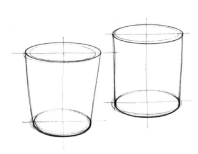

Tip
We drew in 2-point perspective. If you draw in 3-point perspective, it may become unclear weather you are drawing a cylinder or a cone.

2.5 HORIZONTAL CYLINDERS

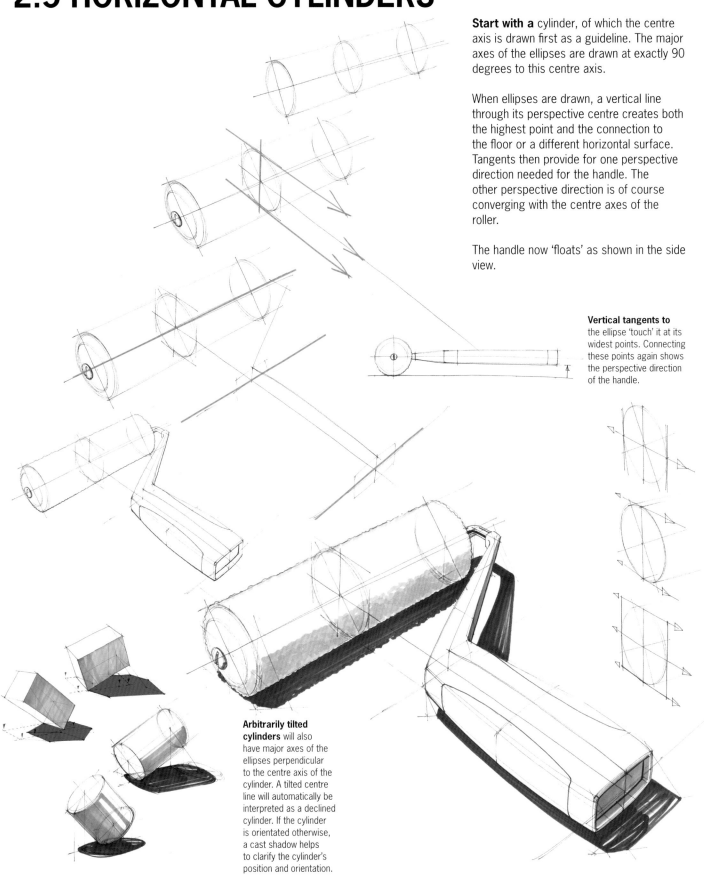

Start with a cylinder, of which the centre axis is drawn first as a guideline. The major axes of the ellipses are drawn at exactly 90 degrees to this centre axis.

When ellipses are drawn, a vertical line through its perspective centre creates both the highest point and the connection to the floor or a different horizontal surface. Tangents then provide for one perspective direction needed for the handle. The other perspective direction is of course converging with the centre axes of the roller.

The handle now 'floats' as shown in the side view.

Vertical tangents to the ellipse 'touch' it at its widest points. Connecting these points again shows the perspective direction of the handle.

Arbitrarily tilted cylinders will also have major axes of the ellipses perpendicular to the centre axis of the cylinder. A tilted centre line will automatically be interpreted as a declined cylinder. If the cylinder is orientated otherwise, a cast shadow helps to clarify the cylinder's position and orientation.

When creating a cast shadow of elevated block shapes (such as the grip), one can see that the cast shadow becomes simpler as the object gets thinner.

With relatively thin objects, a simple projection of the top surface or cross section is used as cast shadow.
This is called a pseudo-cast shadow or a drop shadow. This is relatively close to reality, and a great simplification in drawing, offering speed and efficiency.

One still has to choose an efficient position for this cast shadow. In most cases the best solution is for the shadow to be bigger on one side of the object and not be symmetrical.

Pastel chalk is used on the (brightest) top surface. Scrape off some chalk; mixing might be necessary as it is important that the chalk has exactly the same colour as the marker. Use a relatively big piece of toilet paper or a tissue and apply with big 'brush-like' movements. It is applied in several layers. This ensures a smooth gradient without smudges. The chalk next to the drawing is easily erased.

Colour pencil is used here on the brown surface, adding a gradient to emphasise the curvature of the grip.

2.6 PLANES & SECTIONS

When a drawing is based on sections or planes, the biggest surfaces and sections are drawn first. They also serve well in keeping the shape symmetrical.

The idea sketches of a tent are started with the bottom surface, on which the vertical sections are drawn.

To maintain a transparent appearance, a combination of pastel chalk and colour pencil is used for cast shadow and shading. In this way, the sections, drawn with ballpoint, are kept quite visible. This is necessary, as they are the basis of the tent's structure, and needed as input for further design stages.

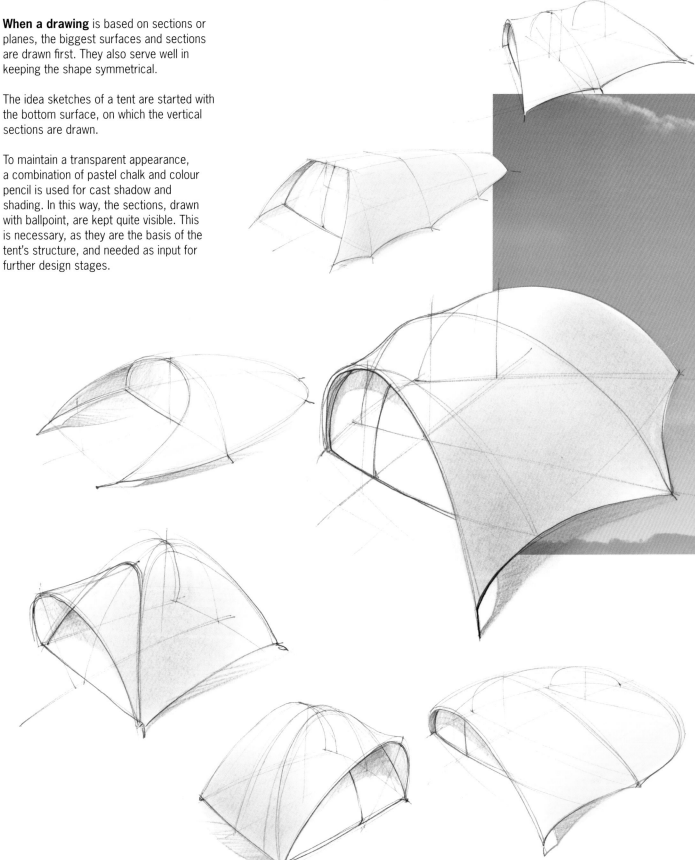

When the viewpoint is slightly altered, this diagonal section is easier to work with.

When a curve is difficult to reproduce or to draw symmetrically, drawing a square or rectangular surface can be of help. You might even use equal points of the diagonals to preserve the curve's symmetry.

2.7 SPHERES

When drawing these kinds of shapes, ellipses play an important role. They are the sections of the spheres, and just like before, they will determine the perpendicular perspective directions of every shape attached to the sphere.

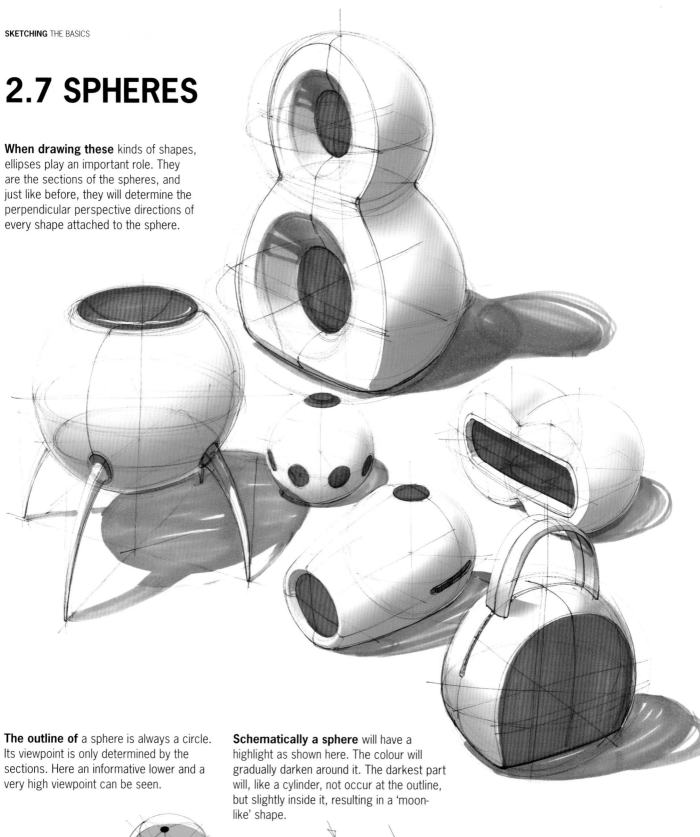

The outline of a sphere is always a circle. Its viewpoint is only determined by the sections. Here an informative lower and a very high viewpoint can be seen.

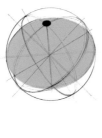

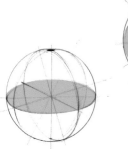

Schematically a sphere will have a highlight as shown here. The colour will gradually darken around it. The darkest part will, like a cylinder, not occur at the outline, but slightly inside it, resulting in a 'moon-like' shape.

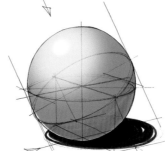

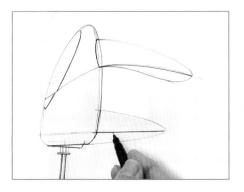

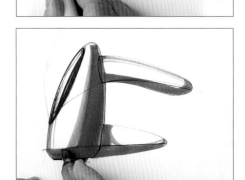

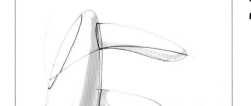

2.8 HOW TO PRACTICE

Whether a drawing is made in side view or in perspective, the sequence of the drawing materials and related choices can be the same.

Start with long, thin sketch lines and choose a direction for the light source. Make stronger lines on the shaded side, bottom and right hand side, and of the separate parts. Apply shading using a grey marker (first try it out in relation to the colour). Apply colour marker and pastel. Make sure the pastel chalk has exactly the same colour as the marker; otherwise the effect of material expression will be lost. Always start 'big' and save details and highlights when finishing the drawing.

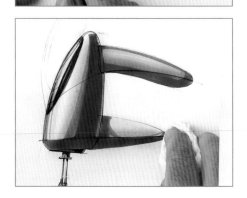

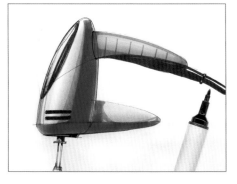

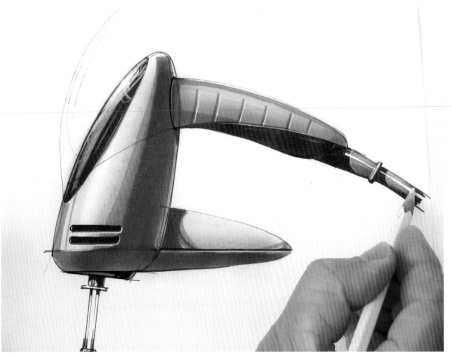

2.9 FINALLY

All the theory described in this chapter is meant to help you develop your drawing skills. Beware, however, that there are also other drawing aspects that can have a bigger impact on perception. Aspects like the general contrast used, size and the position of the sketches in relation to one another.

One of these aspects that is worthy of more attention is overlap. It can occur spontaneously when 'thinking on paper', as in the adjacent drawing (originally A3 size), or it can also be 'staged', as in the drawing below. Here each object was coloured and finished before drawing the next one. Creating overlap on purpose like this helps you train your ability to improvise and to use big (colour) contrast to help shift the attention of the reader from an undesired to a desired spot on the paper. Notice also how overlap makes these sketches more dynamic and adds more suggestion.

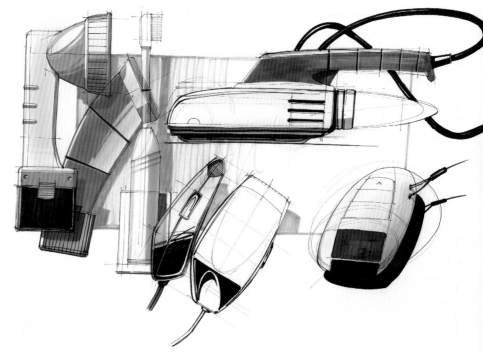

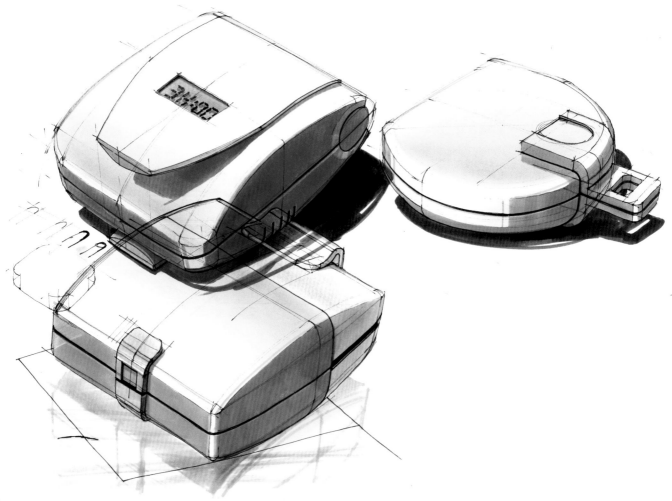

2.10 MORE SKETCHING TIPS

Sketching with a fineliner or marker instead of a pencil and eraser causes you to take decisions, not ponder. This approach may take some time to get used to, but it is a realistic one in product design; it is a high-speed process. While sketching, each time you have to take a clean sheet of paper because the previous one is messed up, you have actually learnt something.

Some may say that studying the work of other people and trying to imitate sketches of others may ruin the development of your personal handwriting. We have seen this attitude cause students to unnecessarily reinvent the wheel again.

It can be very helpful to study the work of people you admire. It may actually speed up your learning, as it makes you aware of the existing level of work in your field, and points out your own strengths and weaknesses. But most of all, it can simply be inspiring.

When you sketch digitally, it is normal to sit in front of your screen and not look at it from an angle. When you sketch on paper, this position is also best. Make sure you look at your paper perpendicularly. Avoid sketching too close to your paper; you might get lost in details that do not have such a big influence.

It is sometimes difficult to 'take distance' from your sketch, to take an objective look at it. A way to look at your sketch fresh again is to look at it in the mirror! The balance of contrast can be better assessed by looking at the sheet of drawing(s) upside down.

CASE

SMOOL, NETHERLANDS

Design of a coffee and tea service for Simon Levelt, 2010
Designer: Robert Bronwasser

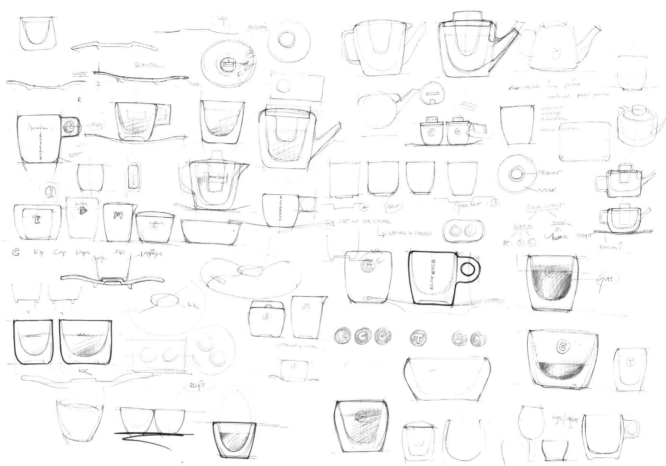

'.. These sketches reflect my thoughts when forming the 'concept'. Usually I fill several A3 papers with scribbles, as a personal brainstorm, out of which one or more interesting design directions can be distilled. I then use Adobe Illustrator to quickly put the design in the right proportions. An advantage of this method is that I can now print it at actual size (1:1) and have the actual proportions at hand. Often some plain foam models are also made at this design stage...'

The sketches seen here are made with black ballpoint pen and colour pencil. Interesting shapes and directions are outlined with black felt pen.

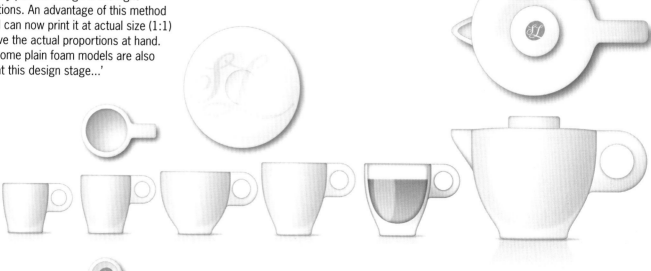

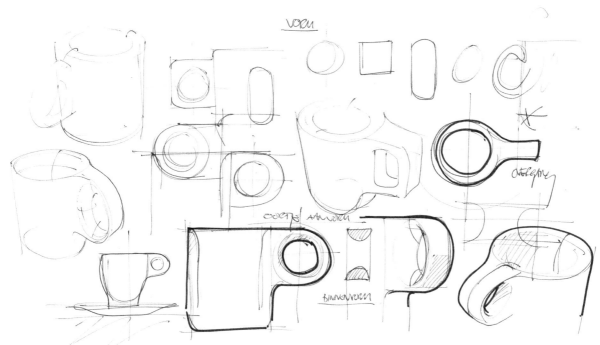

Now designs are set up in DS SolidWorks, so product details and shape transitions can be worked upon with much realism. Realistic renderings are derived for presentation to the client.

'...Because of my experience, it now takes fewer sketches to get to an idea. Decisions and choices are made quicker and are better focussed. I do not show all the drawings to the client; merely the design thought process. I mainly show the result and explain the concept. I also leave out sketches as not everyone is able to 'read' and interpret them correctly.

I now work with freelancers that transform my sketches into computer models. Detailing is then also put into the computer. I use freehand sketches in all phases of the design process: for ideation but also for communication with the 3D-modellers...'

Simon Levelt, a Dutch trading company, established in 1817, is now an internationally known firm in roasting coffee and selling coffee and tea. Special attention to the environment and fair trade is their strong belief. The design of this timeless yet contemporary service set expresses craftsmanship and focuses on the joy of drinking coffee. An exceptional detail is the cast handle of the cups, a novelty in the production of porcelain.

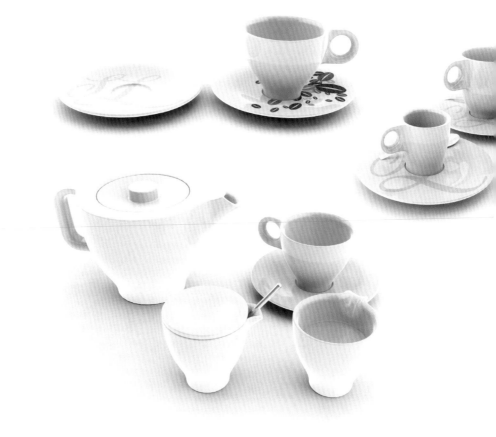

CASE

CARL LIU, CHINA

Origami Chair concept, 2010

The ideation sketches were mainly made for personal use, to figure out the overall look and feel of this chair as well as the design details. The sketches were done by freehand sketching in a sketchbook. Since the sketches were for personal use and not for communication, freehand drawings on paper were fast and efficient. The sketches are 20.5 x 13 cm and made with pen and marker. Some of the sketches were used to communicate with my engineer, for surface building and structure realisation.

The Origami Chair was inspired by Origami art which is a traditional Japanese folk art of paper folding. The goal of this art is to transform a flat sheet of material into a finished sculpture through folding and sculpting techniques. It started as a challenge to use aluminium sheet metal to make a lightweight but strong and durable chair. The seat and back support are made of one piece of aluminium sheet. With a few cuts and folds, the flat sheet of aluminium magically transforms into a strong but comfortable sitting element.

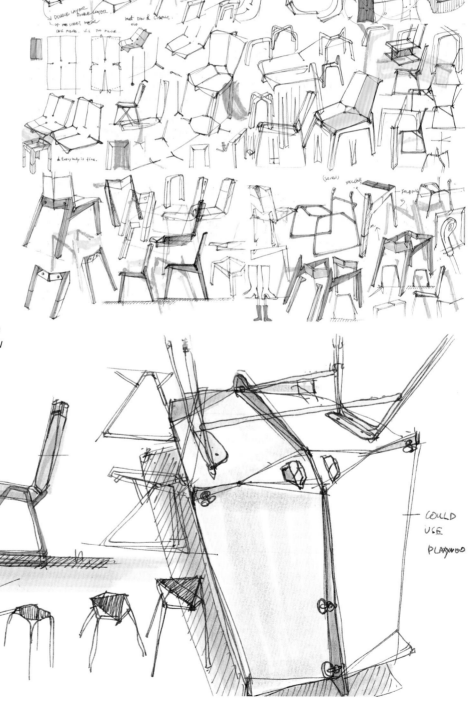

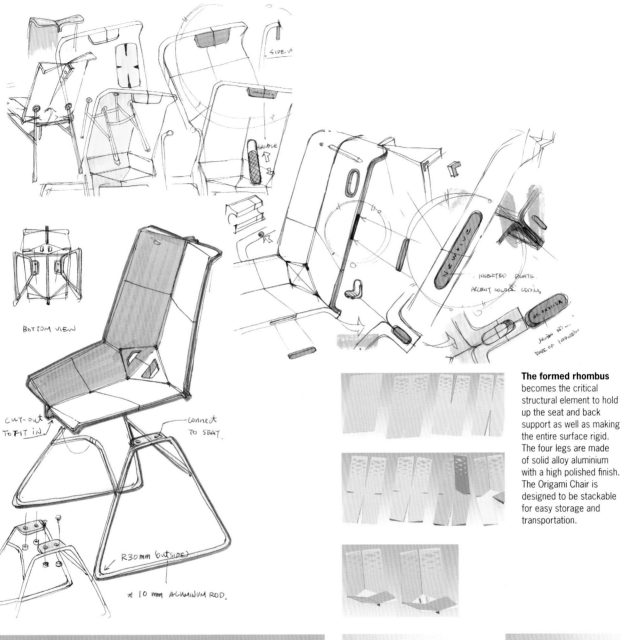

BOTTOM VIEW

CUT-OUT
TO FIT IN!

connect
TO SEAT.

R30mm (outside)

ø 10 mm ALUMINIUM ROD.

SIDE VI

HANDLE

INSERTED PLATE
ARCENT COLOUR COATING

NO. 0X2123A

SERIAL NO.
DATE OF PRODUCTION

The formed rhombus
becomes the critical
structural element to hold
up the seat and back
support as well as making
the entire surface rigid.
The four legs are made
of solid alloy aluminium
with a high polished finish.
The Origami Chair is
designed to be stackable
for easy storage and
transportation.

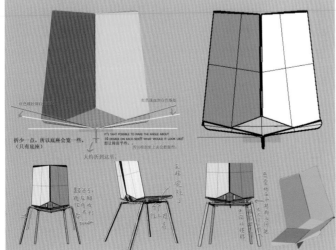

Chapter 3

VIEWPOINT

The choice of the viewpoint has a big impact on a drawing, so it's worth while to make a well-considered choice. Some chosen viewpoints make it possible to give pure shape information about an object (related to the human eye), whereas a different choice can have a completely different impact. An object could appear bigger or smaller, but also nice, impressive or overwhelming. How do you choose and can you predict the result of your choice?

'...Never underestimate the importance of a sketch in the design process. A good sketch can often embody a lot of character which is an essential reference when the design is translated into a 3D model, especially in car design...'
—Doeke de Walle, Designer at Pininfarina

3.1 THE INFORMATIVE VIEWPOINT

There are various kinds of viewpoints. At many stages of the design process, communication of intended proportions is crucial. Those types of viewpoints in which clearly communicating shape information is important are called informative viewpoint.

This viewpoint is all about optimising shape information, including intended scale information: how big is the object. A large object will be sketched with more perspectival convergence than a small object. In some cases the way a product is used influences the choice (user viewpoint).

The open matchboxes, for example, give the optimal shape impression in terms of both size and usage. The boxes above have top surfaces which are too foreshortened or too flat. In fact, they are positioned too near to the horizon, causing this effect. A very flat surface gives difficulties estimating its size, both by the viewer and the draughtsman. The boxes further below have the opposite effect; too high a viewpoint means the need for a third vanishing point, that of the vertical lines, which causes too much distortion to 'read' the actual size of the vertical surfaces. The sketch at the bottom shows two perspectival directions which are near the 90-degree angle. At 90 degrees the 2-point perspective changes into a 1-point perspective, and no side surfaces can be seen.

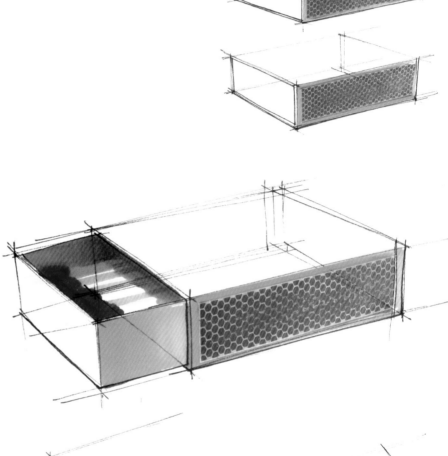

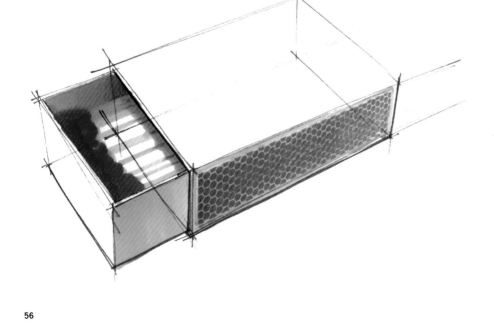

B

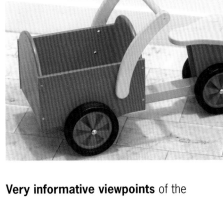

A

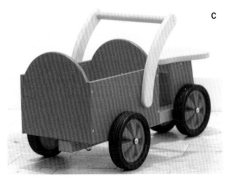

C

Very informative viewpoints of the toddler's red bike are found in photo A, B and C. In photo D the bike appears nice at first glance, but it does not reveal much of the (most informative) side view, and leaves the back of the bike unexplained. The same can be said about E. Photo F is also quite informative, but not optimal. It is even taken from a 'user's point of view', but the viewpoint is so low that the saddle appears too foreshortened to 'read' its shape. Very uninformative is G; it is almost a top view instead of a perspective, and therefore not very spacious. Photo H also gives a good overview of the bike's shape, and photo I emphasizes the box carrier, but leaves the rest of the bike unexplained because of overlap.

In short, it is important that if you were to draw a box around the bike, all 3 visible surfaces should have only a little foreshortening, just like the matchbox. Besides that, there are viewpoints of which a part of the object overlaps another, and thus hides shape information.

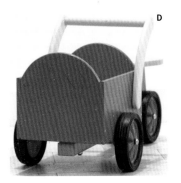

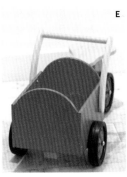

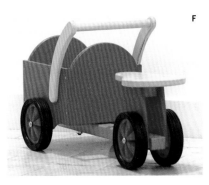

D

E

F

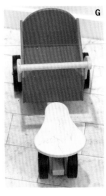

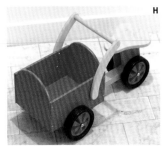

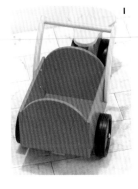

G

H

I

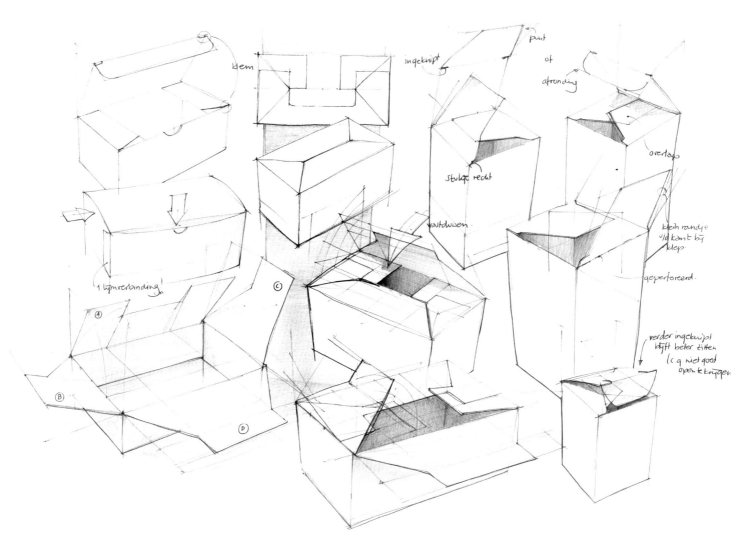

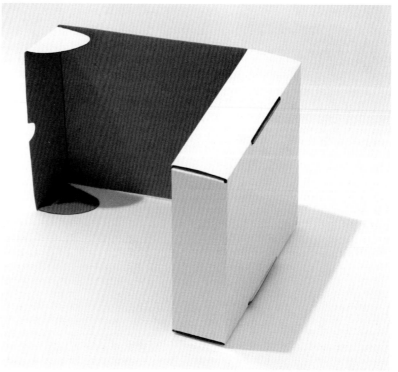

In these sketches various ways of folding carton boxes are investigated and analysed for use in the design of a nest box.

A rather high view point is chosen to keep the emphasis on the top surface where the folding takes place. The overall dimensions of the boxes are unimportant at this stage.

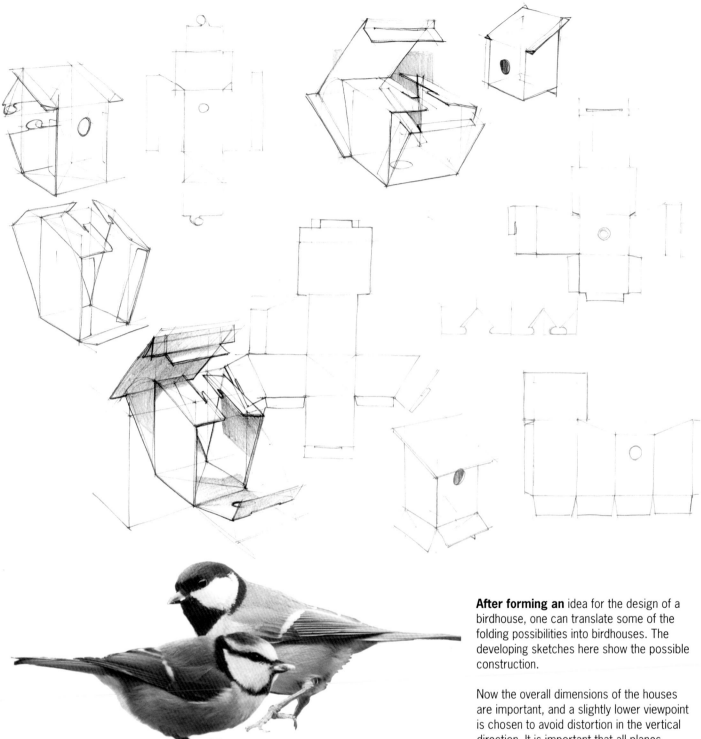

Blue Tit and Great Tit
(Cyanistes caeruleus and
Parus major)

After forming an idea for the design of a birdhouse, one can translate some of the folding possibilities into birdhouses. The developing sketches here show the possible construction.

Now the overall dimensions of the houses are important, and a slightly lower viewpoint is chosen to avoid distortion in the vertical direction. It is important that all planes are clearly visible. The use of a small background and shading are of course also helpful.

The plan views are used to inform on the use of material and also to communicate even more information regarding the folding principle.

Leaving the angle of view in terms of height the same, you may still turn the object in different positions. It is important to create a good view of the two vertical surfaces. One of these vertical sides, however, will in most cases represent the object best. In this example it is the side of the car. Compare it with a child's drawing of a car, who will draw it from the side; this is the archetypal way. This most informative side in a perspective drawing should be the less foreshortened side of the drawing, to reveal maximum information. In the example here, the drawing D at the bottom right is regarded as the result chosen with the most optimal viewpoint.

Some remarks on the other drawings: drawings A and B show hardly any information about the side and are not generally informative. Truck B may have an excellent viewpoint for other purposes; it has its emphasis on the front of the toy. Drawing C, by contrast, is too foreshortened to perceive the front width of the truck.

3.2 SIDE-VIEW DRAWINGS

There are many more or less 2D products, such as flat screen TVs or built-in car information systems. There are also spatial, 3D products that clearly have a more important, or dominant 'face', like clock radios, microwave ovens and washing machines.

It is not always useful to draw a perspective representation of these kinds of products; it could mean an enormous time saver to just draw this 'face' in side view. Drawing in side view in this case thus means more design efficiency.

This sketch of the beamer starts with long thin and smooth lines. The light direction is chosen from the left-hand top side, so all lines on the shadow side, i.e. right and bottom of each part, can be drawn thicker. Doing so in the line drawing adds depth; the lines are called shadow lines. Where a hole in the housing is located (due to a button, for example), the contour of that hole can be thickened completely all round.

When shading and cast shadow are added, a more profound sense of depth and spatiality is added. The main shape of the product (whether flat, curved or hollow), and its rounding become clear. But also the spatially deeper parts or parts sticking out such as ribs can be well perceived now.

Colour and structures are now added. Always make sure there is enough contrast in the drawing, because if you add pastel chalk, contrasts will automatically lessen.

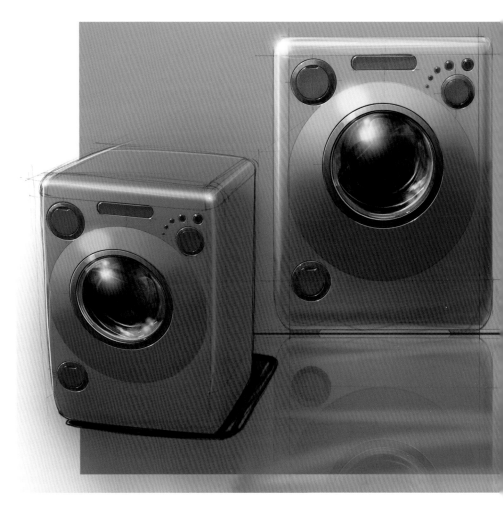

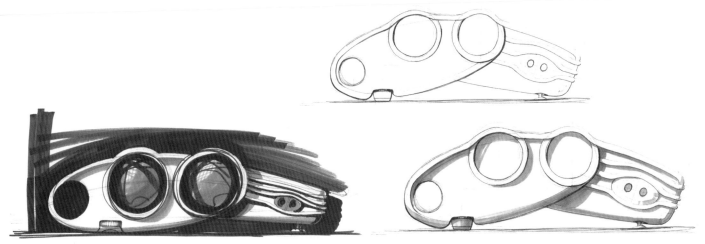

An example of how to draw structures, with hatching in between the ribs, in steps: First draw in arbitrary direction, then a second hatching crossing the first one at an angle (try to avoid a 90-degree angle). The third hatching (also slightly different to the first two) will finish the nonwoven structure.

Even after applying pastel chalk or airbrush, small details can be added with black and white lines.

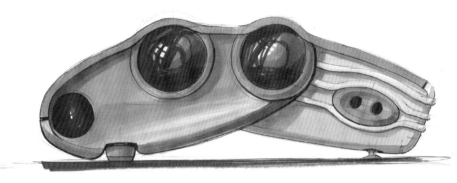

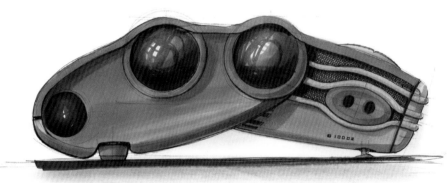

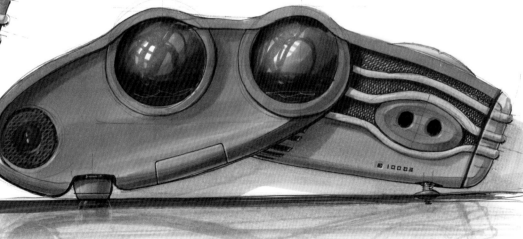

Tip
Adding surroundings to the product, in this case a cast shadow on a back wall and a theoretical reflection on the ground surface using light grey marker and pastel chalk, gives the drawing a more spatial context.

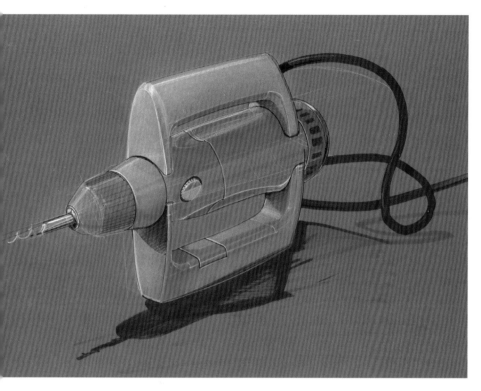

The viewpoint of a product that is drawn from a declined cylinder is largely determined by the first line of the drawing: the central axis. This determines the rotation, and with that, the roundness of the ellipses, which further determines the perpendicular directions used for drawing handles etc.

A horizontal central axis in a perspective drawing means a central perspectival viewpoint (drawing A). This is not a very spatial, informative viewpoint. Drawing B has very flat ellipses which make it difficult to draw sections and tangents. Drawing E, on the other hand, has such a tilted central axis that the shape is too foreshortened in that direction to perceive its precise length. Drawing C and D are more informative viewpoints.

So a central axis that is not too horizontal or too steep is in most cases a good start. The directions of the ellipses are then known (always perpendicular), and only the roundness needs to be estimated. To verify this roundness a set square can be used.

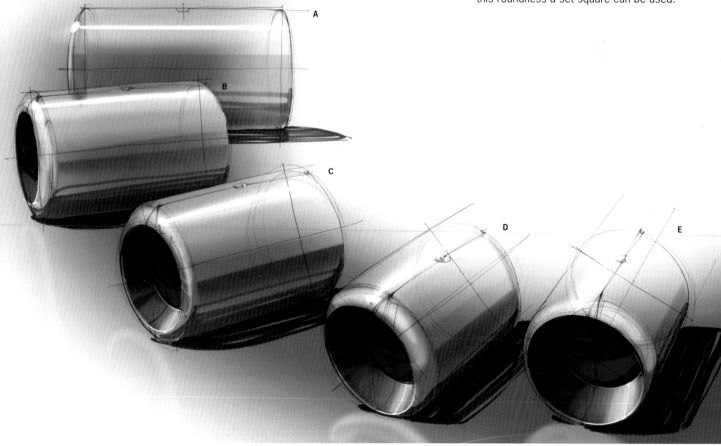

With the same central axis, four ellipses are drawn in this example. A vertical line through the centre of the ellipse crosses it at top and bottom (at this point the cylinder would lie on a horizontal surface). Tangents to these points reveal the perspectival horizontal direction. Drawing two vertical tangents to the ellipse and connecting these points also shows this horizontal direction.

This horizontal direction and the central axis are comparable with the two horizontal perspective directions of a block shape.

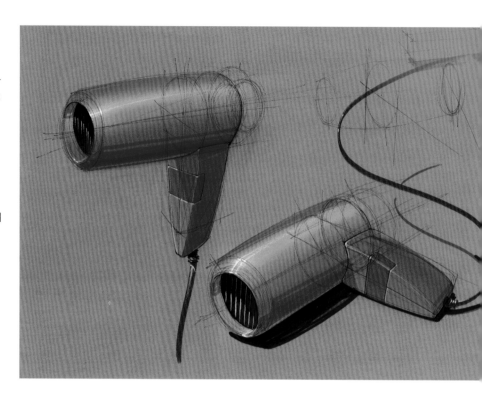

Thus a perspectival square can be drawn 'around' the ellipse. When this is truly a square (the third from the left), the ellipse has a correct roundness.
When starting a drawing, this is a useful tool to check the roundness of ellipses. Later on you can estimate the roundness better, and no check will be needed.

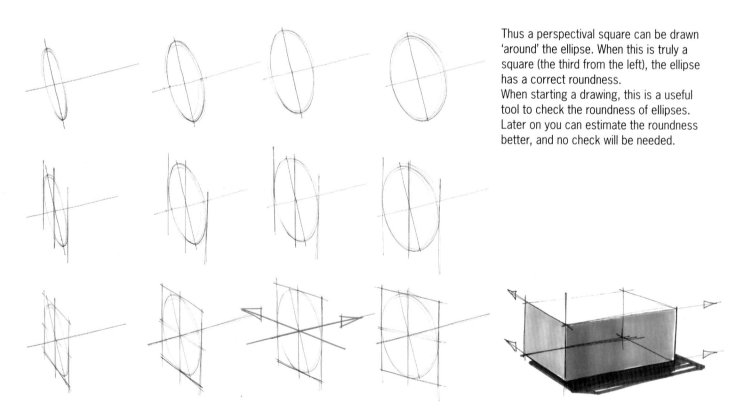

Even in the case of tilted shapes in random orientations, the method of tangents to ellipses can be used to determine the corresponding perspectival perpendicular directions to an ellipse. In these shapes here, one groove is always chosen and drawn, the perpendicular groove can be found using tangents. The thickness of the shapes is of course in the direction perpendicular to the long axis of the ellipse.

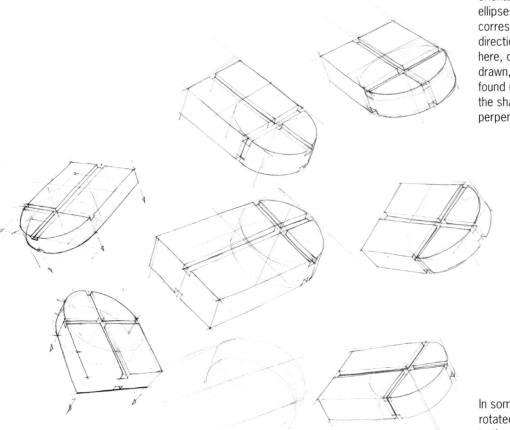

In some cases the original drawing can be rotated slightly. This adds more dynamics to the drawing. This is especially common in car design.

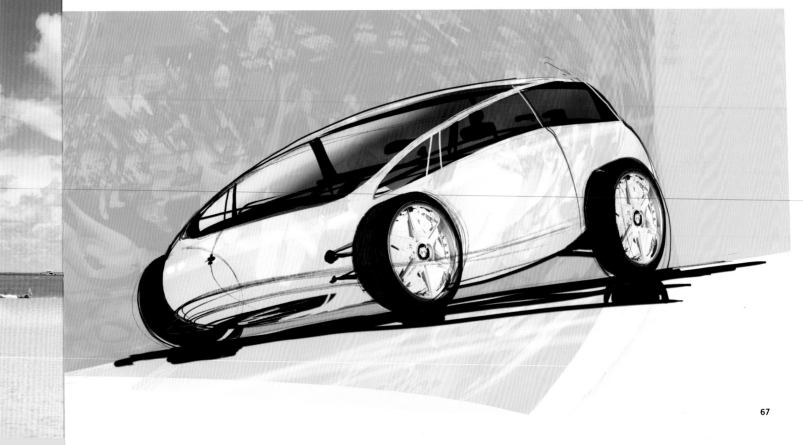

3.5 GROUND-LEVEL FROG'S-EYE PERSPECTIVE

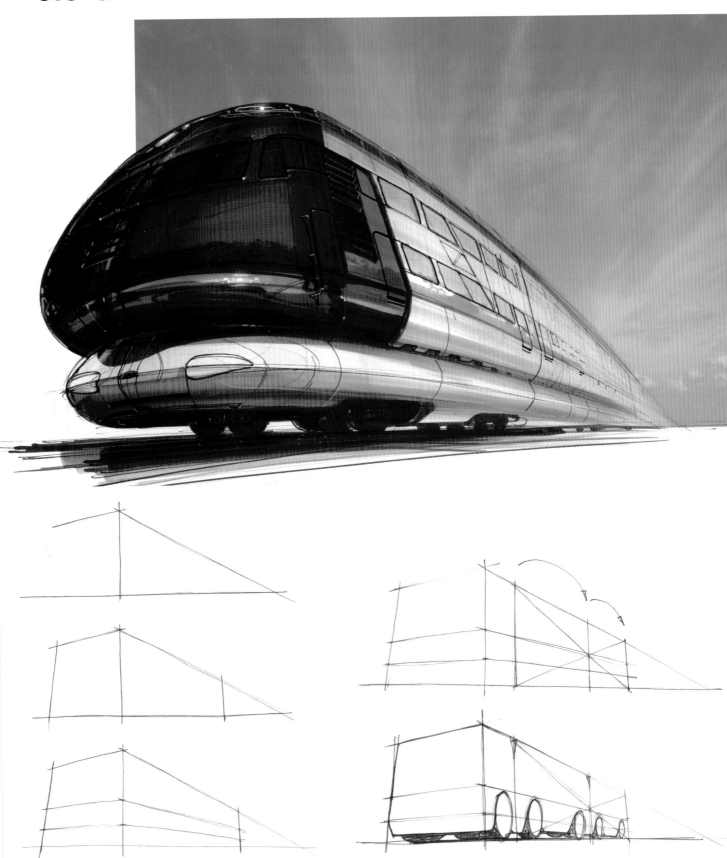

The
give
abou
visua
level
trans
eye l
both
intac
some
persp
objec
is use
conve
drawi

3

Befo
can
relax
your
to m
of th
minu
of gr

Shov
Do n
This
and
slipp
your

The drawing begins
with a horizon and
the nearest vertical
line. In both directions
perspectival convergence
is drawn; one vanishing
point nearby (just in
the drawing), the other
further away. Left and
right boundaries are
slightly tilted to suggest a
third vanishing point. This
will make the object look
bigger. Dividing these
'verticals' in, for example,
halves and quarters and
connecting these points
will give you perspective
guidelines. Notice the
amount of perspective
in the fourth step, a big
difference in size of the
two trailers.

A special variation of eye level is frog's-
eye perspective. Here the viewer has an
extraordinarily low viewpoint; just above the
ground like a frog, just above or even on
the horizon.
The object is drawn almost on the horizon.
As objects are now much bigger than the
viewer, a lot of perspectival convergence
is used; both vanishing points are relatively
nearby. As a result, the object will appear
huge, impressive or in the case of a vehicle,
maybe even 'fast'.

CASE

ART LEBEDEV STUDIO, RUSSIA Crane cab for frame and bridge cranes. 2009
Client: Optim Crane

'...In the concept stage of the project, we actively used digital sketching because it helps us easily combine different shapes and volumes. By doing this we came up with some concrete directions which we developed a step further. One of them was an idea to use a mesh language for surfacing. We found that the idea of using flat plane surfaces perfectly fits this purpose. After that we made a series of inspirational sketches using Adobe Photoshop and Alias Sketchbook Pro mostly...'

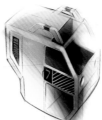
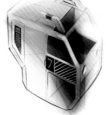
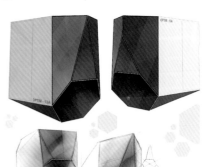

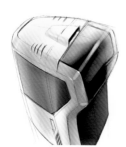

'...**At almost every** stage, sketching helped us to find the right solution. We have definitely saved time and resources by doing loads of sketch experiments at each stage...'

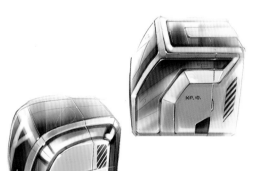

After creating the basic 3D model of the cabin and setting all important layout points, we started sketching again, this time to solve issues of use such as, windows opening, glass cleaning, ventilation and most importantly of all, providing great visibility for a crane operator.

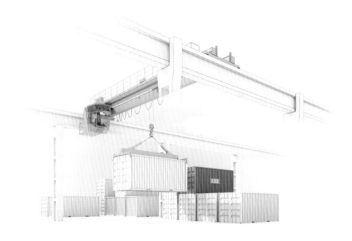

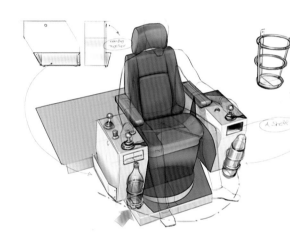

Sketches were also made to understand how to use some technical boxes and spare places around a crane operator.

Finally, a special environment was made, and even some animations in 3D were created. We could thus check the process of lifting containers and moving them around.

The cab is designed for single and double-beam 125-tonne capacity cranes. It boasts panoramic windows, which must be installed with careful regard to production technology and provide a significantly larger field of view.

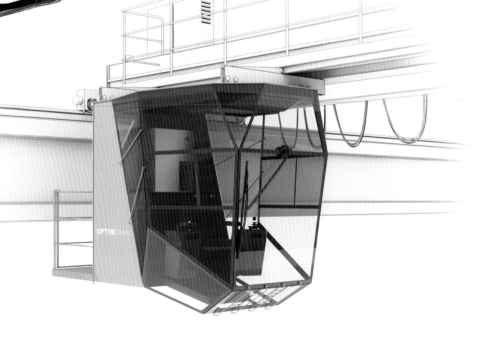

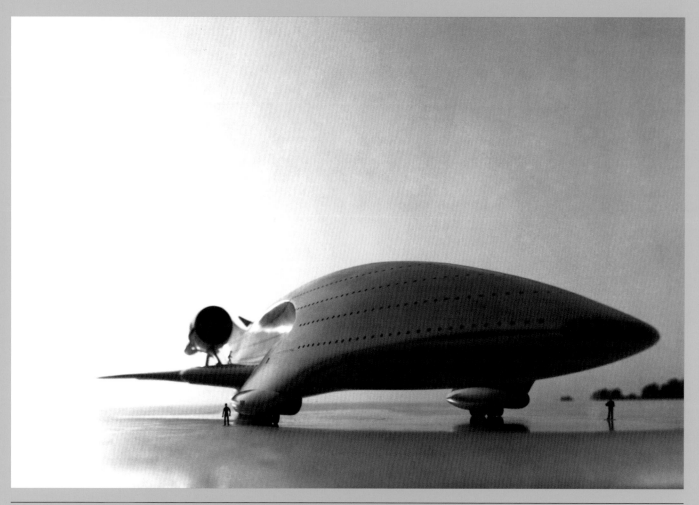

The mega-passenger aircraft Megalodon by Colani, 1977. The mega-passenger aircraft is based on the shape of the Megalodon shark. Colani presented his own mega-version of a passenger aircraft seven years after the 747 first went into service. It has four flight decks, swing-wings at the rear, and two fivefold drives. Each flight deck can seat up to 1000 passengers.

Chapter 4

SKETCHING PROGRESS

This chapter continues with the drawing approach as discussed in the previous chapters. Only this time, we will discuss more realistic situations. To better explain the various approaches, the previous chapter divided products into separate categories of shapes: block, cylinder and cone, sphere and plane. This chapter starts with shapes that are a combination of those, and moves on to shapes with more complexity. Drawing aspects like line perspective, shading and drawing materials are not treated separately but integrated.

It remains important to analyse an object's shape, and be able to simplify it into a combination of geometric shapes. It is useful to practice this and build a mental library of shapes that are easily reproduced. This will help you to draw automatically, without thinking, and enable you to predict what will happen and what is the best approach.

Room for estimation and improvisation will speed up your drawing and give it a more intuitive 'handwriting' and thus lead to more convincing and inspiring drawings.

'.. In an increasingly digital world, sketching is still the most direct and effective way to translate designers' thoughts into concrete results; for personal reflection and to communicate with others..'
—Jeroen Verbrugge, Head of Design at FLEX/the INNOVATIONLAB®

4.1 STARTING WITH A BLOCK?

Of course you don't always have to start drawing, say, a hair dryer with a cylinder. If the character of the object is more block shaped, a block is used as a starting point and circular parts are added later.

Compare the different approaches. The hair dryer above starts with a block (three cubes behind each other) and adds a cylindrical part within one of these cubes. Tangent lines are then drawn to start shaping the handle.

The hair dryer below, on the contrary, starts with a cylinder and uses tangent lines to the ellipses to add the handle.

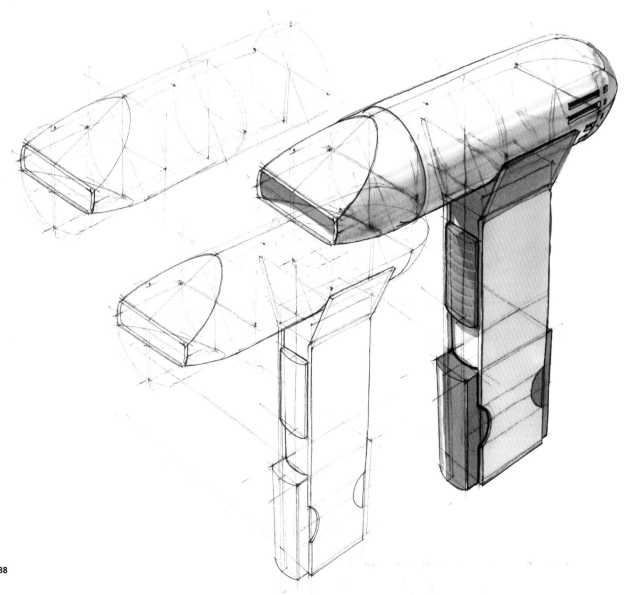

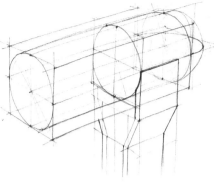

A cylindrical shape of course hardly ever starts with a block because you get a lot of extra lines, which will inevitably get in the way. This kind of misinterpretation of the drawing approach will also result in sketches that look unnecessarily complicated.

All sketches here started by the drawing cylinders or ellipses, not blocks.

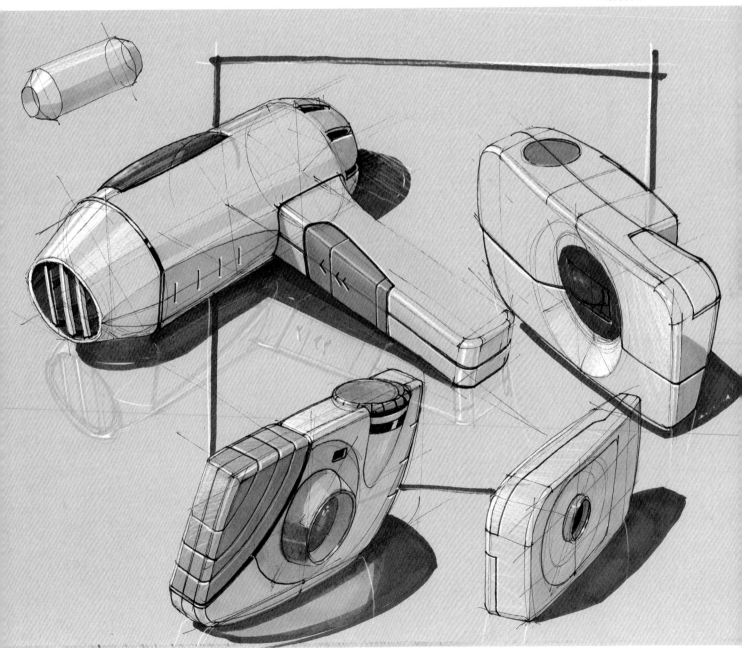

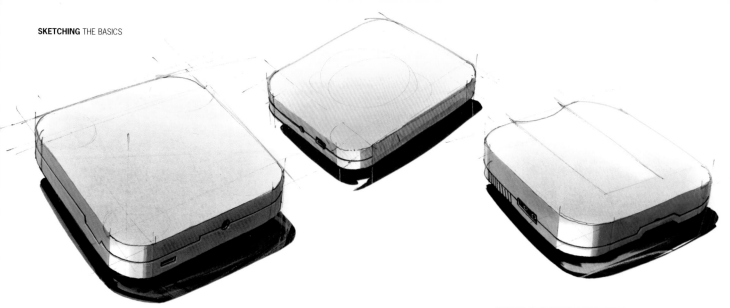

4.2 SINGULAR ROUNDING

When the cylindrical parts become relatively small, we speak of rounding. Singular rounding, in one direction only, is seen here.

There are several approaches to drawing a singular rounding. In the step-by-step instruction here, the more elaborate one is used, to highlight the relation of the rounding to the block shape.

In the case of quarter-circle roundings, they will form an ellipse when put together again. Thus the shading of the rounded edges will also form a cylinder when put together. Compare the cylindrical parts here with the rounding of the final toaster drawing.

When the rounding consists of four quarter circles, the separate rounding can be put together and form an ellipse again.

Dividing the ellipse into four parts, one can distinguish two sharply curved roundings (around the long axes), and two less sharply curved ones. The latter are easier to draw and therefore usually drawn first.

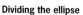

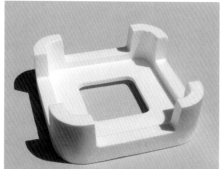
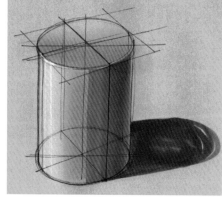
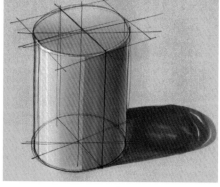
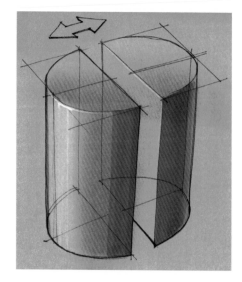
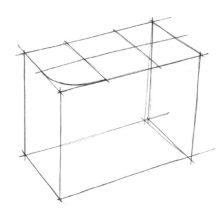
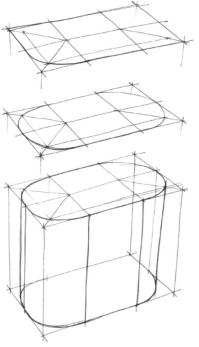

To keep all four roundings of the same proportion, a diagonal can be used to indicate the more sharply curved roundings in the outer squares.

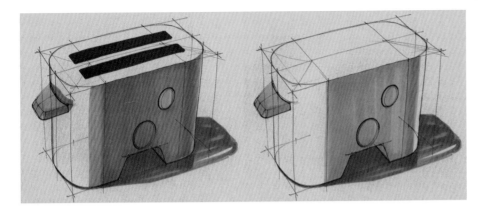

When drawing on coloured paper, you can use the same sequence of materials as on white paper. Here is a real opportunity for adding highlights with a white pastel and colour pencil.

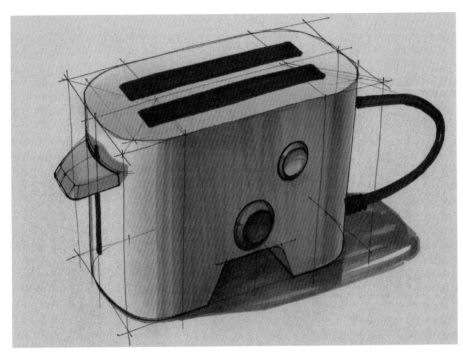

In applying marker on a singularly rounded shape, you must 'defined' that shape well with lines. It is important that the shape transitions of the surface are clearly marked. That is, the start and end of the rounding in this case should be clearly visible. The flat surfaces can then, for example, be shaded first. Shading is applied only a little on the rounding, as rounding is usually brightened by reflections. The brighter the reflections, the more contrast will be seen in shading.

When a relatively large part of the rounding is not touched by marker, an extended gradient of pastel chalk will make the object glossier.

On top of that, a white pastel chalk can be added, plus a highlight using pencil. This will of course have a far more dramatic effect on coloured paper than it would on white paper.

Even on the shaded side, some highlights, added by white pencil, can serve as an eye-catcher.

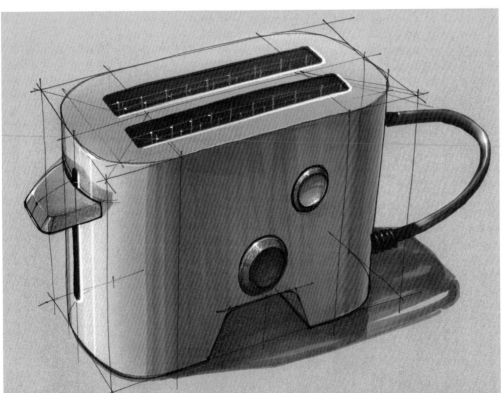

91

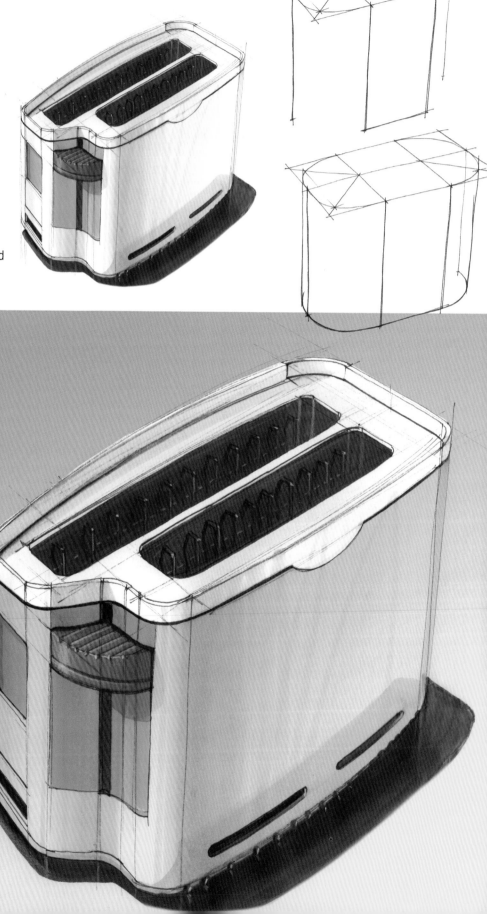

Still drawing singular rounding, as seen in the drawing approach here, one uses less of the block shape as a guide for the rounding. The rounding is well defined on the top surface, and then repeated on the base surface.

The advantage of this approach is not only fewer lines, but also there is room for a more complex combination of rounding, and the opportunity to freely adapt the shape's total proportions while drawing.

The toaster is finished in Adobe Photoshop, a background gradient is added from front to back and orange to black, and its opacity is changed. The background colour is removed from the top of the toaster to give it a more metal-like appearance.

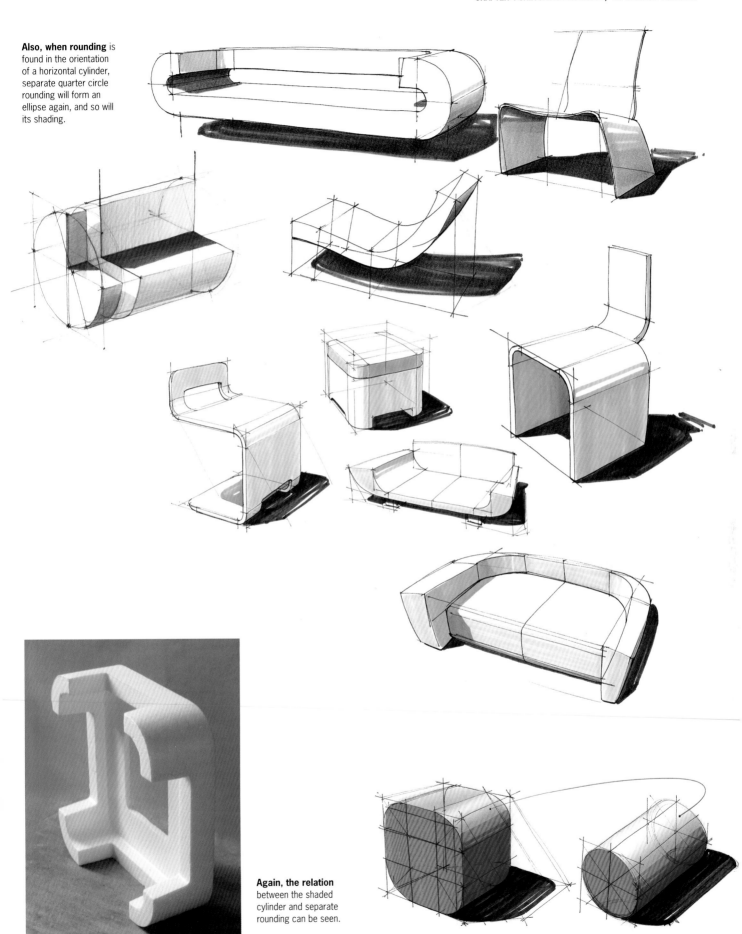

Also, when rounding is found in the orientation of a horizontal cylinder, separate quarter circle rounding will form an ellipse again, and so will its shading.

Again, the relation between the shaded cylinder and separate rounding can be seen.

4.3 MULTIPLE ROUNDING

Almost all products have rounding. Not only for aesthetic reasons, but also for constructional reasons (mould casting, etc.). Here, rounding in all three spatial directions are combined. In the most simple situation, these three roundings are of the same size. On the now rounded corner there is a part of a sphere.

It is very important to draw the start and end of each rounding in the line drawing. Shading can then be easily applied. With grey marker, start for example with the shaded flat surface, then the singular rounding (each part of a cylinder). The multiple roundings are then shaded as parts of a sphere, creating a 'hollow moon' shape.

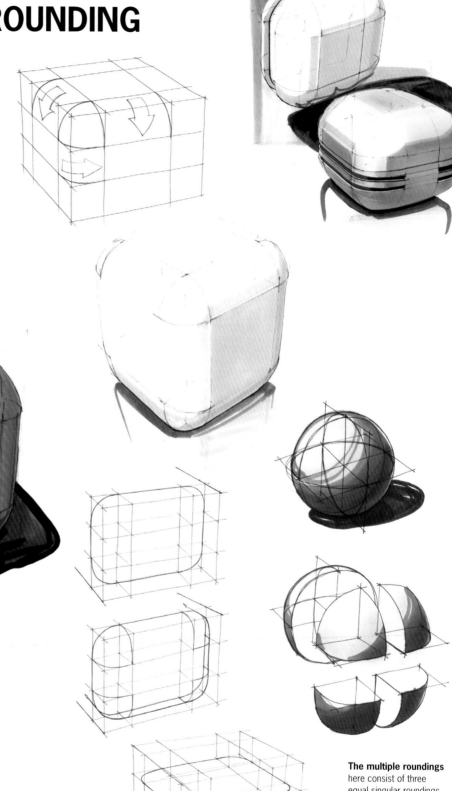

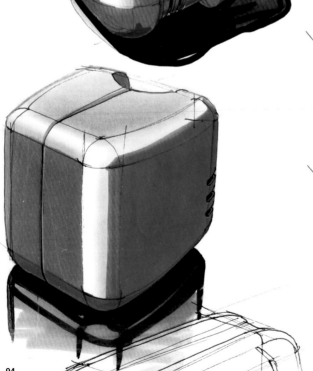

The multiple roundings here consist of three equal singular roundings. Their relation to each other and to the block shape can be seen here in these theoretical shapes. The roundings furthest away are the least visible.

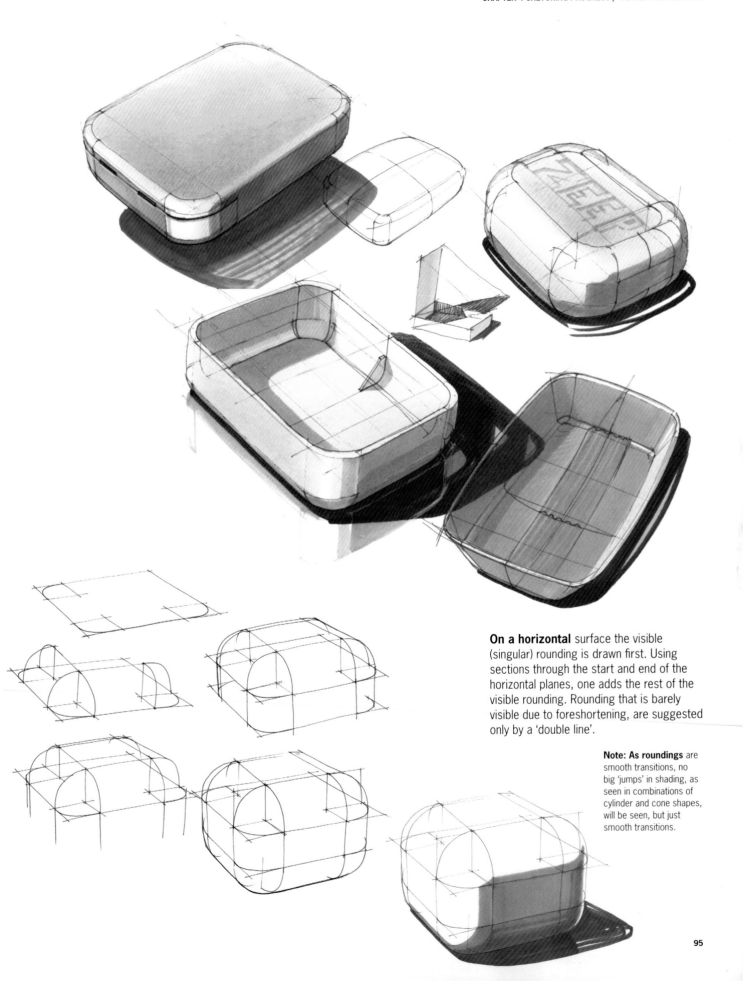

On a horizontal surface the visible (singular) rounding is drawn first. Using sections through the start and end of the horizontal planes, one adds the rest of the visible rounding. Rounding that is barely visible due to foreshortening, are suggested only by a 'double line'.

Note: As roundings are smooth transitions, no big 'jumps' in shading, as seen in combinations of cylinder and cone shapes, will be seen, but just smooth transitions.

Maybe the most common rounding to be seen in product design consists of a combination of rounding of unequal sizes.

The shape could start with the biggest rounding, the top surface in this case, onto which smaller ones are added 'outwards'. Only the visible ones are drawn; the others are only suggested.

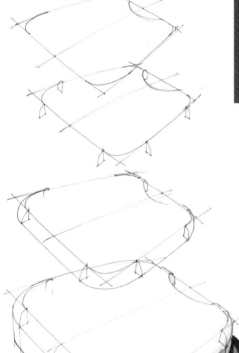

A disadvantage of this method, as seen in the drawings on the left, is that it increases the size of the product slightly.

As a comparison, the smaller rounding can also be added 'on top' of the first start surface. This way the overall shape of the product will remain set by the first drawn surface. It results, however, in a drawing with more lines, which could be unwanted.

Shading these unequal roundings is basically the same as the equal rounding, but somewhat transformed. First, the right-hand flat side is shaded, together with the two singular roundings attached. The multiple rounded 'corner' at the front is then shaded, connecting the shade of the two previous roundings. When colour marker is applied, enough white should be left open on the rounding. Especially in glossy materials, rounding is perceived as a very light (bright) area. The gradients needed can be made with pastel chalk.

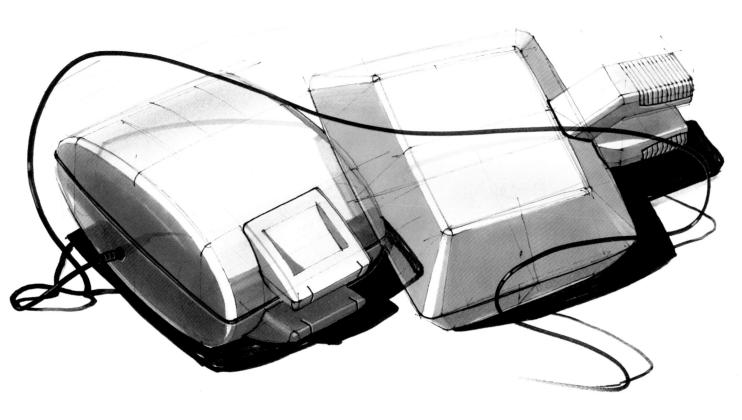

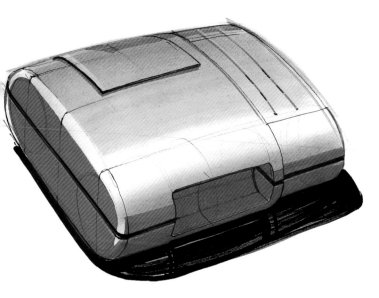

In these objects flat and slightly curved top surfaces can be seen. A smooth pastel chalk gradient on a flat surface will indicate the object's glossy material. Apply more pastel in the front areas, always less at the back. On a slightly curved surface this gradient should be stronger and be dependent on the light direction. It is very important that the pastel chalk colour is the same as the marker's colour. In most cases a mix of pastel chalks is needed.

Note the different approaches: a flat top surface can be seen in the top right sketch, and a curved top surface approach is seen in the top left object. Here pastel chalk is also applied at the far end, and some white is left out in the middle. In the sketch of the red object, the choice is to emphasise the rounding.

Tip
As roundings get smaller, they can eventually be suggested by a double line. Make sure you do not use too much marker between these double lines, as rounding will usually contain much white, owing to reflection.

4.4 TUBES

Tube-like shapes and connections require some exercise in ellipses and sections. First start with a section of both tubes.

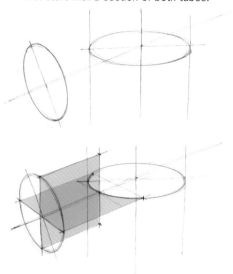

Then bisect the ellipse of the smaller tube in the same direction as the big tube and its perpendicular. Two surfaces can now be drawn, connecting to the bigger tube. The outer points of the connection are now defined. Some extra sections can give more hints of the final saddle-like connection.

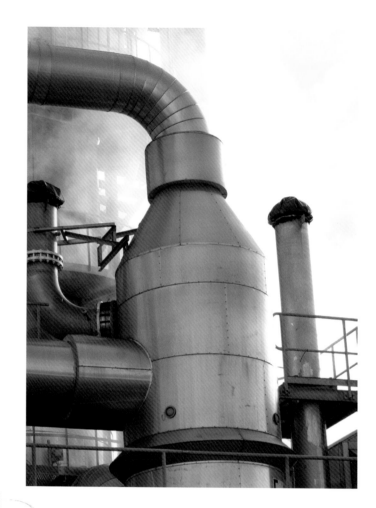

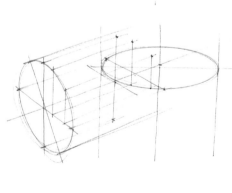

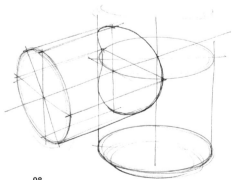

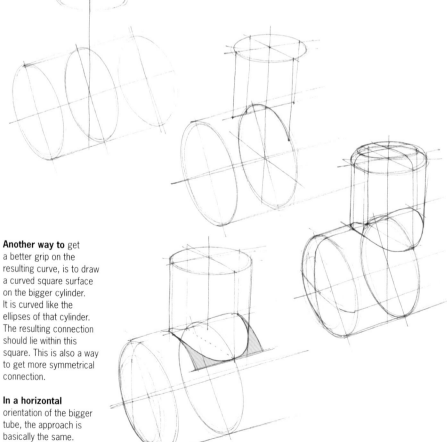

Another way to get a better grip on the resulting curve, is to draw a curved square surface on the bigger cylinder. It is curved like the ellipses of that cylinder. The resulting connection should lie within this square. This is also a way to get more symmetrical connection.

In a horizontal orientation of the bigger tube, the approach is basically the same.

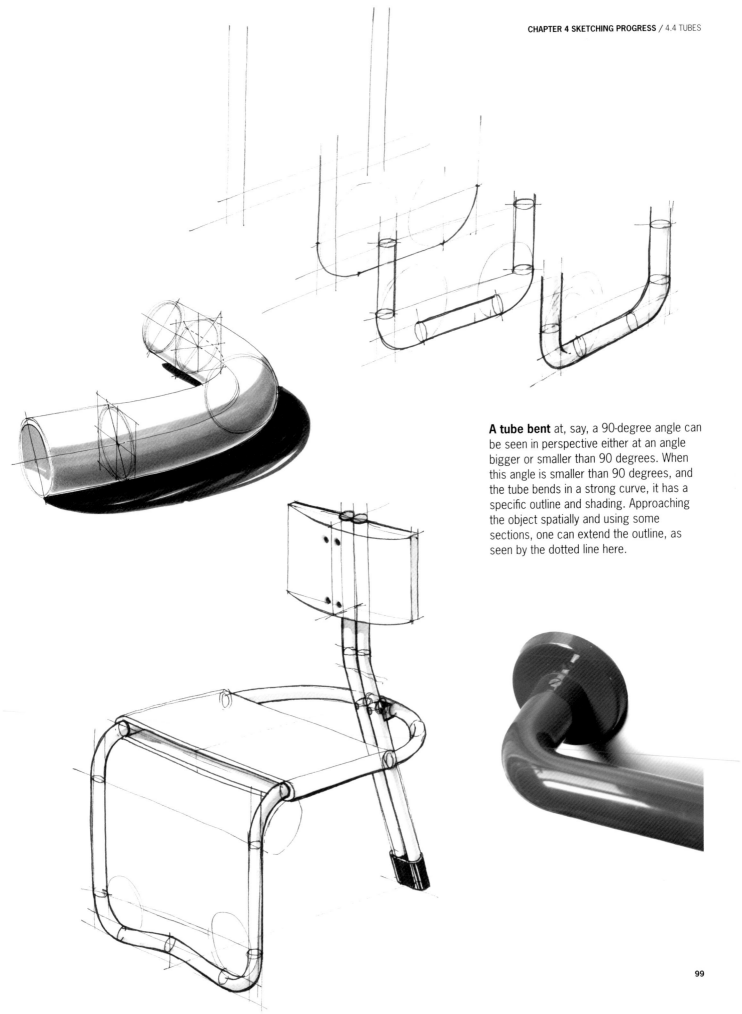

A tube bent at, say, a 90-degree angle can be seen in perspective either at an angle bigger or smaller than 90 degrees. When this angle is smaller than 90 degrees, and the tube bends in a strong curve, it has a specific outline and shading. Approaching the object spatially and using some sections, one can extend the outline, as seen by the dotted line here.

4.5 PLANES AND SECTIONS

A basic shape such as a cube, block or cylinder is a good start when making a drawing. Sometimes, however, an even better starting point is a plane or a section. This method of sketching is also a good way to train yourself to draw transparently, meaning you can always see through the object and 'see' the invisible points.

The shapes here are all drawn from a plane or a section. This approach to drawing might possibly give the most freedom of shape forming and allow room for improvisation, as shapes are literally growing beneath your fingers and can be adapted at nearly all stages of the drawing.

Sectional lines are also helpful in keeping the shape symmetrical. Diagonals can be used to reproduce a symmetrical curve.

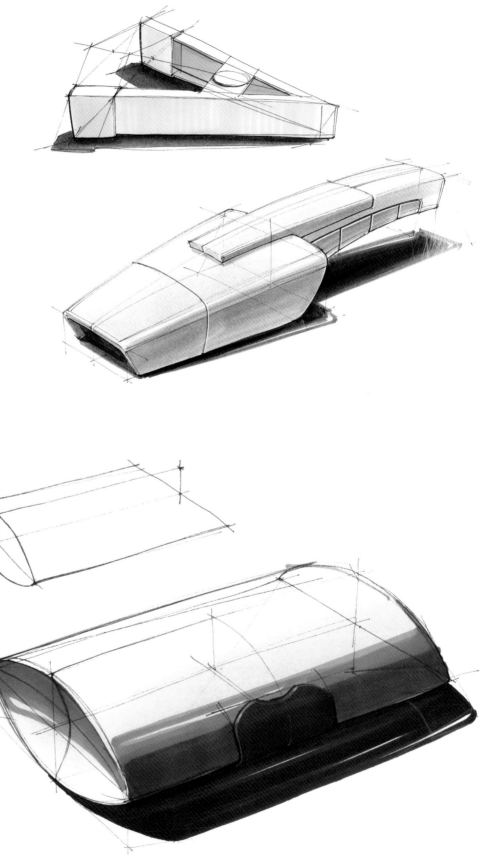

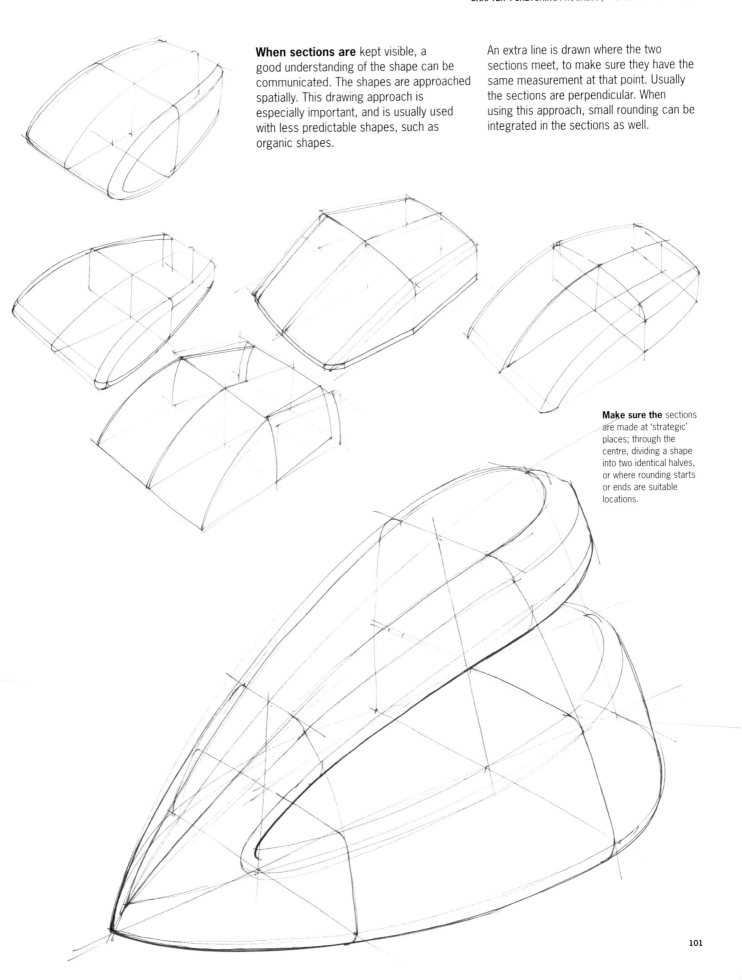

When sections are kept visible, a good understanding of the shape can be communicated. The shapes are approached spatially. This drawing approach is especially important, and is usually used with less predictable shapes, such as organic shapes.

An extra line is drawn where the two sections meet, to make sure they have the same measurement at that point. Usually the sections are perpendicular. When using this approach, small rounding can be integrated in the sections as well.

Make sure the sections are made at 'strategic' places; through the centre, dividing a shape into two identical halves, or where rounding starts or ends are suitable locations.

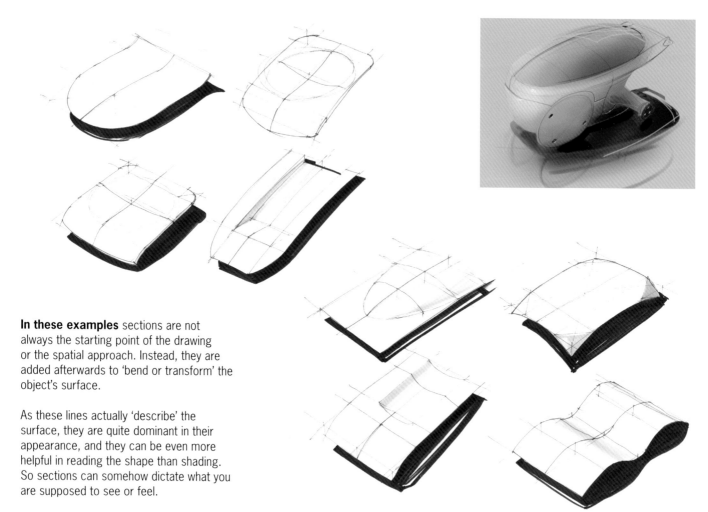

In these examples sections are not always the starting point of the drawing or the spatial approach. Instead, they are added afterwards to 'bend or transform' the object's surface.

As these lines actually 'describe' the surface, they are quite dominant in their appearance, and they can be even more helpful in reading the shape than shading. So sections can somehow dictate what you are supposed to see or feel.

Here you see two versions of the same shape, made by changing just the curvature of the surface.

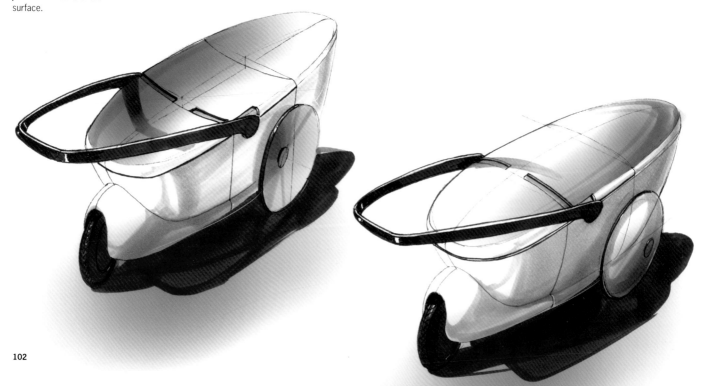

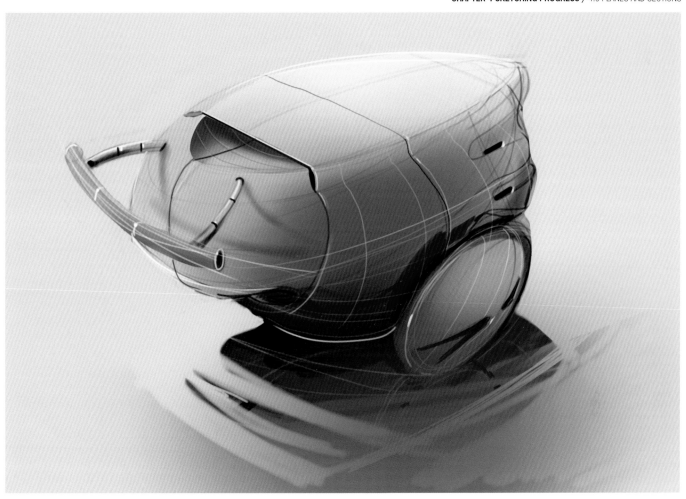

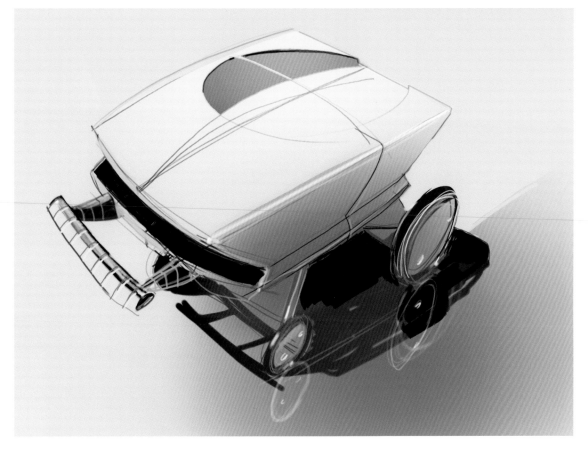

With some practice, the sections are placed at the most effective or strategic places. A shape can change a lot in appearance by the sections. This again leaves room for a lot of drawing freedom in shape, and in changing the object while drawing.

4.6 HOW TO PRACTICE

A lot of products are formed by a combination of shapes; a combination of approaches may be necessary to draw them informatively. For example, a combination of a round and square shape might be the case, but it might not be so obvious with which shape to start.

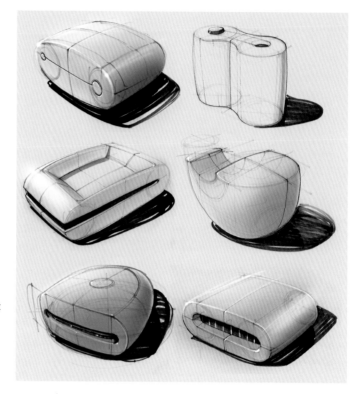

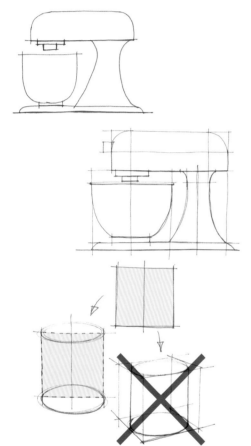

Start by drawing an analysis of the shape in side view. It is important to 'define' measurements and elongate lines in order to define parts in relation to each other. Adjust it a bit for a better exercise result.

The first drawing is of no use here. It may show the product's real proportions, but nothing is 'defined'. When the right measures are defined, as in the second drawing, the total length or height, for example, can be related to the diameter of the bowl.

A cylinder of which the height is the same as the width, is drawn first with a square (dotted line) onto which the ellipses are placed. It is of no use to start drawing a cube, as this does not make drawing the ellipses easier, and results in a drawing with a lot of lines.

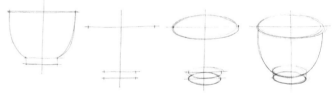

The bowl is drawn first, using the proportions of its side view to place the long axes. Then a cross section is drawn in a chosen direction, and the main proportions of the side view are placed.

Note: this chosen direction is a decisive moment in your drawing, as is your choice of the width of the ellipse (angle of vision is now set).

It is usually best to simply start with the biggest shape, and work your way down to the details. This will assure for a more secure perspective of the drawing than the other way around; when you start with a small shape, and then make a bigger shape based on this smaller one, the possible little mistake in the smaller shape is multiplied, and more prominent in the bigger shape. Starting with the bigger shape will also give you a quicker overview of your drawing.

A good exercise is to take an existing product, in this case a KitchenAid mixer, and analyse its shape, and try out different levels of simplification.

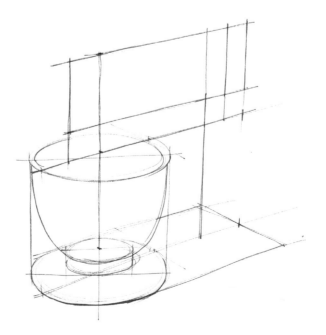

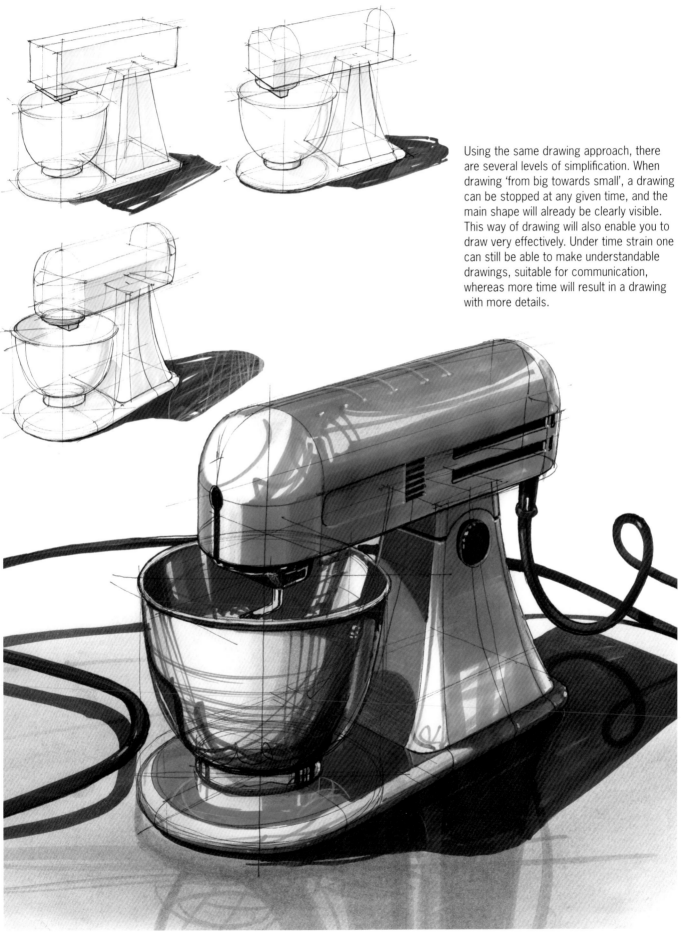

Using the same drawing approach, there are several levels of simplification. When drawing 'from big towards small', a drawing can be stopped at any given time, and the main shape will already be clearly visible. This way of drawing will also enable you to draw very effectively. Under time strain one can still be able to make understandable drawings, suitable for communication, whereas more time will result in a drawing with more details.

CASE

IDEA DAO DESIGN, CHINA

eAlbum project for Keen High, 2009
Lead Designer: Carl Liu

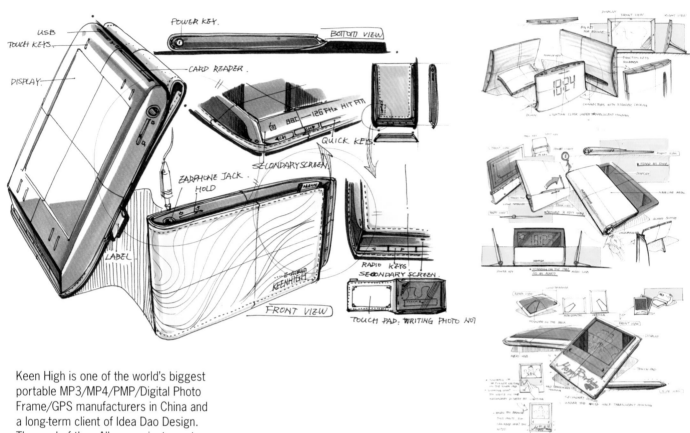

Keen High is one of the world's biggest portable MP3/MP4/PMP/Digital Photo Frame/GPS manufacturers in China and a long-term client of Idea Dao Design. The goal of the eAlbum project was to design an electronic album for people who enjoy watching photos while they are on the go. The model was simple and clear; the design had to be pocket-able, slim, chic, and user-friendly. The digital album is equipped with SD card reader and USB connectors for easy downloading.

The sketches were done freehand on A4 copy paper, with pen, pencil and marker. The presentable sketches needed to convey both the design details and big ideas; and sometimes even with scenarios to explain how the design worked. The quality of the sketches had to communicate and be read correctly by non-designers. Sketching proved to be an efficient method during the product development process.

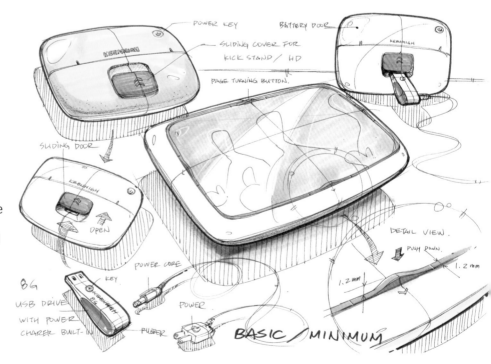

ONE HAND OPERATION (ERGO - HOLDING)

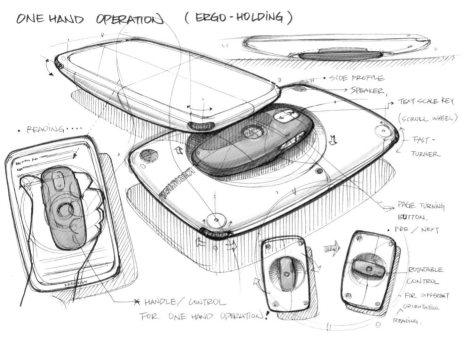

· READING · · · · ·

· SIDE PROFILE
· SPEAKER

TEXT SCALE KEY
(SCROLL WHEEL)

· FAST -
TURNER

PAGE TURNING
BUTTON.

· PRE / NEXT

ROTATABLE
CONTROL
FOR DIFFERENT
ORIENTATION.
READING.

✱ HANDLE / CONTROL
FOR ONE HAND OPERATION !

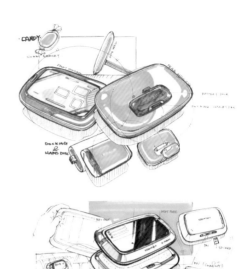

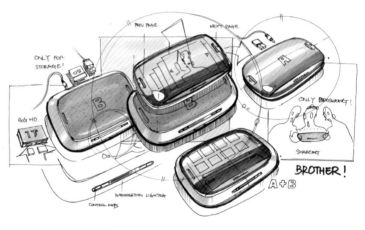

This project has gone through thumbnail ideation sketches and presentable sketches. Ideation sketches were used for internal discussions to determine the initial concepts.

The concept proposals were generated by quite a few designers for a good range of designs. The overall outcomes were shown to the client for evaluation before moving forward to the next design phase.

Presentable handmade sketches were shown to the client to decide on potential design directions, as seen here.

VAN DER VEER DESIGNERS, NETHERLANDS

Yepp Mini child bicycle front seat for GMG, 2008
Designer: Joep Trappenburg. Engineer: Albert Nieuwenhuis

Yepp is a line of bicycle seats with a soft EVA seat shell inspired by Crocs shoes. With Yepp Maxi (rear seat) already designed earlier that year, the process of designing this bicycle front seat started with exploring shapes, clamping mechanisms, product layout, etc. Initial sketches were made with ballpoint pen, and partially traced with a black fineliner.

To define the main shape of the design, this key ballpoint pen sketch of the design proposal was scanned and partly coloured with Corel Painter software. The sketch is made to explore the product on a more detailed level in terms of shape, product layout, materials, and to explain the fixation to the bike.

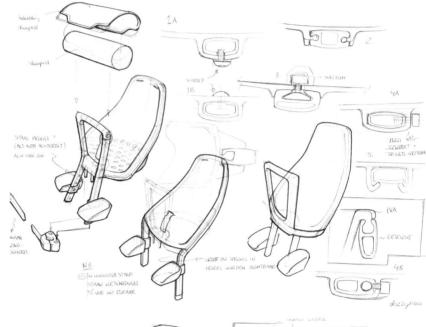

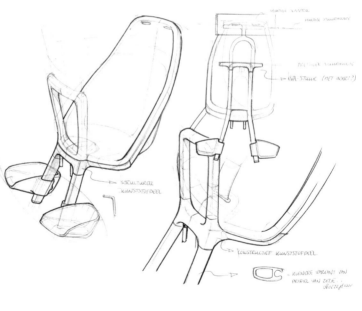

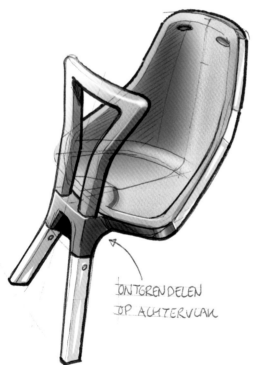

The key sketch of the locking mechanism consists of digitised handmade sketches, partially coloured in Corel Painter. Although the sketch was made to explore the locking functionality, construction and materials, it was also suitable for internal communication to engineers and for updating the client.

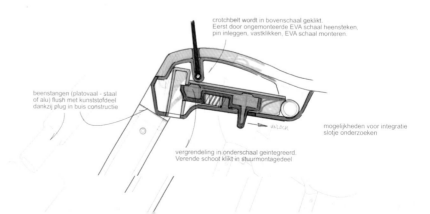

'We called this drawing the "Design freeze" sketch. It was made to mark the final direction of the project, to convince the client to give the go ahead, and as a starting point for the engineering done by my team mate Albert. It shows all the main elements of the construction and their relation, materials used, and main shape characteristics.

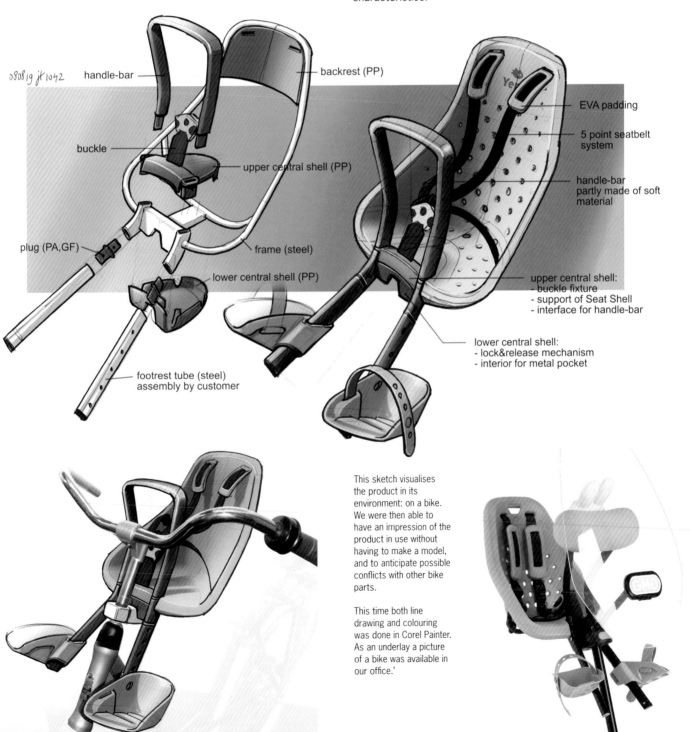

080819 jK 1042

handle-bar

backrest (PP)

buckle

upper central shell (PP)

EVA padding

5 point seatbelt system

handle-bar partly made of soft material

plug (PA,GF)

frame (steel)

lower central shell (PP)

upper central shell:
- buckle fixture
- support of Seat Shell
- interface for handle-bar

lower central shell:
- lock&release mechanism
- interior for metal pocket

footrest tube (steel) assembly by customer

This sketch visualises the product in its environment: on a bike. We were then able to have an impression of the product in use without having to make a model, and to anticipate possible conflicts with other bike parts.

This time both line drawing and colouring was done in Corel Painter. As an underlay a picture of a bike was available in our office.'

CASE

ROY GILSING DESIGN, NETHERLANDS

Client: BEICK
Designers: Roy Gilsing, Jorrit Schoonhoven, Angelo Jansen

The Beick Project is an initiative of the firm Scoof. It enables the consumer to create a personal bike online, based on a unisex frame. Beick evolved from the Dutch bike tradition and is the result of a quest for an inspiring alternative to the conventional bicycle supply. In this formula the user is central, and the bike becomes an extension of one's lifestyle and individual needs.

Beick was designed and developed in the Netherlands, and further developed and produced with manufacturers in Asia. The main shapes of the parts were communicated through 3D CAD modelling. The communication with the designer was done by e-mail. Each time the prototypes were sent over from China for evaluation.

Studying the height of the mid-frame was done by sketching on an underlay. The question of when a frame appears 'male' or 'female' was researched in order to design one unisex frame that would appeal to both sexes.

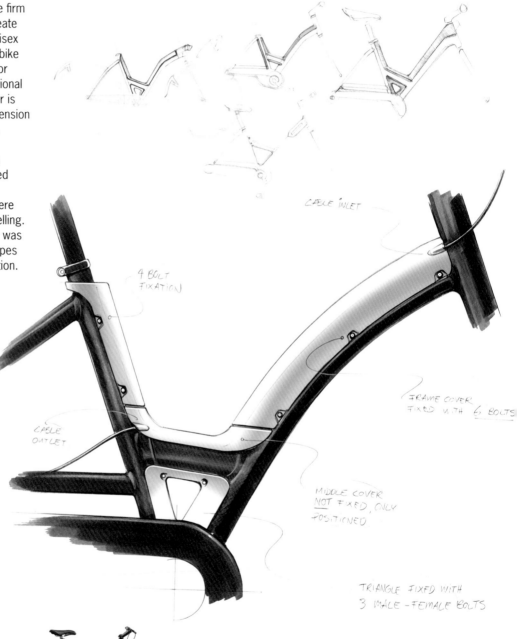

CABLE INLET

4 BOLT FIXATION

FRAME COVER FIXED WITH 6 BOLTS

CABLE OUTLET

MIDDLE COVER NOT FIXED, ONLY POSITIONED

TRIANGLE FIXED WITH 3 MALE - FEMALE BOLTS

'...I usually sketch on marker paper. I start with blue-grey colouring pencil, sometimes with a black ballpoint, and I use a fineliner for outlines and a slightly thicker black marker to emphasise shading. After that I use (Copic) markers to draw shadow, dark reflections and vibrant colour details. Then I scan the drawing, often at 200 dpi, without the sharpening scan option.

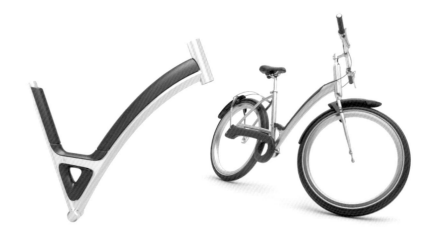

'...After the initial sketches in side view, the designing was mostly done using 3D CAD modelling. All renderings are derived from this 3D development. Presentation was not necessary as we did not work for a client.

The sketches of details and parts were an addendum to clarify aspects of the technical detailing to the Chinese engineers. I regularly chose to send handmade sketches for communication instead of 3D CAD models. There actually is only one rule: what is the clearest and fastest form of communication.'

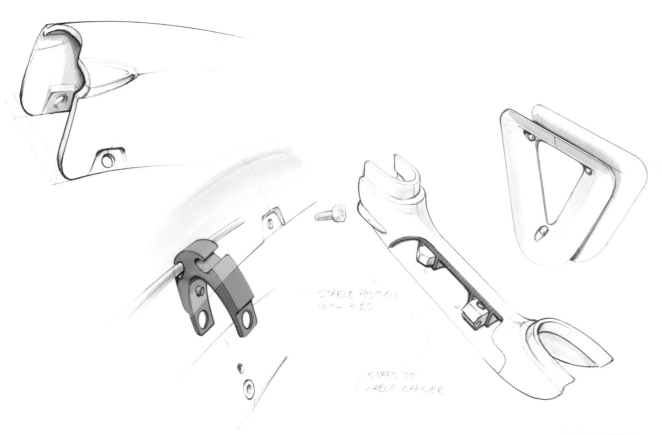

I use the level adjustments of Adobe Photoshop to make the white parts really white and the black areas blacker. If this is detrimental to the light marker strokes, then I use the dodge tool (in the highlight range) to whiten the bright areas. Those bright marker strokes and areas are really important not to lose! Sometimes I use gradients for large areas, make shaded areas and a background, or place bright light reflections and highlights, as seen left...'

EXPRESSING COLOUR AND MATERIALS

This chapter shows some widely used drawing techniques in relation to product colour and material context: sketching on white paper or coloured paper, digital sketching, and combinations of both. These drawing techniques do not differ much in their approach, yet the resulting drawings can have a very different 'feel'.

There are situations where no colour is used and situations where material expression can be the guideline for the choice of drawing materials. The material expression of matt versus glossy as well as glass and metal are discussed step-by-step to explain the use of different drawing materials at different stages.

The chapter concludes with a combination of hand-sketched drawings on paper, scanned and digitally enhanced to show possible product graphics and textures.

'..When we talk about design in terms of styling and form-giving, sketching plays an obvious role; it allows designers to freely and intuitively explore forms. It's great because it can be done anywhere with very few tools and it allows designers to pay attention to detail or paint images with big gestures.

When we speak about design as a holistic approach to create better things, I see the ability to sketch as an essential tool for designers to communicate with others. Sketches allow designers to create new insights for others and for themselves, thereby fuelling the innovation process..'
—Michiel Knoppert, Art Director / Lead Designer for Next Gen Products at Dell

5.1 SUGGESTING DEPTH

In chapter two we explained the general step-by-step use of traditional drawing materials like marker and coloured pencil. Of course the choice of paper influences sometimes the drawing tactics and creates opportunities.

5.1.1 white or coloured background

When the colour of an object is not important, a sense of space can be suggested effectively by shading only. Using the white of the paper for bright areas, one can suggest the shaded side and cast shadow with grey and/or black markers.

With coloured paper, another option for light and shading arises. Shading itself can still be suggested in the same way, but highlights can now be expressed using white pencil, thus adding to the grey range of the drawing and giving it more visual richness.

So with a little more effort, a much more sophisticated look can be obtained. As for the drawing approach itself, it is sometimes even perceived as easier to point out the areas where a shape is brightest instead of where the shading is.

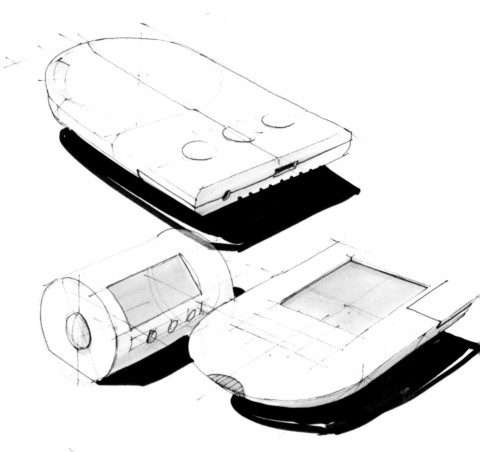

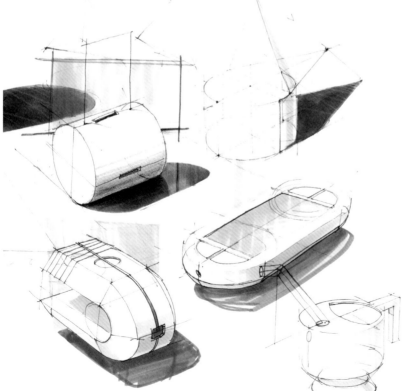

The sketches on coloured paper on the opposite page are an example of how to practice drawing on coloured paper and are drawn 'from nature'. Lines are first drawn with a fineliner. The product shapes are analysed and simplified as a combination of geometrical shapes such as cylinders, blocks, curves and transitions between them. Small roundings are omitted.

But not only is the shape simplified, so too are the tonal variations of the objects. Use only a minimum of shading, use only one grey marker, and use black for cast shadow. Adding multiple layers with the same marker to create slightly darker tones is advised instead of using different grey markers. A black pencil can also be handy to make a gradient. Finally, a soft white pencil is used for the highlights. It is worth while to give them extra attention.

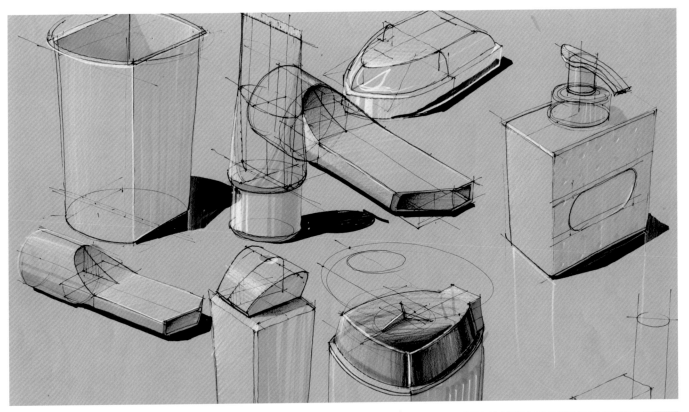

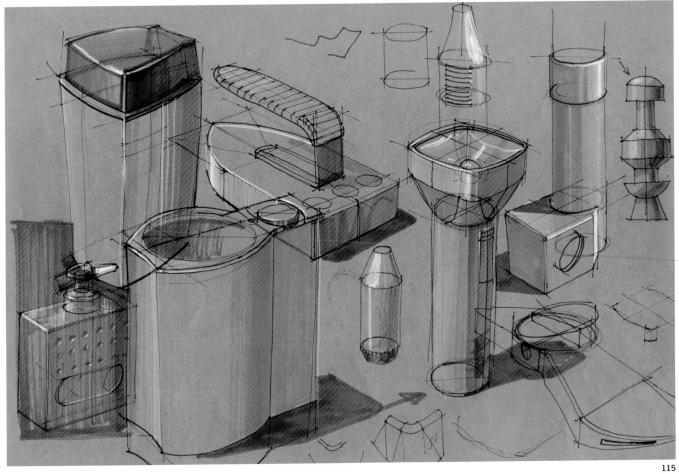

When only one medium such as coloured pencil is used, depth is added to the drawing mainly by line thickness variation and some hatching. Sometimes a line drawing is enough to describe the design at that point in the process. The choice for using coloured pencil can be a personal one. But of course it can also depend on the design, and the need to be able to start very 'softly' and to be able to keep on drawing and adapting the design in one drawing before the final hatching.

If you draw on white paper, beware of the choice of coloured pencil. For example, with a bright blue it is difficult to suggest shading (it actually brightens up in multiple layers instead of darkens); use a darker blue instead. For the same reason, darker red or purple-red is a better choice than orange-red. Yellow obviously has too little contrast with the white of the paper, so don't use it.

These considerations in relation to the coloured pencil also need to be made while drawing on coloured paper.

A pencil has the advantage of making line thickness variations within one line, sometimes helpful in creating emphasis or depth. It also gives some designers more 'freedom', or it is simply a preference.

Tip
A special kind of guideline is the cross-section. During drawing it is very handy to preserve the shape's symmetry. For the viewer it is a dominant line that follows the curvature or 'dents' in a surface and accentuates them.

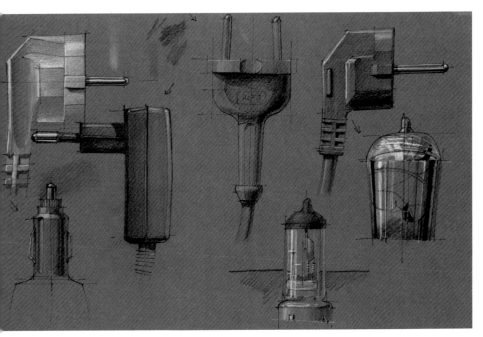

In these drawings only black and white pencil and black fineliner were used. Instead of grey marker, coloured pencil was used. When shades of grey or white are subtly combined, darker or lighter materials can be distinguished. This is a first step towards material expression.

Two main aspects are important when hatching: first the direction of the hatching should support the orientation of the surface (see marker techniques).

Second, use a layered approach, in which slightly different directions of hatching add up to get darker shades.

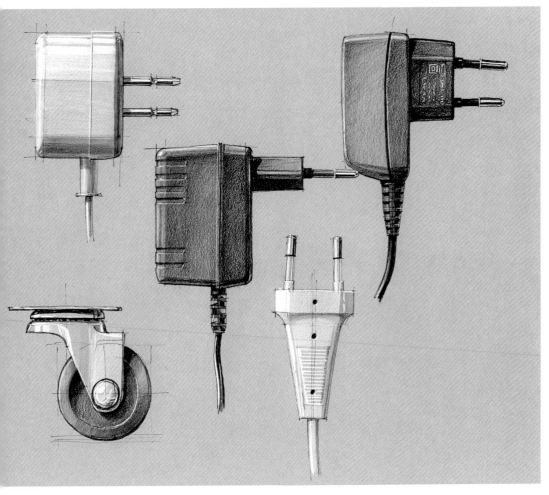

5.2 COLOUR BASICS

The most widely used colour system is Munsell. In this system all colour appearances can be described by three characteristics: hue, lightness (value) and saturation (chroma).

The hue is commonly known as the name of the colour, such as orange, green and so on. Technically, it is determined by its wavelength only. The Munsell system then implies that this pure colour can also be mixed with non-colour, white/black or grey.

Saturation thereby defines the intensity of the colour. A highly saturated colour consists of pure colour only; a less saturated colour is pure colour mixed with grey.

Lightness represents the amount of white in the colour mixture. Brightness depends on the energy level of the radiated colour; it can make a colour mixture more vivid.

In the colour wheel one can see the relation between the different hues. The inner stripes represent the primary colour. Secondary colours are obtained by mixing two primary colours. Mixing colours that lie opposite each other in the colour wheel results in grey. For example, primary red and secondary green.

reference color

less saturated

less bright

more bright

more light

less bright and less saturated

less light and less saturated

The described colour approach can also be found in many photo-editing and sketching software. A typical way of visualising these colour characteristics is displayed here. On the outer ring the hue of the colour is seen. The triangle displays variations in saturation and lightness of that particular hue. The triangle's outer right point represents this colour in full saturation. Towards the top point more and more white is added; towards the bottom point more and more black is added. Moving horizontally to the left, from an arbitrary location within the triangle, will mainly cause its saturation. Moving towards the lower black point will cause a colour to become less bright and less saturated.

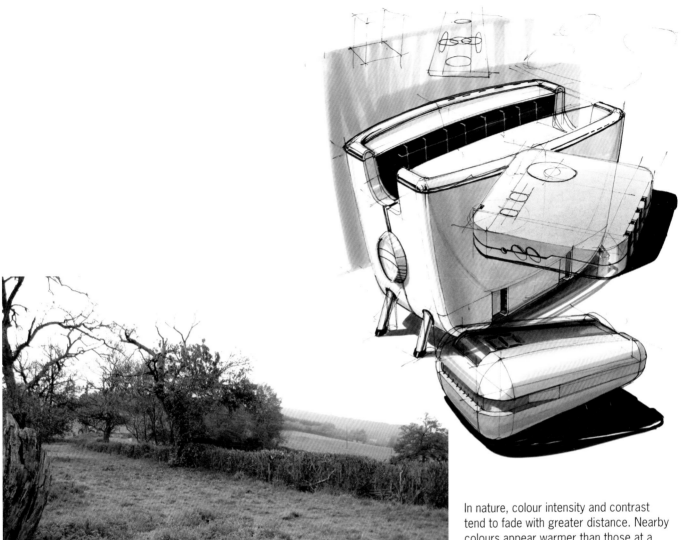

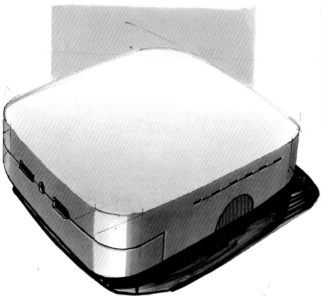

It is very important to use a pastel chalk that has the exact same hue as the colour marker, for only then will the spatiality and light effect be credible. If this colour is chosen slightly differently, the effect will not work properly.

In nature, colour intensity and contrast tend to fade with greater distance. Nearby colours appear warmer than those at a greater distance. These phenomena from nature can be applied to create depth in a composition. This also generally suggests that added backgrounds should contain less colour intensity and contrast and be cooler than the object of the sketch.

When we sketch an object and apply shading with marker as seen in this brownish object, we apply only colour marker on the left vertical side of the object. It is usually referred to as the 'full colour' side. This can be regarded as the surface with most colour intensity (saturation). On the right vertical side, first grey marker and then, on top of that, colour marker was used. This side's colour is less saturated and less bright. On the top surface a colour pastel chalk of the same colour as the colour marker is applied with a gradient towards the back, using the white of the paper. The top surface's colour is now much brighter than the full colour side.

5.3 COLOURED BACKGROUND

The paper colour can also be used to give an impression of the object's colour. This will also speed up the drawings a bit, compared to drawing on a white background.

As we see in these examples hardly any marker is used for shading or colour. With the colour of the paper as a base colour, some pastel chalk with a more saturated and warmer colour is applied to the object very near to the viewer. Here this is the vertical side on the left that is the 'full colour' side of the object. Warm colours are perceived as being closer than cool colours, and in this case they give the drawing more depth, but also richness in colour range.

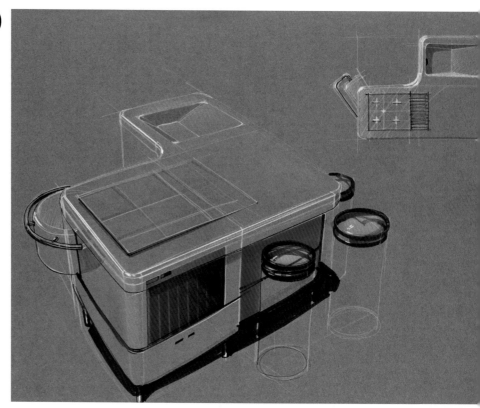

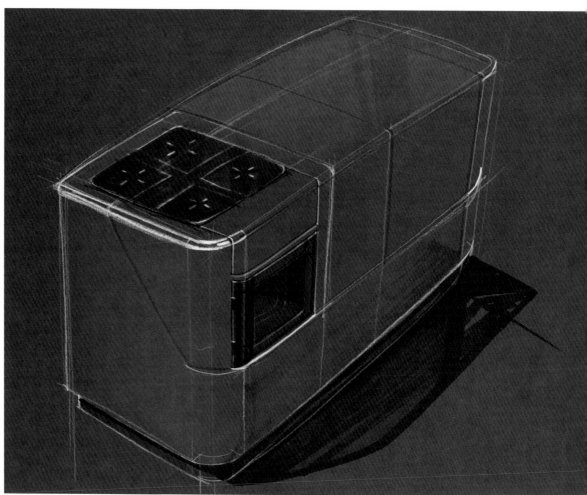

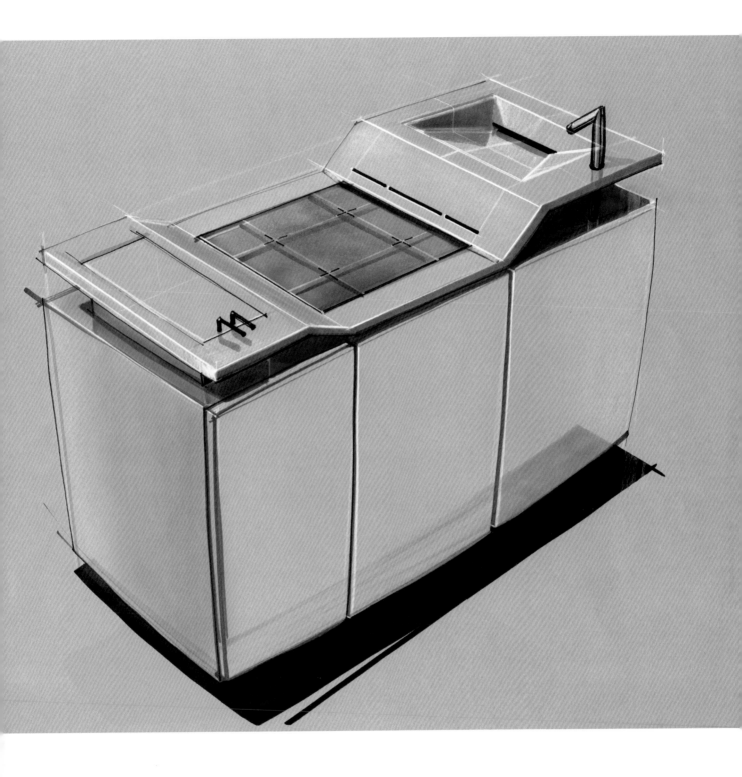

The sketch starts with grey marker used as a sketching tool. Darker parts of the object are drawn with a black marker shade. Notice how introducing this bigger contrast already gives body to the sketch and draws the attention away from any 'wrong' lines.

Colour marker is used only little, mainly to suggest blue reflections. With the addition of pastel chalk, colour is added to the object. Pastel chalk is applied layer by layer to build it up. Use a big cloth of soft paper and big movements. Notice the brighter areas on the top surface. Here the blue chalk is mixed with some white.

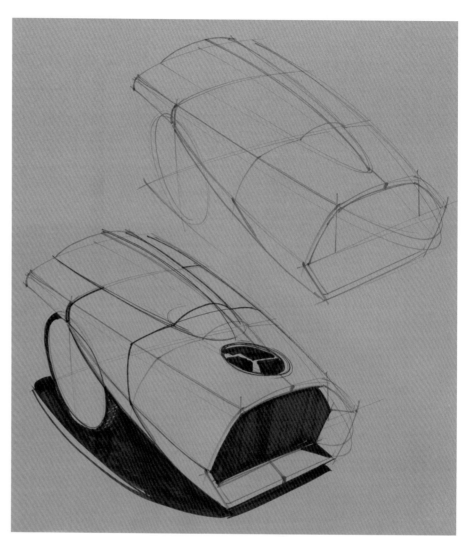

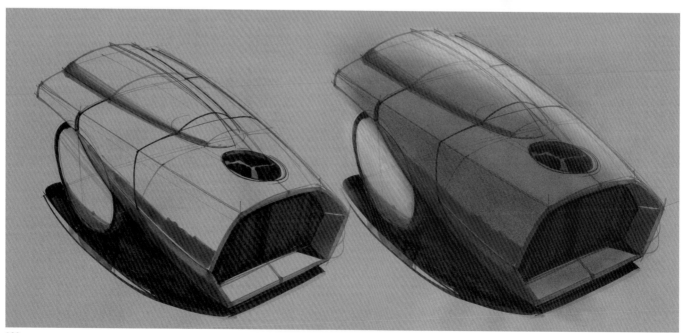

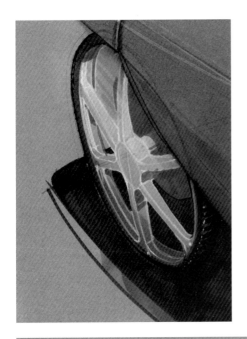

Because of adding the pastel chalk, some dark marker parts have become brighter, thus diminishing the overall contrast of the drawing. Now an eraser and the dark marker are used to bring back contrast.

The final step in this sequence is applying white pencil and gel-pen for highlights. This is a step that demands little effort but has a big impact on the drawing. These highlights are mainly applied at the front of the drawing and increase the feeling of depth by having more contrast in front, and less further away.

All drawing materials can be used like sketch tools. This attitude enables you to still change the object at a later stage of the drawing. Here you see the wheel transformed completely.

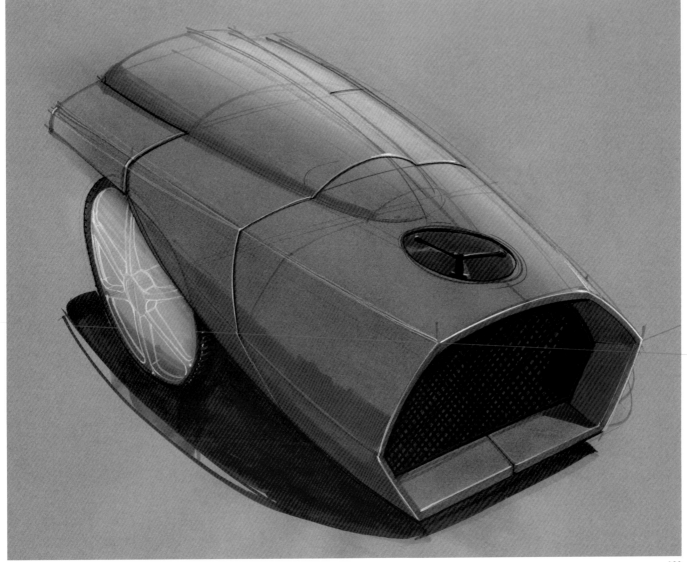

In these quick sketches grey marker is used for the initial line drawing. In early shape exploration, it has the advantage of not forcing you to decide to draw details. The soft appearance of the drawing can be seen. Here, different layers and gradients of pastel chalk were used for the effect of focus on the chosen shape. This was further exaggerated by using some black fineliner and marker to give this drawing even more contrast.

The pastel chalk as used here on paper has the same effect as a digital airbrush in computer sketching. So after the application of grey tone and cast shadow on a drawing on paper, it is also an option to scan it and finish it digitally.

Tip:
Drawing on coloured paper is a good preparation for digital drawing. Use only some marker, preferably dark, and use pastel chalk for a colour indication. The latter is comparable to digital airbrush.

5.4 DIGITAL SKETCHING

The advantages of digital sketching are numerous. In addition to the modern feel of compared to drawing on paper, a digital drawing allows you to make adapt to a design relatively easily. It is also easier to process in the digital document flow. For example, the use of a digital underlay is more effective than a paper underlay. This can be a photo of a product or an early foam model. Pieces of photographs can be added to a drawing to give it more realism.

It is preferable to use multiple layers instead of the 'undo' function. This latter has the same effect as an eraser. Multiple layers also offer the possibility to make easy adaptations or show more variations of one design. In general, variations can be made more quickly than on paper.

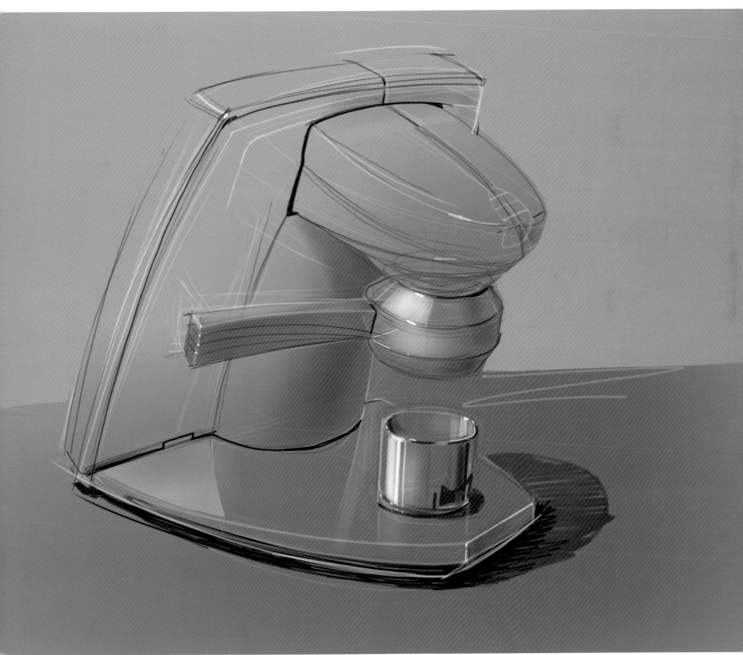

5.4.1 step-by-step digital sketching

Whether you draw with computer programs like Photoshop, Painter or Sketchbook, similar digital approaches can be seen. A pressure-sensitive A4 plus size Wacom Tablet was used here. Start by choosing the canvas colour, not too dark and not too bright. Use a thin airbrush to make the line drawing. Here a black or dark grey colour was chosen to keep the opacity 100%.

Adding colour was done with a digital airbrush, this time using a very large tip size (see the green circle), and an opacity of 10% or less. You can add layers of airbrush and keep the gradients soft and smooth.

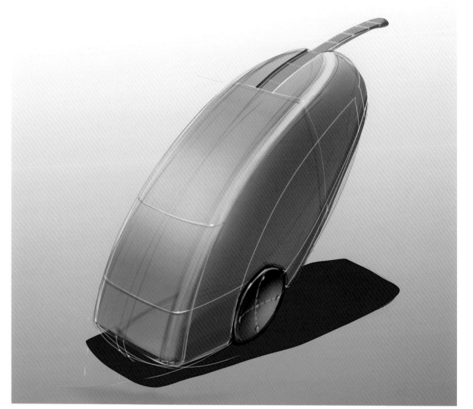

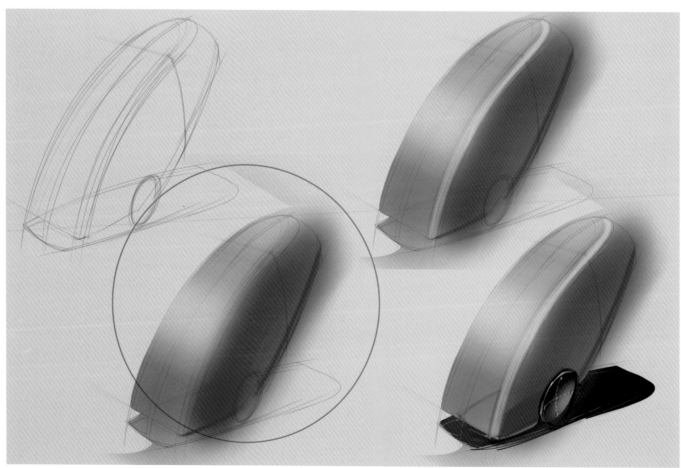

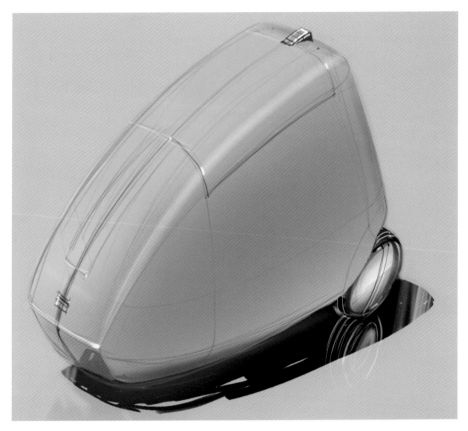

Having first given (full) colour to the object, one can brush the shaded side, mixing it 'towards' a dark grey, thus making it both darker and less saturated. Cast shadow and wheels are done with a stronger brush/felt pen. It also allows you to change the base of the object.

Highlights are added with a thin airbrush, again with the opacity at a 100%. Special attention is given to the cross-sections and details. Try not to zoom in too much, as your efforts on pixel level will probably not be very effective.

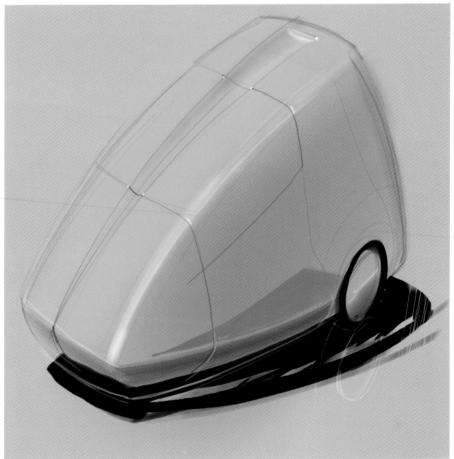

When you do not erase all brushstrokes, some colour can be left to give the impression of a surface. Adding another warm colour in front of the object can also do the trick.

The material expression of this suitcase is very glossy. See how the cast shadow reflects in a green colour.

5.5 MATERIAL EXPRESSION

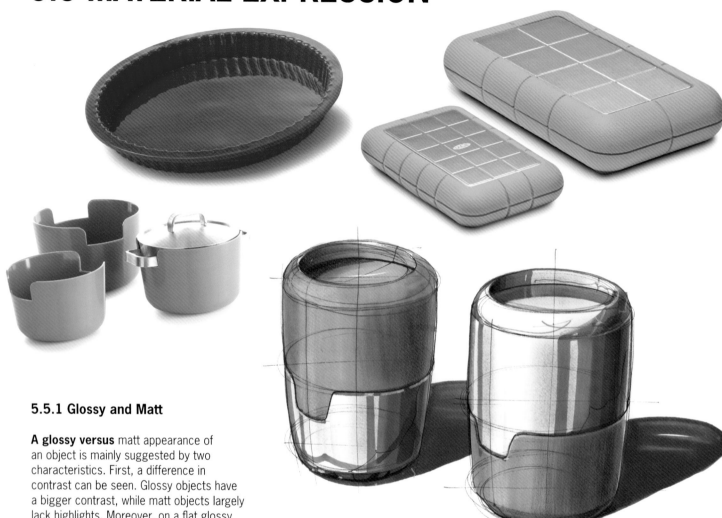

5.5.1 Glossy and Matt

A glossy versus matt appearance of an object is mainly suggested by two characteristics. First, a difference in contrast can be seen. Glossy objects have a bigger contrast, while matt objects largely lack highlights. Moreover, on a flat glossy surface a gradient from full colour towards white can be seen.

The second characteristic has to do with reflections and cast shadow. Reflections dominate on a glossy surface. These reflections always appear mainly in the colour of the glossy material. There is little or no cast shadow on a glossy surface. A matt material displays hardly any reflections, but mainly cast shadow.

In a drawing in which the product material is expressed, it will be effective to exaggerate these characteristics.

Here you see the different marker strategies between glossy and matt material expression.

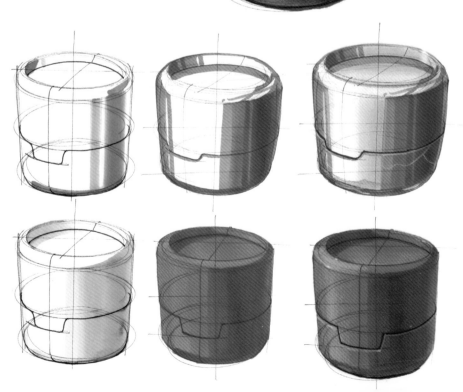

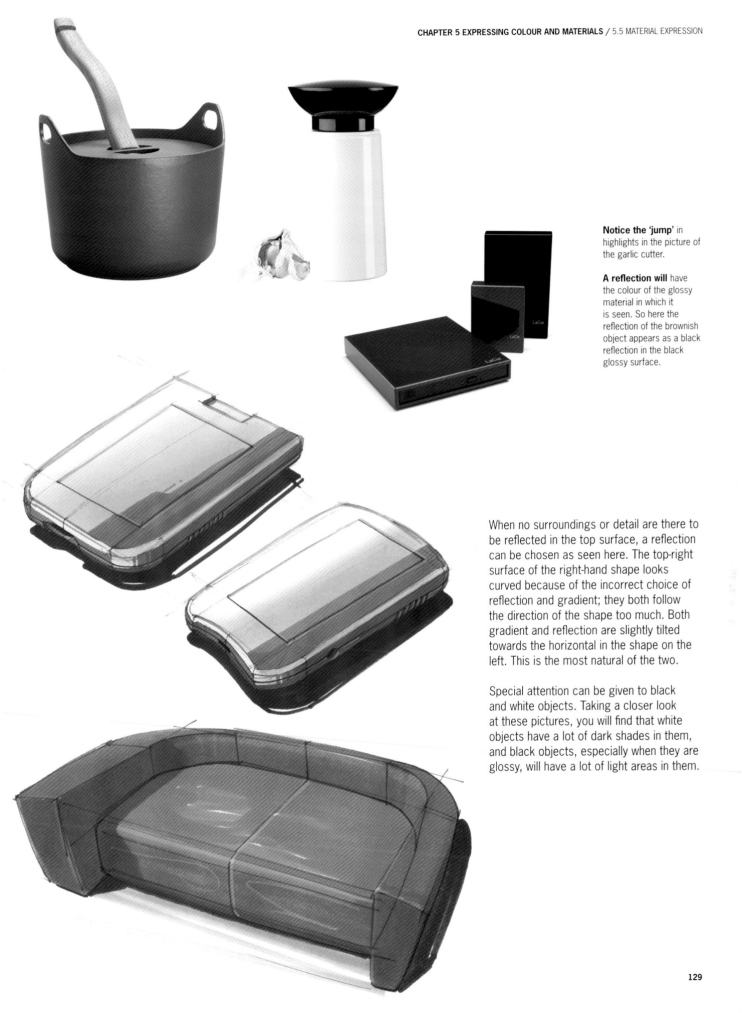

Notice the 'jump' in highlights in the picture of the garlic cutter.

A reflection will have the colour of the glossy material in which it is seen. So here the reflection of the brownish object appears as a black reflection in the black glossy surface.

When no surroundings or detail are there to be reflected in the top surface, a reflection can be chosen as seen here. The top-right surface of the right-hand shape looks curved because of the incorrect choice of reflection and gradient; they both follow the direction of the shape too much. Both gradient and reflection are slightly tilted towards the horizontal in the shape on the left. This is the most natural of the two.

Special attention can be given to black and white objects. Taking a closer look at these pictures, you will find that white objects have a lot of dark shades in them, and black objects, especially when they are glossy, will have a lot of light areas in them.

5.5.2 Transparency

Glass has several handy and distinguishing characteristics one can use to express it in a drawing. First of all, it is obviously transparent. In a drawing, this simply means that it is handy to draw something 'behind' it to show this transparency. In the step-by-step example, cast shadow is chosen for this reason. A rounded object such as a glass will also distort what is seen through it. This is called refraction.

Another characteristic of glass is the compressed reflection seen in the material. You will find these reflections mostly where the material is thick. They appear mainly as black and whites.

Glass is also very shiny, which means using bright highlights in the drawing. These highlights can hardly be seen on a white background, as in the pictures. In a drawing it is effective to choose a darker background. Here it is done using pastel chalk.

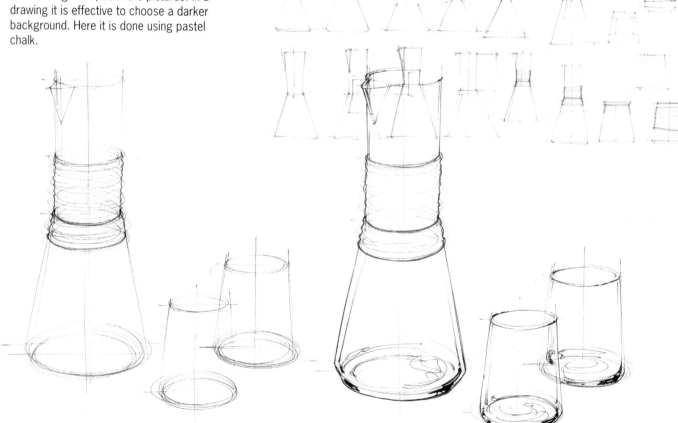

First, a line drawing is made with black fineliner. It is possible to sketch very loosely, especially in positioning the base ellipses. Notice the number of lines used and their visibility in the end result.

The same fineliner is used to darken some contour lines, to express material thickness and to draw the black reflections in thicker glass areas.

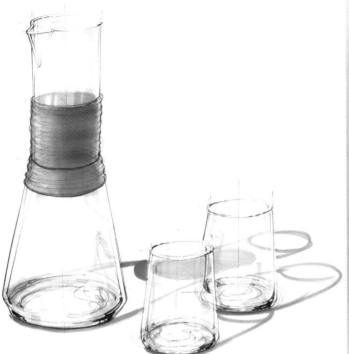

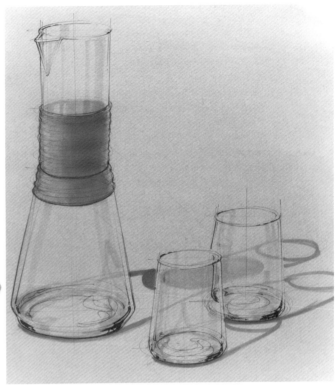

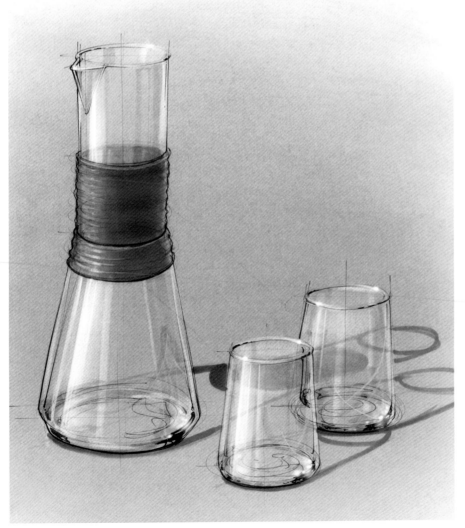

Glass casts a shadow from the thicker glass parts. This effect is somewhat exaggerated. A single layer of grey is used where the cast shadows are seen through glass. Multiple layers of grey are used to draw the shadows next to the glass. On the glass itself this single layer of grey is also used for shading and a 'pointy' reflection. Notice that these glasses are not transparent at all near the contour.

Pastel chalk is applied, so reflections and highlights can be drawn. In this abstract environment a warmer colour is used nearby, and a cooler one at the back, thus adding to the suggestion of depth.

Highlights and reflections are mainly 'drawn' by erasing the pastel chalk. Only some white pencil and some white gel-pen drops are added to finish the drawing.

When highlights are important, it is again obvious that drawing on coloured paper can be very efficient. Here, the use of white pastel chalk in the glass will make it stand out against its background.

Previously, transparency of glass was expressed by placing something behind it. In some cases, an object or something else is already at hand, such as in the example of the coffee grinder or the car windows. Sometimes, the transparency of the glass is overruled by bright reflections and highlights, especially on the more angled surface of the side windows. They prevent the material's transparency. In the cylindrical shapes, you most likely see this more to the side where there is more curvature.

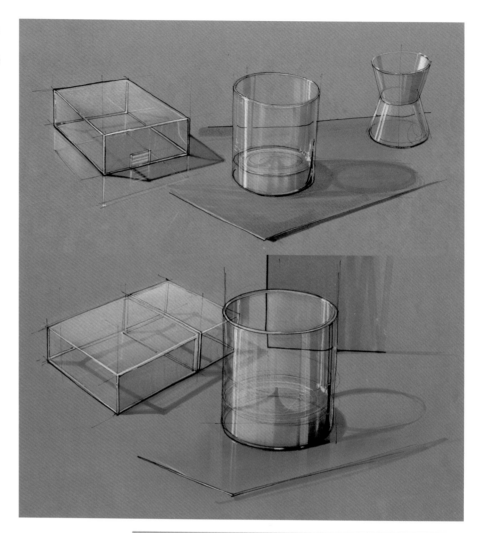

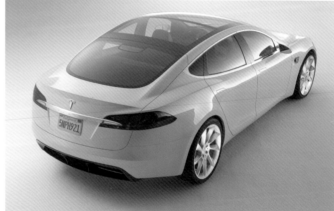

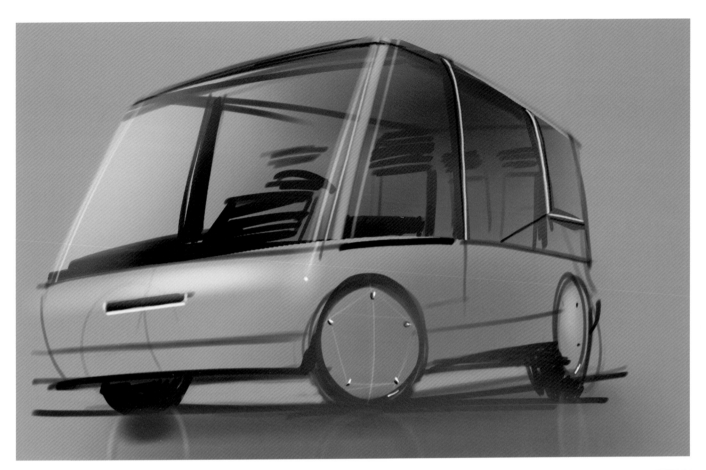

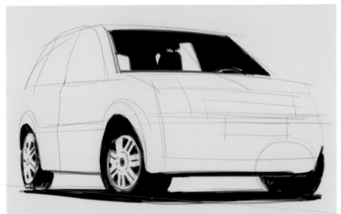

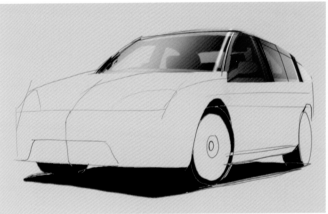

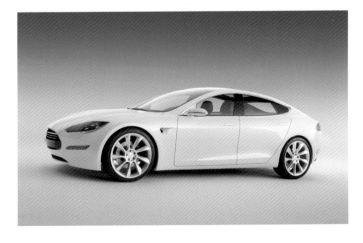

In largely 'flat' surfaces like the car glass, transparency will be optimal when looking at it perpendicularly, and reflection/highlights will mostly be seen when looking at the glass from an angle.

First the car's interior is drawn in black only. After that, a large and brighter airbrush is used to partially cover this interior again. Some colour is given to the glass as well. Bright reflections are seen on the rounding in front, but also to the far left and right, further away from the viewer, as you are less perpendicular to these spots.

5.5.3 Metal

The representation of very glossy metal (chromium) theoretically consists solely of reflections of its environment. When the chromium surface is curved or rounded, these reflections are compressed, resulting in its typical 'stripy' appearance with high black and white contrasts. On a cylindrical object, these stripes are always in the longitudinal direction.

With photographs of chromium, the reflections are created in a studio setting that may differ greatly from reality. When drawing from nature, you are advised to simplify these reflections, like a studio setting, and use shading knowledge for spatiality. On an upright cylindrical shape, for example, use a dark reflection on one side and a high reflection on the other side, so as to add to the feeling of depth in the drawing.

When you draw on white paper, the black-white contrast, and especially the highlights, will stand out better if you use coloured surroundings. These coloured surroundings can at the same time cause reflections in the material, which thus add to the effect.

The positioning of the reflections is most important. The compressed reflections are mainly visible on the outer sides of the cylindrical shapes.

Adding a little blue to the top side, and a little ochre to the base is called the earth-sky effect. It adds to the sense of depth in the object and a richer colour experience. It refers to a chromium object standing in the desert with only earth and sky reflected, as seen in this picture.

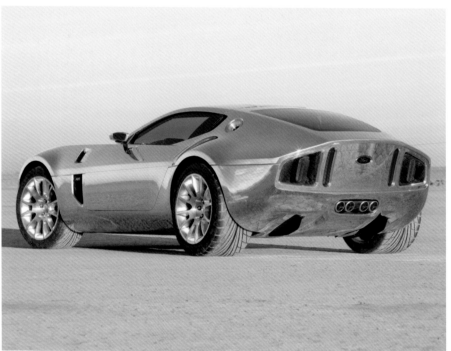

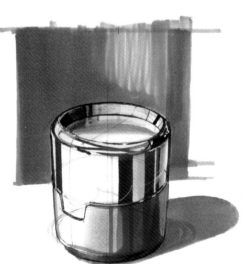

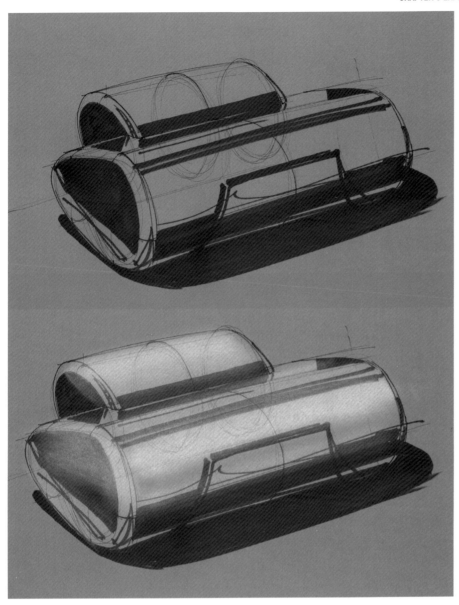

Curved and rounded metal may display unexpected reflections. In drawing, it is advised to simplify these reflections so that they will not visually dominate and cause a loss in depth of the object.

In the step-by-step drawing no surroundings to be reflected are at hand, so a theoretical one is drawn. The sky provides highlights, and imaginary surroundings cause dark reflections. These dark reflections start with a black marker.

White pastel chalk is then applied, covering almost the whole shape. On the spots of highlights, multiple layers of chalk are used.

Adding some blue and ochre for the earth-sky effect adds the only colour to the drawing.

Brushed or sandblasted metal loses in high contrast and reflections, so shading will become more important again. It is also important to pick the right 'colour' of cool grey.

Just like previously, the drawing deteriorates once the layers of chalk have been applied. Applying marker and fineliner to the shape, you will see that it revives again. It brings back its sharpness. Only partially use the fineliner on black so that a distinction can be seen in more shades of black and grey. Again, it is this tonal variation that enriches the visual experience or makes the object look more real.

Finally, some highlights are set with white pencil and some white gouache paint or gel pen. Here, too, be mindful with the white highlights.

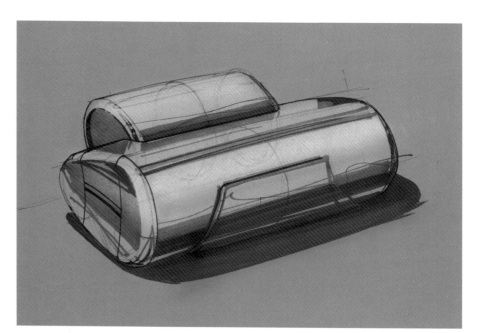

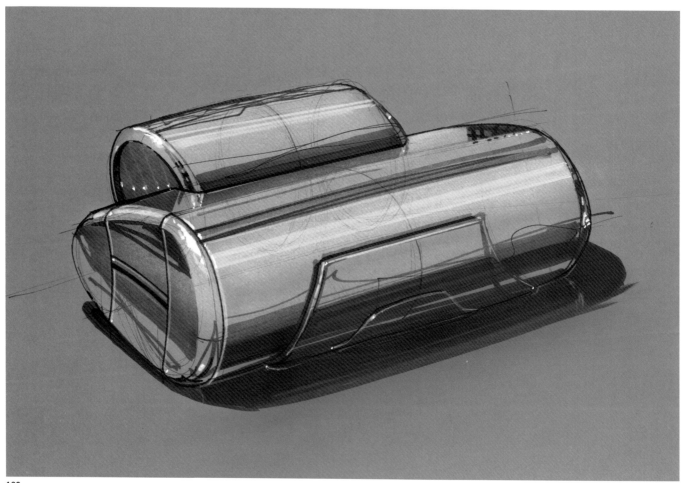

In this example the metal parts are mainly flat surfaces. Here, too, there are no surroundings to be reflected, so a theoretical one is drawn. Once again, the sky provides for highlights and imaginary surroundings below the horizon for dark reflections.

The reflections on the ring are kept mainly dark below, so spatiality is retained.

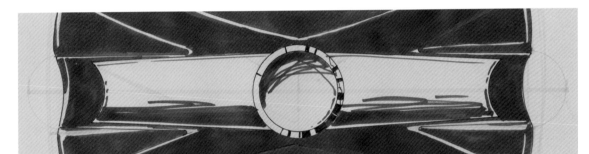

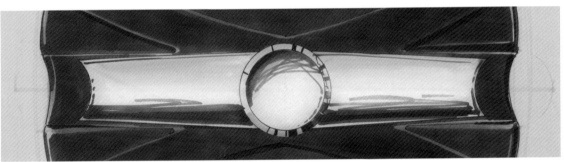

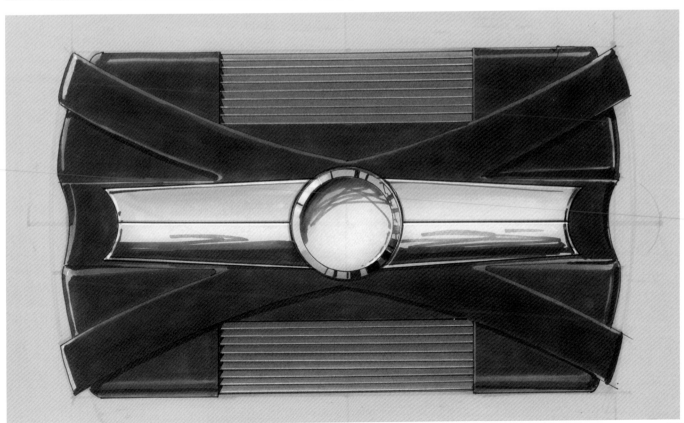

5.6 PRODUCT GRAPHICS

Adding a texture or graphics to a relatively simple shape can spice up and change the impact of a drawing completely. It can be of use for scale and context, and it makes a simple drawing more realistic with little effort.

Adding these surface details can be saved for last, after the main shape has been given colour. In the examples, you find the steps needed to add these small surface details.

Start with grey marker to draw the outline and fill the details. Use a black fineliner to suggest product parts or small voids. Taking light and shade into account, placing grey marker in combination with white pencil either concavely or convexly can be suggested. You can do this easily by hand or with a ruler.

Bigger holes can be added afterwards as well using a black marker in combination with a white coloured pencil.

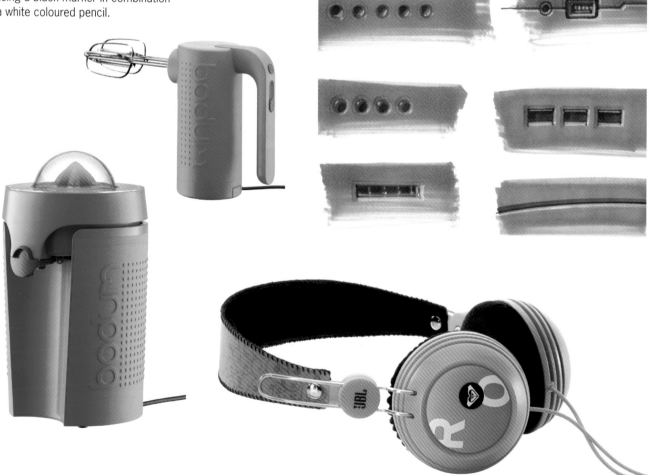

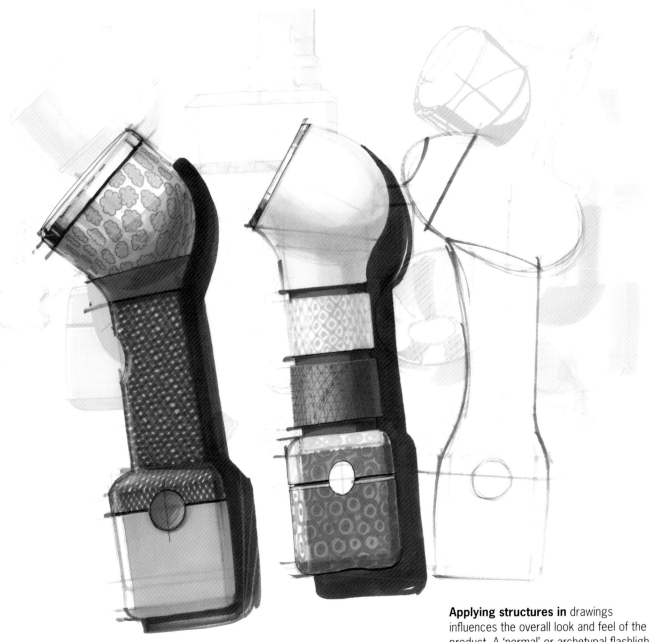

Applying structures in drawings influences the overall look and feel of the product. A 'normal' or archetypal flashlight will change dramatically. But you see these structures added to a product are often used for the same reason.

In this example the flat top surface seems to become less flat owing to the block structure added in perspective.

There are of course digital opportunities in adding these details. Scanning and adding graphics by computer, for example, can be very effective. An application widely used is to add the name or logo of the brand to a sketch.

Adding text to a design by computer is easily done. Here you find the word 'fridge' added as plain text, with the object's colour, and adapted in perspective. The same word is blended onto the side of the refrigerator with the 'bevel and emboss' function in Adobe Photoshop.

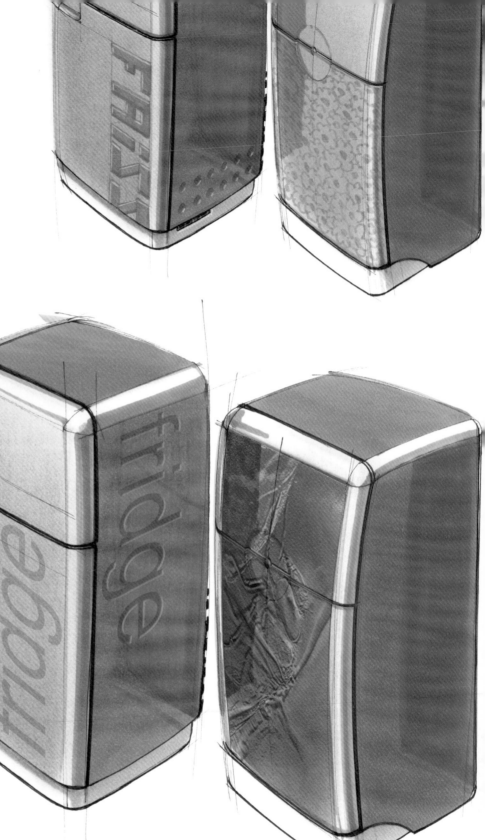

When a drawing is scanned, remember that the paper's white may become a little darker. Use image editing to whiten the bright areas of the scan, leaving the lines intact.

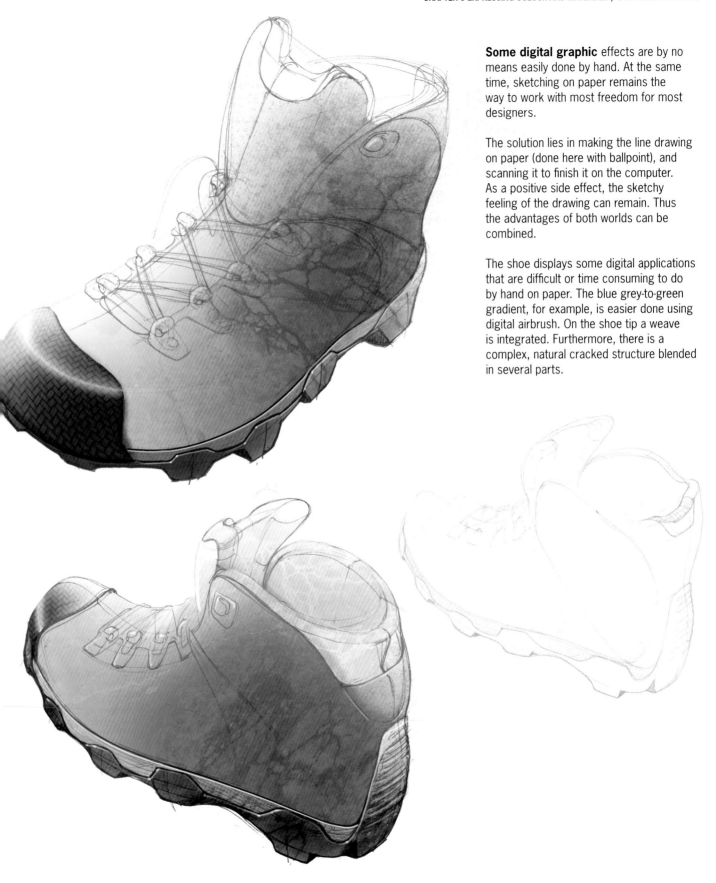

Some digital graphic effects are by no means easily done by hand. At the same time, sketching on paper remains the way to work with most freedom for most designers.

The solution lies in making the line drawing on paper (done here with ballpoint), and scanning it to finish it on the computer. As a positive side effect, the sketchy feeling of the drawing can remain. Thus the advantages of both worlds can be combined.

The shoe displays some digital applications that are difficult or time consuming to do by hand on paper. The blue grey-to-green gradient, for example, is easier done using digital airbrush. On the shoe tip a weave is integrated. Furthermore, there is a complex, natural cracked structure blended in several parts.

Tip
When every product colour has its own document layer, colour adjustments can be easily made afterwards.

5.7 HOW TO PRACTICE

This exercise can also be done on coloured paper to encourage or prepare for digital sketching.

The shape elements to use are a wedge and a cylinder. You can use them in various proportions, orientations and combinations. You can combine the wedge with three cylinders to make a vehicle, or an audio speaker, or even a handbag.

Just start with a blank mind and make a combination. Let your imagination guide you in making sketches. Once you 'see' what it can be, don't worry about the construction of various parts. The sketch may leave a lot open to suggestion. It is not meant to be a carefully constructed shape.

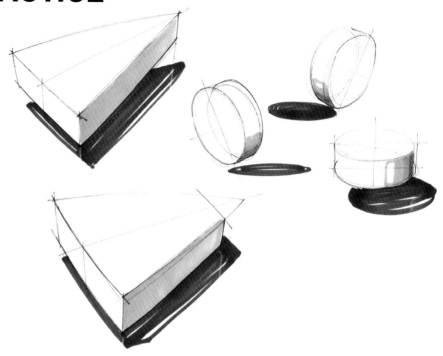

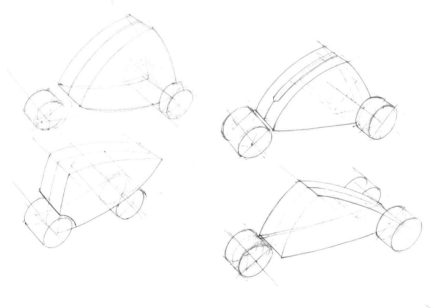

The line drawing is finished by thickening shading lines and lines where various parts connect. Do not make too many details but just enough to make the shape understandable.

Use the marker effectively for only the most necessary shading, cast shadow and, if the object is meant to be shiny, reflections. Now use a lot of (dry) pastel chalk. With digital sketches, this will be an 'airbrush' tool. Finally, details and highlights are added.

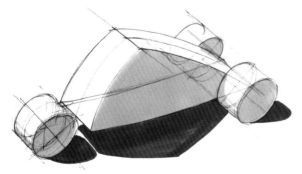

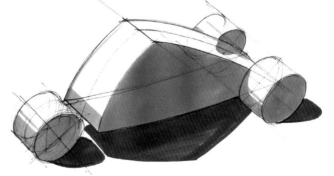

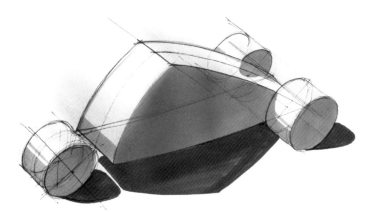

Notice that some white is left on the wheels between the marked areas and the pastel chalk. This way more contrast is achieved, which will enhance its shiny appearance.

Pastel chalk is applied on the body of the vehicle to connect to the marked area. A reflection of one of the rear wheels can be seen.

Now scan the drawing, and digitally add product graphics or a structure. Here rubber tire, a rim and a grill structure are added. Make sure you invest some time to carefully rotate and scale the cylindrical shapes in order to adjust them to the perspective of the sketch.

To realistically integrate these image parts, extra reflections are needed in the blue car body. In addition, the chosen light direction of the sketch needs to be applied to the image parts. Here, the rubber tires are darkened and lightened accordingly. Some highlights were added to the rims.

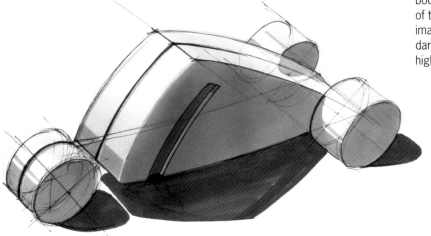

CASE

FLEX/THE INNOVATIONLAB®, NETHERLANDS

The FlooW is an electrically powered (semi)covered Quadricycle, developed by ComfortMobiel Products for the commuter market, 2010.

Brainstorm

We sketched one idea per sheet, using a big Edding marker and sketching big! It was not important whether the perspective was wrong. Quantity and speed are what counts. We used colour to emphasise details and add words and arrows. Mostly of these sketches are for internal use only, even though clients often like to see these drawings.

Sketch Phase

In this phase sketches were made with pencil and fineliner. Some sketches were scanned, touched up and coloured in Adobe Photoshop to communicate ideas and thoughts. Some ideas have been drawn more dynamically to emphasise the effect. Exaggerating shapes, lines, directions is sometimes an interesting way to communicate the essence of the design proposal. Note the highlight colours. The obvious components of the FlooW have been left without details to emphasise the purpose of the image. Some subtle black fineliner lines were added for more 'depth' and dynamism in the drawing.

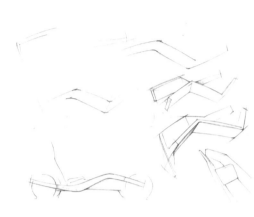

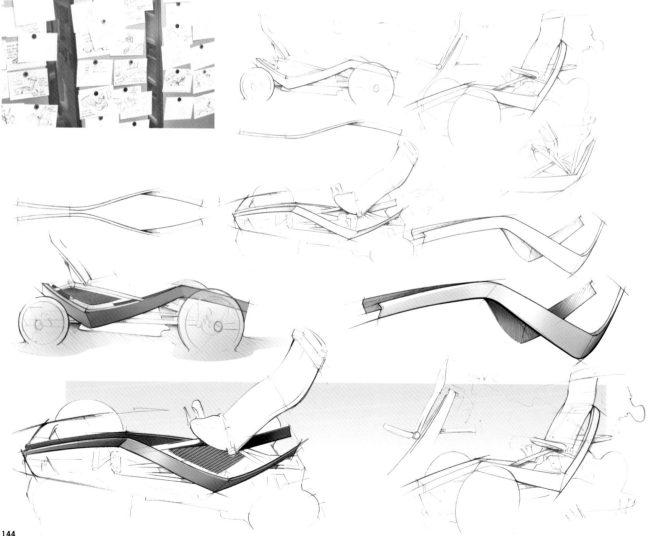

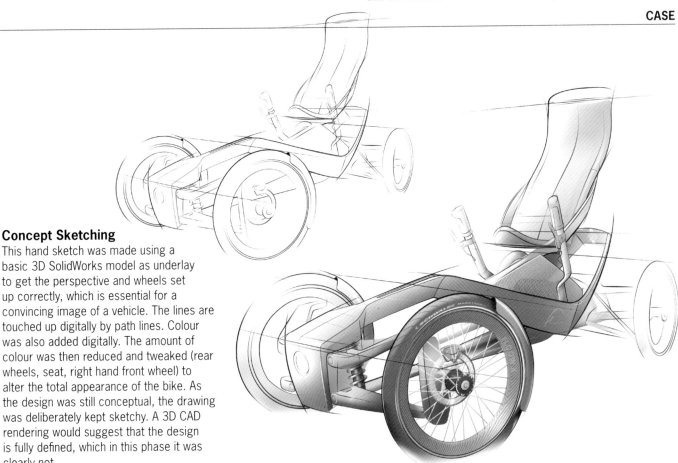

Concept Sketching

This hand sketch was made using a basic 3D SolidWorks model as underlay to get the perspective and wheels set up correctly, which is essential for a convincing image of a vehicle. The lines are touched up digitally by path lines. Colour was also added digitally. The amount of colour was then reduced and tweaked (rear wheels, seat, right hand front wheel) to alter the total appearance of the bike. As the design was still conceptual, the drawing was deliberately kept sketchy. A 3D CAD rendering would suggest that the design is fully defined, which in this phase it was clearly not.

3D 'Sketching' Model

A 3D shape can be explored on paper or computer, but nothing beats the real thing. We used model foam, loads of tape, wood, and in this case tent poles. It is excellent for design discussions too.
Photos of such quick set-ups can become perfect underlays!
...and we had loads of fun with a drivable FlooW prototype at the office.

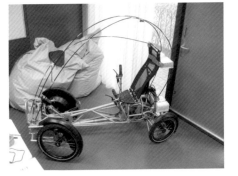

To show the effect of the new design style on the whole appearance of the FlooW, this 100% Photoshop drawing of the shape theme of the FlooW quadricycle was made. '..I really wanted to express the dynamics of the new backbone frame and its shape. So I started off with a black field in which fluent lines of light indicate the 'flow' through the vehicle, literally. No detailing, just the basic movement to express the basic thought...'

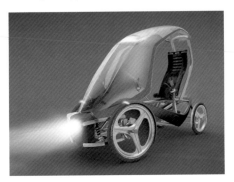

Concept Presentation

This digital tablet drawing was based on a 3D rendering. The lights, reflections, perspective and effects have been exaggerated slightly to make the image more striking and keep it conceptual.

CASE

BMW GROUP DESIGNWORKS USA, SINGAPORE

Racing Bike Project for NeilPryde, product introduction 2010
Design team: Joe Tan, Nils Uehllendahl, Sonny Lim.

The development time of the NeilPryde Alize bike was relatively short. All the coloured pencil drawings were created purely for internal design development and some of them to communicate with our client. Communicating ideas and shapes efficiently was the main goal of these drawings.

The initial sketches were created in Adobe Photoshop using pictures as underlays. The Dodge and Burn tools were used extensively to rapidly shade the surfaces and to underline shape transformations and different curvatures.

After confirmation from NeilPryde of the 2D sketches, we started developing the bike frame in 3D Alias Studio software. As refined 3D Alias surface modelling is very time consuming, we jumped from 2D Illustrator/Photoshop drawings to 3D Alias models and back again. The sketches were used as an underlay for creating 3D surfaces, and rough 3D renderings were subsequently used as underlays to refine the shape further.

The goal was to define the final surfaces and lines as accurately as possible before creating the final 3D Alias model. This iterative process allowed us to design the Alize bike very quickly.

Chapter 6

FAST AND FEARLESS

You have probably noticed by now that, irrespective of the correct perspective and shading, some drawings 'have it', while others just don't. A drawing can be made neatly, with all the right things like well-balanced contrast here and there, correct line thickness and beautifully applied colour and so on, but unfortunately all this does not make it a 'wow' drawing. Actually, it may look quite dull....

Some drawings are just more energetic and convincing than others. Sometimes a rapidly made sketch at the start of the day is more powerful and convincing than all drawing you did later on, desperately trying to repeat this scribble. 'And I wasn't even paying all that much attention' you may say about this sketch.

That may be precisely the reason that this sketch is so powerful: your relaxed and confident attitude while sketching it. When you have mastered most of the skills needed, you do not have to worry so much or think so long about the right perspective or shading. They tend to come naturally by themselves. And when you do not have to struggle with these practical issues anymore, you can develop a more relaxed and loose attitude, free your mind and get the focus where you need it most: on expressing your ideas and personal style.

This chapter discusses the dos and don'ts that you may encounter while sketching your way towards this level of free sketching. We will start by discussing the line drawing only, and after that the drawing choices as your sketch develops.

That is why we stated at the start of this book that you shouldn't rush things. The basics need to be learnt and then applied without even thinking about them. Or at least you do not want to be so tense that your attitude hampers the flow of ideas.

A typical learning curve among students may be a free attitude at the start of the course. Then, once they have become aware of but not yet mastered all drawing aspects, they get a little tense. And later on their attitude becomes freer. Keep on practicing and this tense feeling will disappear again. And that inevitably makes the accuracy of the perspective less important. You should not be afraid of failing, and you know that if one sketch has wrong outcome, you have the ability to make a dozen more.

"...applying all drawing theory nicely is not the main issue; drawing freely is more important. Consistently drawing that way, you will develop a distinctive handwriting or style.
Just like human beauty, suggestion and defect will lead to attraction..."
— Gianni Orsini, Designer

6.1 LINES

As you have seen already, the drawing material used after the line drawing has a great impact on the perception of the sketch. Knowing this, you can view the line drawing as an aid for the next materials like markers. It is therefore worthwhile to keep adapting the shape until you are satisfied, knowing that any 'wrong' lines will not be of much importance later.

The drawing starts with long thin lines that extend much further than the object. The focus is on the direction of the lines, not on the end points. The shape changes and grows as the sketch develops. At a certain moment, there may be so many lines that the shape loses clarity.

Darkening some of the lines can clarify the sketch again. Lines on the shaded side of the object can be drawn slightly thicker for spatial purposes. Thickening these 'shadow lines' can also bring back clarity to your drawing. This can even be a good moment to use a French curve or a ruler.

In the original sketch, these lines are darkened. This clarifies the shape of the object and makes the sketch workable. Applying just a quick airbrush and some highlights can transform this sketch into a presentable spatial drawing. The result is a clearly legible shape, and the sketch is still spontaneous thanks to the sketchy lines.

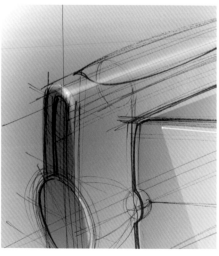

Tip
Let the drawing grow and change as it develops rather than precisely duplicating the mental image you had at the start.

Sometimes a drawing is adapted so much that it is no longer legible. A solution may be to start thickening the 'right' lines. This, however, may result in a messy sketch and leaves little room for variations in line thickness.

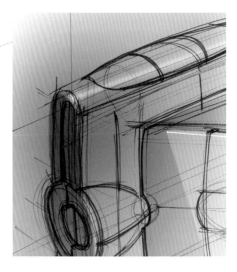

6.1.1 Tracing

Although it is good not to make a habit of it, it may sometimes be wise to trace the initial drawing. A way of tracing that is inappropriate for design sketches is to start tracing very carefully and to get rid of all the 'wrong' lines and leave out all help lines and guidelines. The result may look clean, but it is not efficient in terms of time and rids your sketches of all spontaneity and, far worse, personal handwriting and suggestiveness. Such drawings generally all look the same and lack all dynamism left in their lines.

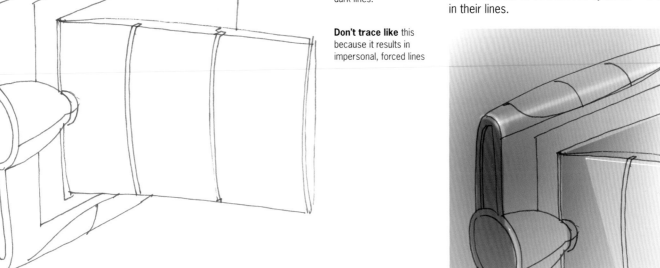

Don't add too many dark lines.

Don't trace like this because it results in impersonal, forced lines

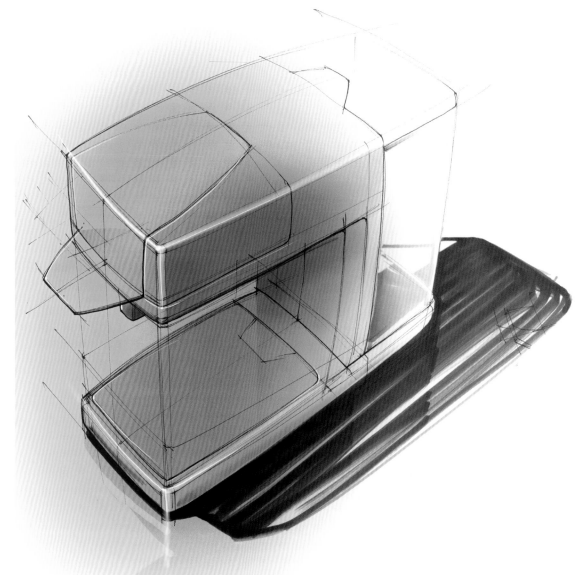

The use of (marker) colour and contrast (e.g. by shading) gives body to the drawing and takes the focus away from the line drawing. The line drawing is then of lesser significance and is literally an underlay. So do not hesitate to use enough guidelines and make changes until you are satisfied with your design.

There are complex situations in which you might know in advance that a lot of adapting will be made to the line drawing. One way of avoiding getting stuck with too many dark lines and keeping the drawing the same is to make an underlay drawing.

In this case you start drawing with a light marker or a coloured pencil for example. When the shape is almost ready you switch to a darker medium, like fineliner, to finish it. It remains equally important to trace lines in such a way that your handwriting remains spontaneous, as if you are drawing it for the first time.

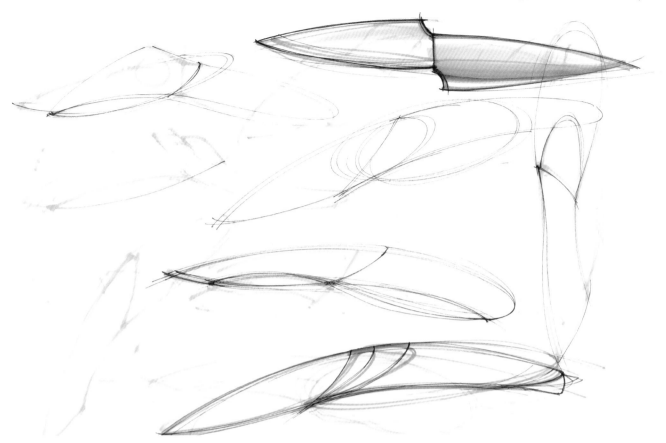

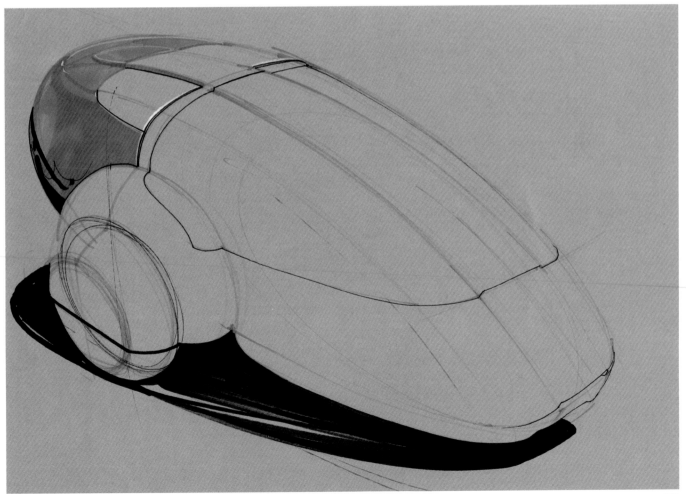

6.2 MARKER USE / AFTER THE LINE

Drawing freely not only with line drawing, but also with all the other drawing materials is illustrated here. Notice the way the marker is used like a sketching tool. A knowledge of material expression enables you to improvise and look ahead.

Use the (marker) sketch lines to express materials. The focus of the colour marker lies on the reflection of the cast shadow in the base body of these vacuum cleaners.

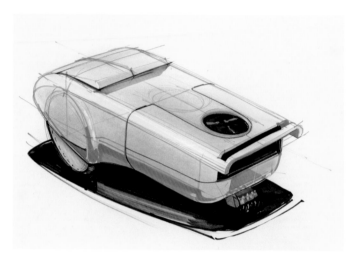

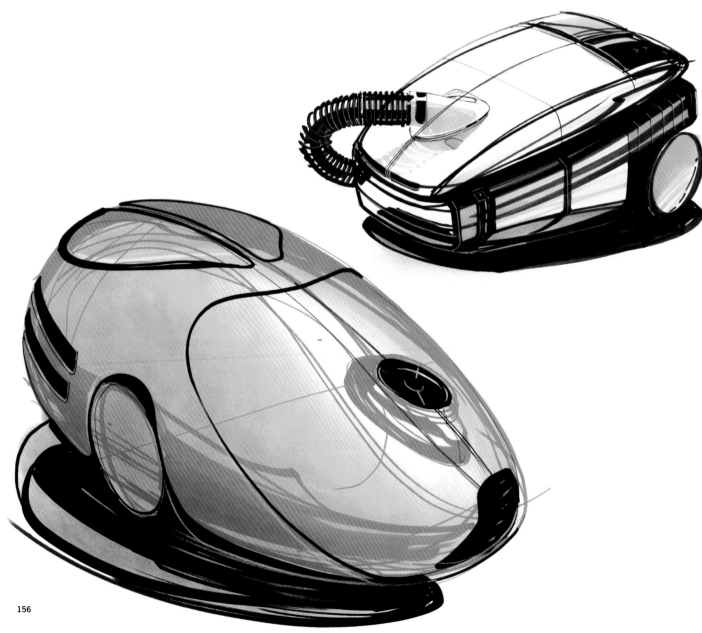

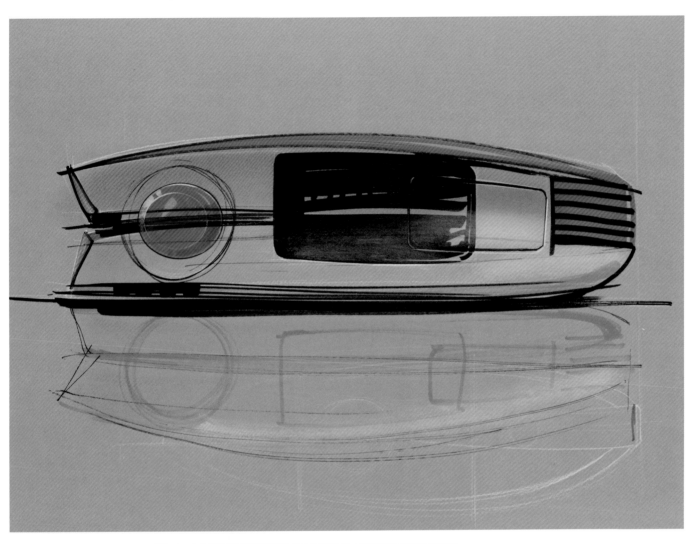

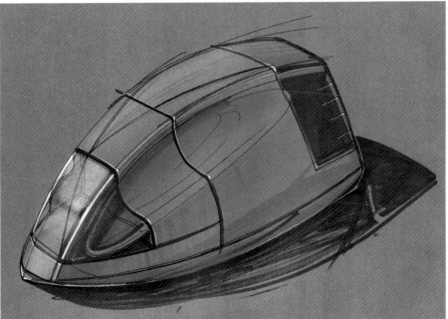

Sketching on grainy coloured paper or background enables you to use a lot of chalk or digital airbrush. That is why just a little colour marker is used in these examples.

Choosing the same colour for the paper and the object, and then adding just a slightly warmer colour chalk on the object, increases the difference between the background and the object because we perceive warm colours to be nearer.

It is of course also possible to give the object another colour than the sketch paper. Because of the level of detail, this sketch starts with fineliner. A lot of lines can be used to determine the exact shape of the object.

A minimum amount of shading is then added with grey marker. Some reflections on the floor are also sketched with the grey marker. Even at this stage you can see the emphasis in detailing the shape at the front. When applying pastel chalk, a slight fade-out gradient towards the back will keep the emphasis at the front where more interesting details can be seen, and also enlarge the sense of depth in the drawing. In this phase the drawing might look very smudgy and less interesting than before, but that will disappear again in the next stages.

Pastel chalk is then erased largely around the shape. Some chalk remains on the floor to provide some surroundings for the object and to refine reflections, making the whole appearance more interesting.

The final step in this sequence is applying white pencil for highlights. This might even be the step with the most impact on the drawing. Again, these highlights are mainly applied at the front of the drawing, making the contrast greatest there, and increasing the sense of depth by reducing the contrast further away.

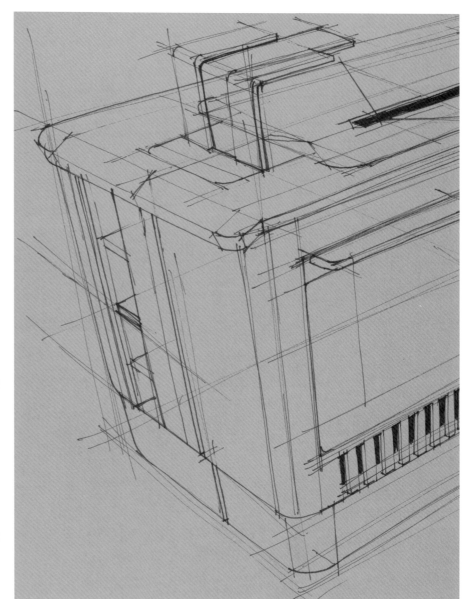

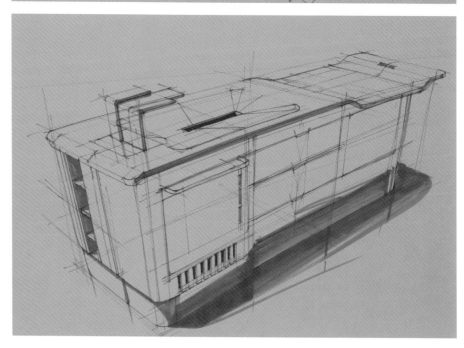

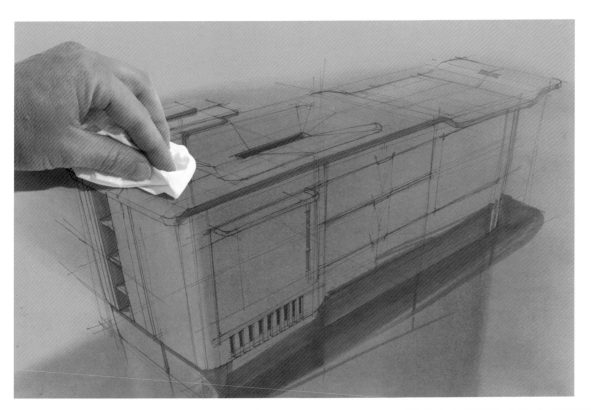

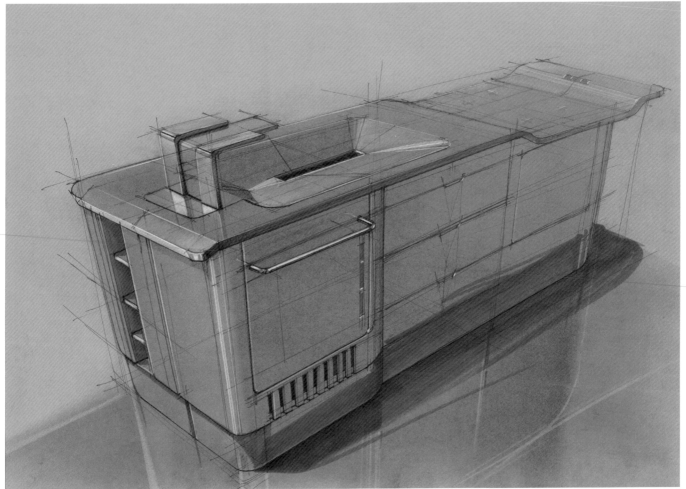

6.4 INTUITIVE SKETCHING

These objects are drawn very fast and
fearlessly, but using a completely different
approach in (line) drawing. First a 'doodle' of
lines is drawn. These doodles then become
the inspiration for the final spatial shape.

The purpose of this method lies in the
unexpected turns your drawing will take
and the surprising shapes that will arise.
Innovative shapes can be found that would
not seem obvious at all at first.

As you can see, this is a method that is
best done digitally, so that brighter colour
layers can easily cover over earlier black
areas.

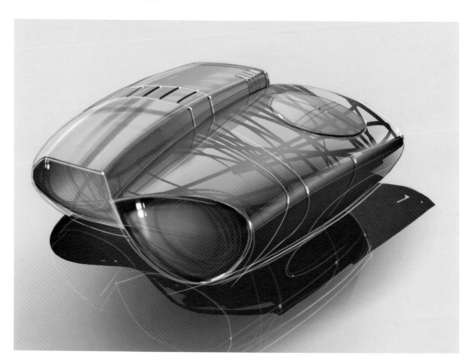

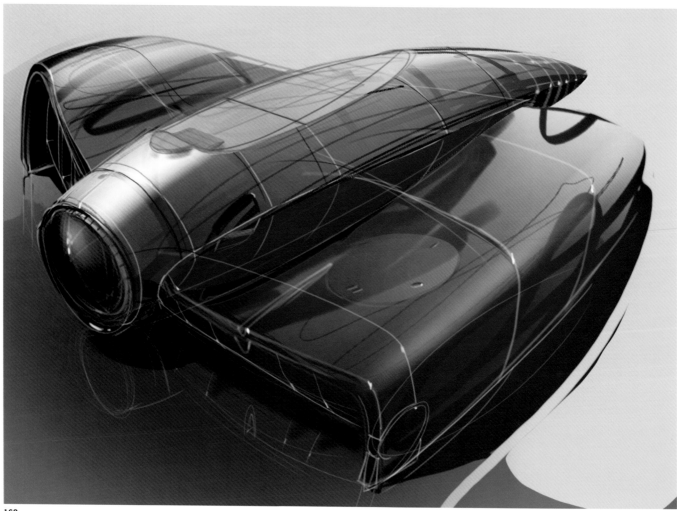

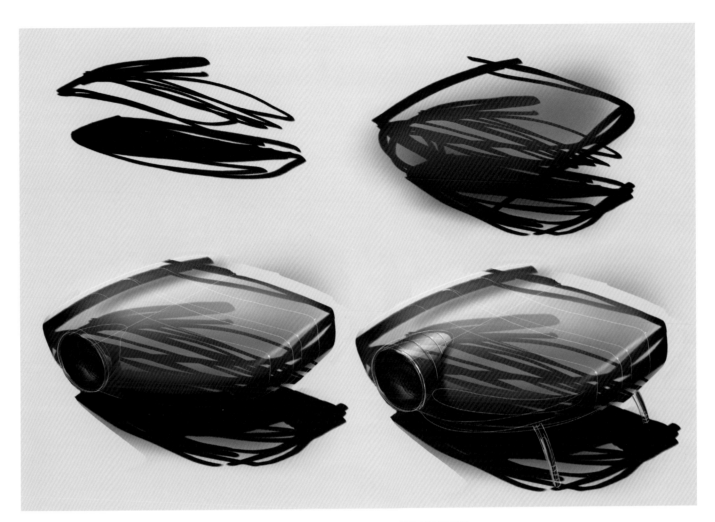

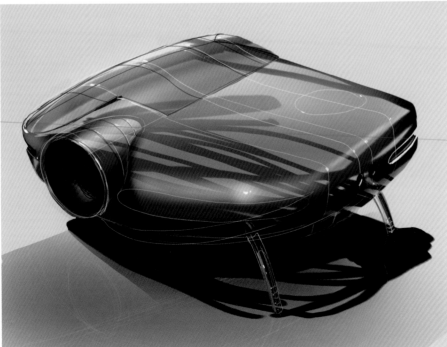

Starting with a doodle looks strange at first sight, but it is an interesting way for some designers to come up with a totally new shape instead of being preoccupied with an archetype. If you ask people to draw a pair of binoculars, nearly everybody focuses on two cylindrical shapes or an equivalent to these shapes. Starting with a doodle may create something else.

You can actually see this change happening is this example: a search for a new shape for a video beamer. It looks like intuitive shaping and changing contours, like a 2D equivalent of 3D clay modelling. Shaping and reshaping, choosing and rejecting, and finally detailing and finishing.

CASE

DUCATI MOTOR HOLDING SPA, ITALY

Ducati Monster motorcycle, 2007 Ducati Design Team
Senior Designer: Bart Janssen Groesbeek

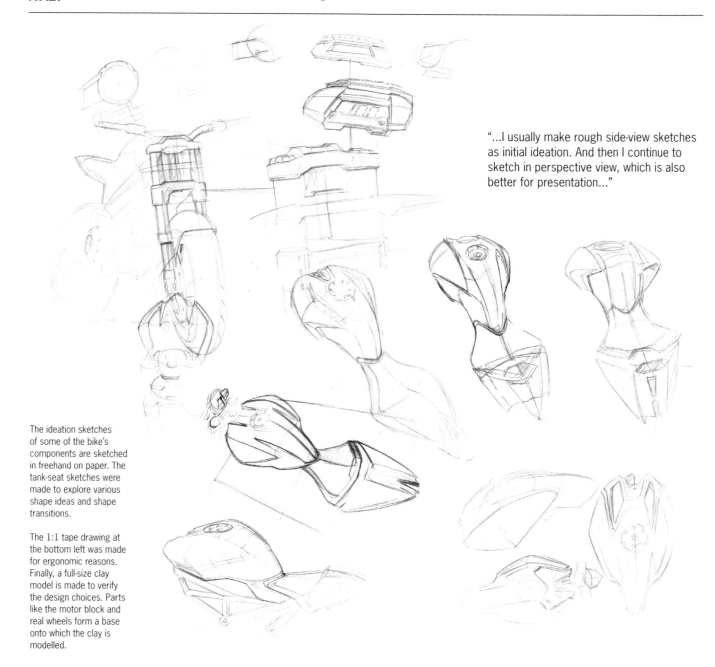

"...I usually make rough side-view sketches as initial ideation. And then I continue to sketch in perspective view, which is also better for presentation..."

The ideation sketches of some of the bike's components are sketched in freehand on paper. The tank-seat sketches were made to explore various shape ideas and shape transitions.

The 1:1 tape drawing at the bottom left was made for ergonomic reasons. Finally, a full-size clay model is made to verify the design choices. Parts like the motor block and real wheels form a base onto which the clay is modelled.

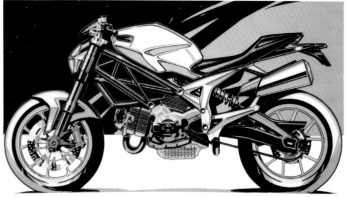

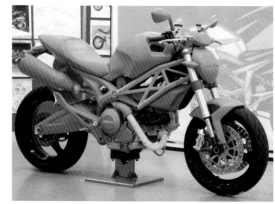

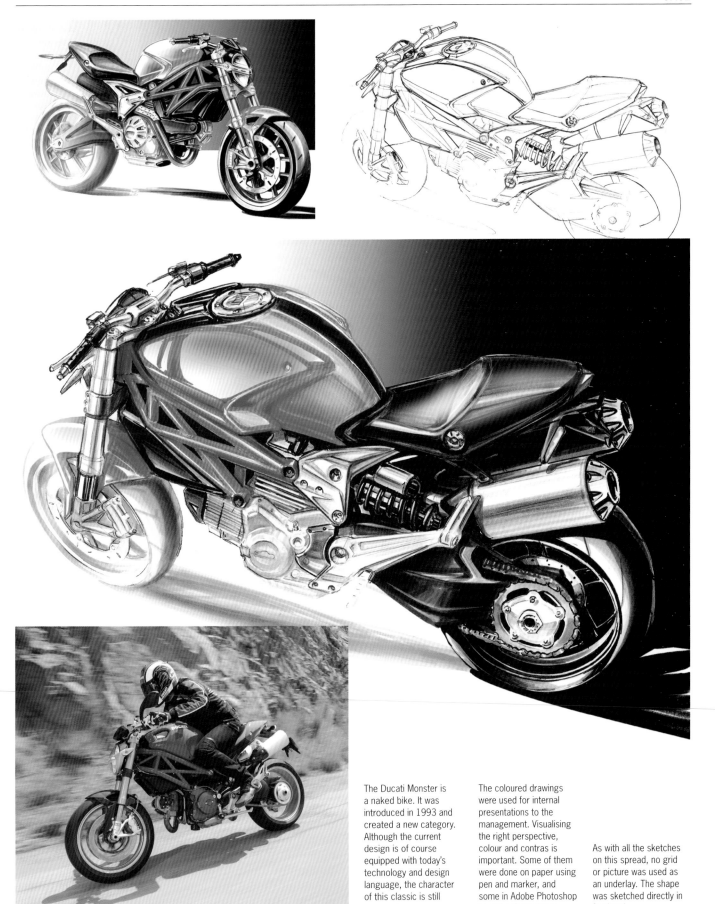

The Ducati Monster is a naked bike. It was introduced in 1993 and created a new category. Although the current design is of course equipped with today's technology and design language, the character of this classic is still apparent.

The coloured drawings were used for internal presentations to the management. Visualising the right perspective, colour and contras is important. Some of them were done on paper using pen and marker, and some in Adobe Photoshop to add soft gradients.

As with all the sketches on this spread, no grid or picture was used as an underlay. The shape was sketched directly in freehand.

Chapter 7

PRODUCT CONTEXT

A sketch made during the design process may be perfectly understandable to anyone involved in that process. But take it out of its design context, especially when it is very innovative, and an outsider will have no clue as to what it is all about.

A pitch to management, for example, can highlight this problem. To explain the design idea, a general context is needed -- in many cases its user-driven context. Sketch-ing during brainstorm sessions does not always focus on the shape of an object. Sometimes the context of the whole idea requires most attention. Closely related to this are sequential sketches like user guides, manuals and product scenarios.

This chapter deals with various sketches and the way they relate to their product context.

'... I always digitally paste real wheel rims to early car sketches, because wheels give the sketch a good feeling, just as wearing good shoes does to emphasise a smart suit...'
— Emanuele Nicosia, Design Director, Beestudio, Pune, India

7.1 ADDING PRODUCT DETAILS

You can transform a very simple shape into a product by adding typical details such as parting seams, tabs, buttons, displays and cords. This has many advantages. For the viewer, these details convey information about the size of the product, and lend a sketch a more realistic character, which can make it easier to understand.

For the designer it may serve as a means to enliven the product idea and stimulate us to think more about an idea. Adding these details can be done relatively quickly, but they can dramatically change a sketch.

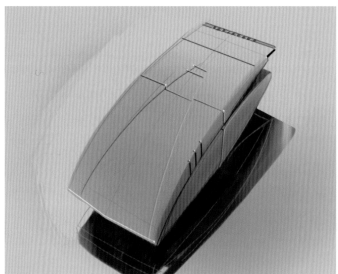

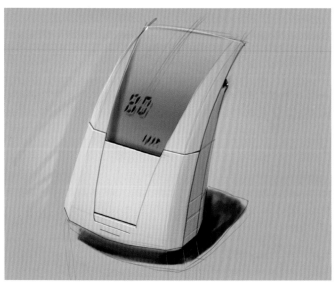

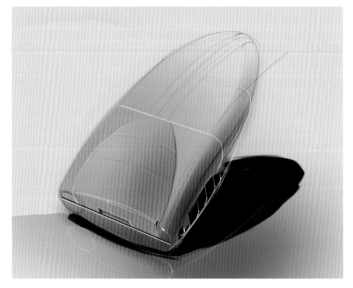

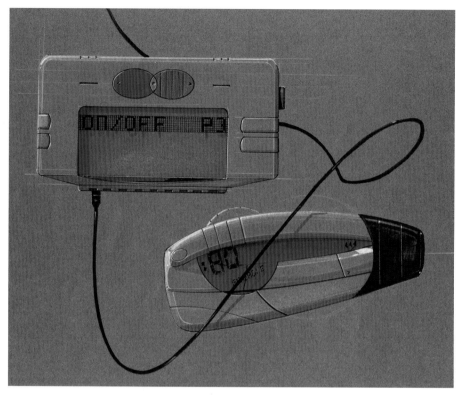

Because of the importance of the product details, it is worthwhile searching for the right layout. This can be done easily in side view, using the convenience of a coloured background, ruler, French curves and templates. Drawings at full scale can help with ergonomic issues. Using your own hand then as a reference helps to examine sizes and dimensions of details.

Tip
In both examples the colour of the object is independent of the paper colour. Add some chalk and a slight difference to the paper colour will be enough to suggest colour.

Tip
A lot of products have a 'face', a side view that tells more about the product and its most characteristic view. It is this view that is drawn in side view.

7.2 SCALE AND SIZE

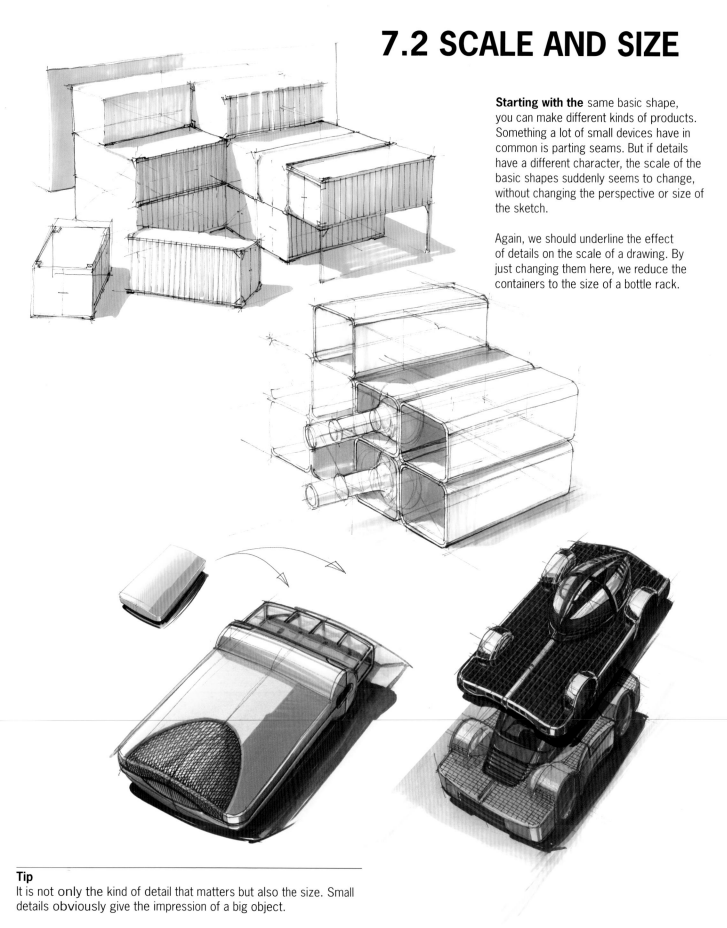

Starting with the same basic shape, you can make different kinds of products. Something a lot of small devices have in common is parting seams. But if details have a different character, the scale of the basic shapes suddenly seems to change, without changing the perspective or size of the sketch.

Again, we should underline the effect of details on the scale of a drawing. By just changing them here, we reduce the containers to the size of a bottle rack.

Tip
It is not only the kind of detail that matters but also the size. Small details obviously give the impression of a big object.

CASE

JAM VISUAL THINKING, NETHERLANDS

Supporting idea and concept generation based on macro-trends for Just Imagine 2009
Sketches by Jan Selen and Jeroen Meijer

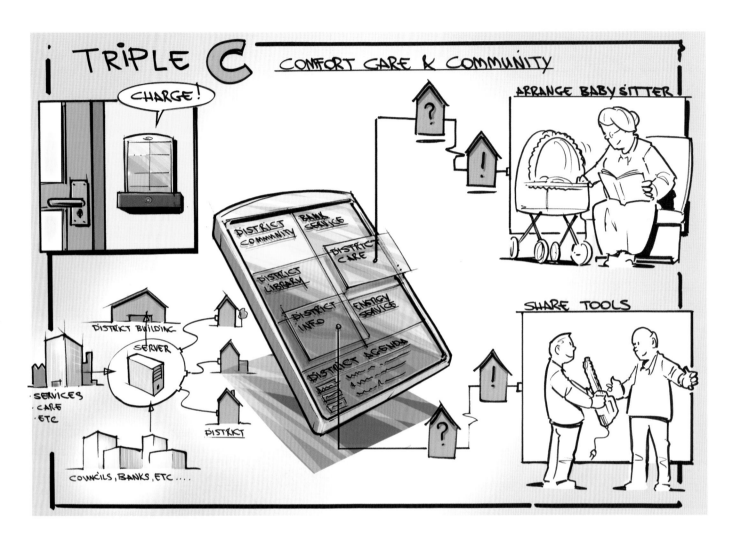

Innovation is part of every strand of society these days, and most companies do not use sketches for communication purposes as designers do. Despite all the nice words spoken and written, JAM helps clients to understand their ideas better by creating these sketches.

A sketch can catch an idea in just one image, which helps the people involved to understand and communicate their thoughts and ideas. This makes it easier and faster to develop them. In creating these sketches, you should understand for whom they are intended. Simplicity is the key word, and the level of information has to be balanced within the context where visuals are used.

The goal in this specific workshop was to support an elevator pitch during a presentation. The level of information was therefore kept to a minimum: a product sketch with little technical background combined with some additional user scenarios.

The sketches serve as visual guides to support what needs to be told about the concept. Using small scenario sketches while explaining a product concept can help an audience to develop empathy for the user and understand the need for a product.

As the client explains his or her ideas, a rough set-up of the overall concept is sketched out 'live'. This creates a shared feeling for the sketch and is a great way to check if all the information is correct. It is wise to involve the client from the start. Sketching out a rough concept of what sketches are needed to convey the story or idea engages and challenges the client to rethink the content of their story.

7.2 SCALE AND SIZE

Starting with the same basic shape, you can make different kinds of products. Something a lot of small devices have in common is parting seams. But if details have a different character, the scale of the basic shapes suddenly seems to change, without changing the perspective or size of the sketch.

Again, we should underline the effect of details on the scale of a drawing. By just changing them here, we reduce the containers to the size of a bottle rack.

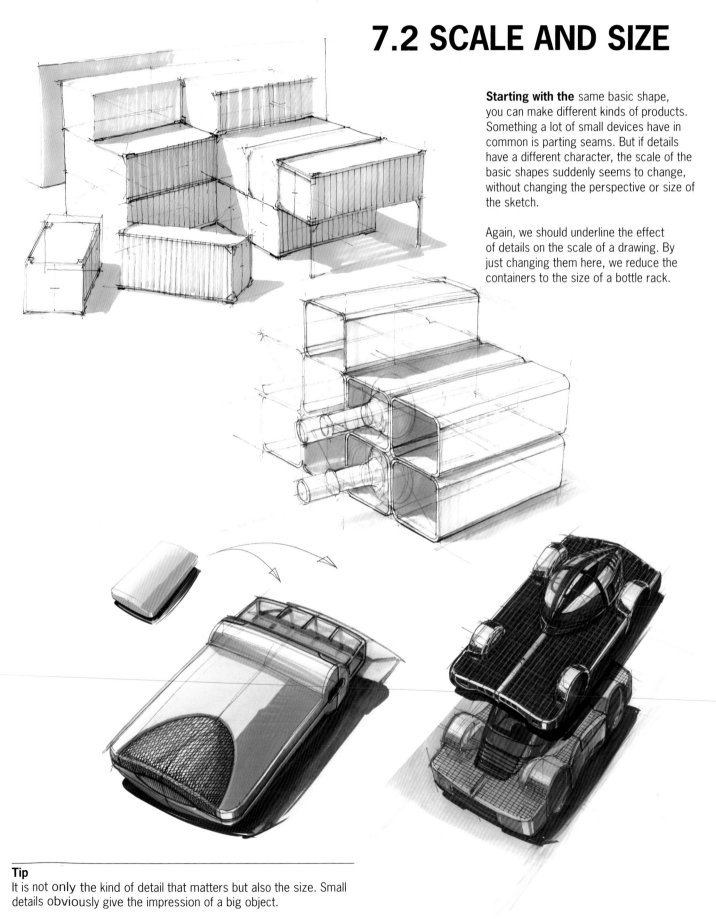

Tip

It is not only the kind of detail that matters but also the size. Small details obviously give the impression of a big object.

CASE

JAM VISUAL THINKING, NETHERLANDS

Supporting idea and concept generation based on macro-trends for Just Imagine 2009
Sketches by Jan Selen and Jeroen Meijer

Innovation is part of every strand of society these days, and most companies do not use sketches for communication purposes as designers do. Despite all the nice words spoken and written, JAM helps clients to understand their ideas better by creating these sketches.

A sketch can catch an idea in just one image, which helps the people involved to understand and communicate their thoughts and ideas. This makes it easier and faster to develop them. In creating these sketches, you should understand for whom they are intended. Simplicity is the key word, and the level of information has to be balanced within the context where visuals are used.

The goal in this specific workshop was to support an elevator pitch during a presentation. The level of information was therefore kept to a minimum: a product sketch with little technical background combined with some additional user scenarios.

The sketches serve as visual guides to support what needs to be told about the concept. Using small scenario sketches while explaining a product concept can help an audience to develop empathy for the user and understand the need for a product.

As the client explains his or her ideas, a rough set-up of the overall concept is sketched out 'live'. This creates a shared feeling for the sketch and is a great way to check if all the information is correct. It is wise to involve the client from the start. Sketching out a rough concept of what sketches are needed to convey the story or idea engages and challenges the client to rethink the content of their story.

After the initial sketch, a proposal for the next phase was shared with the client for feedback. There are always going to be little insights and corrections, as this is usually the first time their ideas take shape.

Then the sketches were finalised using Alias Sketchbook Pro. The colouring was kept very basic. Using one support colour effectively creates the setting and enables room for points of focus by slight colour variations.

7.5 STEPS AND SEQUENCES

A typical context for drawings can be found in sequential drawings such as those we find in instruction guides or user manuals. Here each sketch is related to the previous one and next one in terms of sequence. This series of drawings is meant to inform the user, so the object and the procedures should be clearly legible. This calls for an informative viewpoint and consistency, for instance in shading, throughout the whole series.

If you take the exact same viewpoint for each step, the whole sequence will become quite lifeless. An instruction such as the one here is also meant to stimulate action. Slight variations in both viewpoint and size can make up for this and enliven the sequence.

Unlike the widely used top-view approach of folding steps, you see in perspective that the arrows representing the action are relatively large.

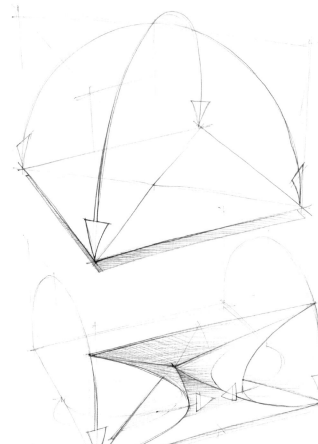

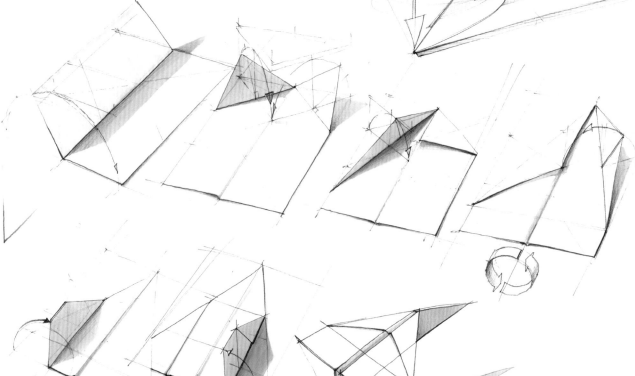

Tip
Making a cube out of the paper base square can help in finding the right dimensions.

To depict the arrows, the positions at the start, end and especially the midpoint are drawn. Now two squares are added to guide the half circle movement. An elliptical shape can then be formed. Now choose a position for the paper that will give the sketch a spatial boost, and at the same time keep the total step and action recognisable.

In western culture, we read from left to right and top to bottom. These directions should be considered when making combinations of sequential sketches. In the example of the airplane, these reading directions are applied, which result in a clear understanding of sequential steps.

As you can see in the example on the two pages, these culturally determined reading directions are not applied literally, but taken as a guideline for positioning the sketches.

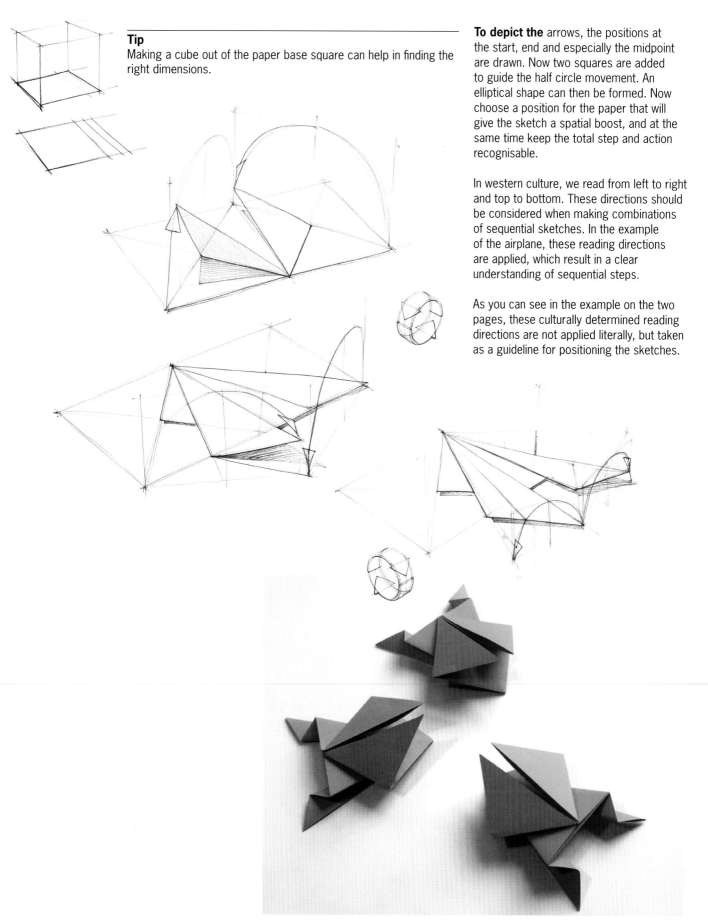

7.6 FOCAL POINT

How do you read a sketch? Can you direct the observer in a certain way? Can you shift the emphasis of a sketch to influence the observer? The answer is yes. In this section you will learn several ways to create a so-called point of focus, a spot to which attention is drawn.

The most simple and obvious way to emphasise part of a sketch is simply to add a circle. This effectively directs the observer towards a certain spot.

In more elaborate drawings, for presentations and suchlike, this principle also works and can be more sophisticated. But you must carefully balance the composition to maintain focus on the emphasised elements and use the rest of the sketch for support only.

Here you find two methods in black and white, with a difference in contrast. To keep emphasis on the detail, the rest of the object's brightness and contrast are subdued. When the detail is in colour, this produces an extra contrast, and the brightness and contrast of the rest of the sketch can be sharper.

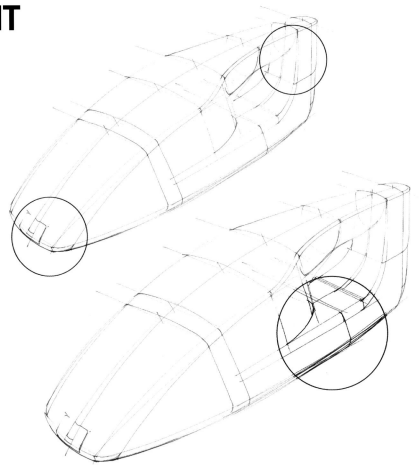

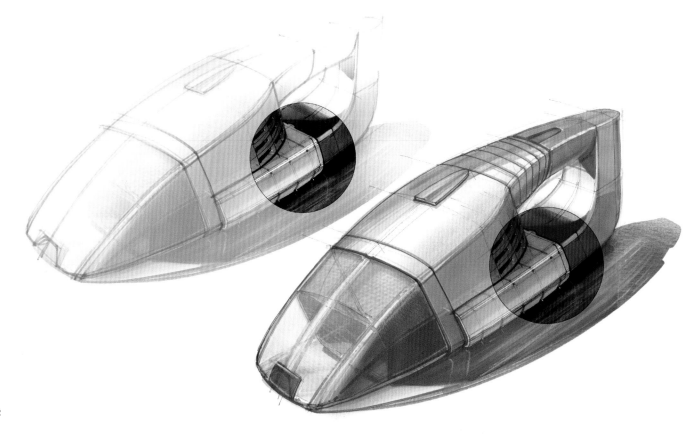

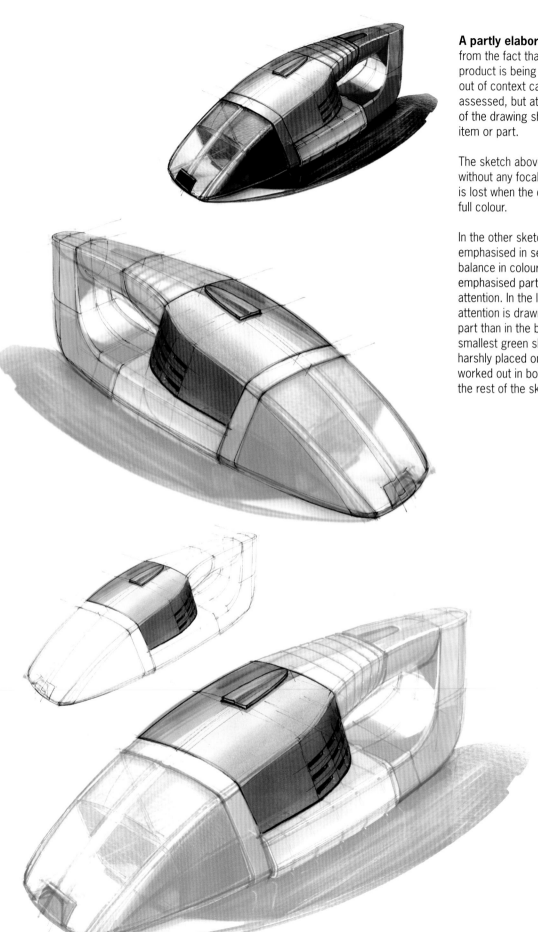

A partly elaborated sketch can originate from the fact that only part of a complex product is being viewed. A design taken out of context cannot always be properly assessed, but at the same time the focus of the drawing should be on that particular item or part.

The sketch above is coloured completely, without any focal point. The attention point is lost when the complete object is drawn in full colour.

In the other sketches a product part is emphasised in several ways. Again, the balance in colour contrast between the emphasised part and the rest needs some attention. In the larger brown sketch more attention is drawn subtly towards the central part than in the bigger green version. In the smallest green sketch the emphasis is quite harshly placed on the green part, as this is worked out in both volume and colour, and the rest of the sketch is only in lines.

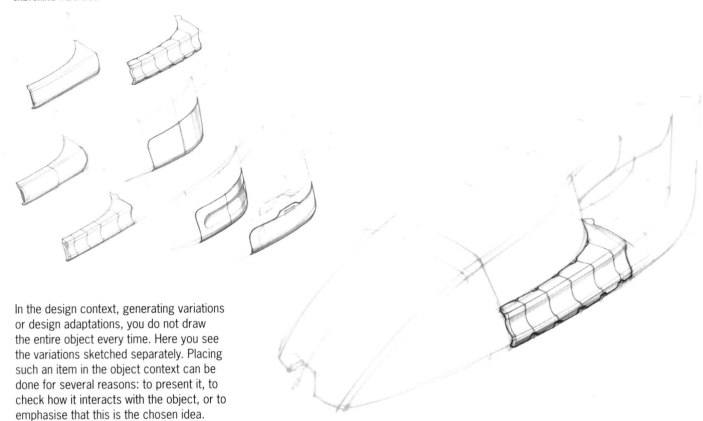

In the design context, generating variations or design adaptations, you do not draw the entire object every time. Here you see the variations sketched separately. Placing such an item in the object context can be done for several reasons: to present it, to check how it interacts with the object, or to emphasise that this is the chosen idea.

In this combination, most emphasis is put on the (re)designed part through contrast. It appears darker and has more detail.

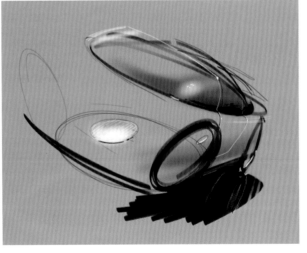

A more subtle application of this principle can be seen in these sketches. The focal point is not outlined by part of the product, but there is a more gradual fade out.

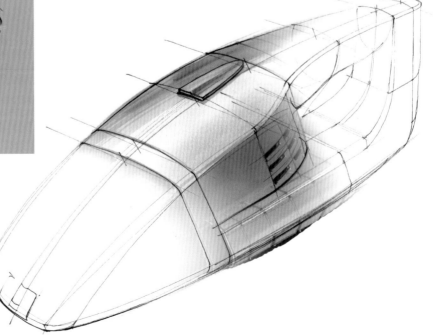

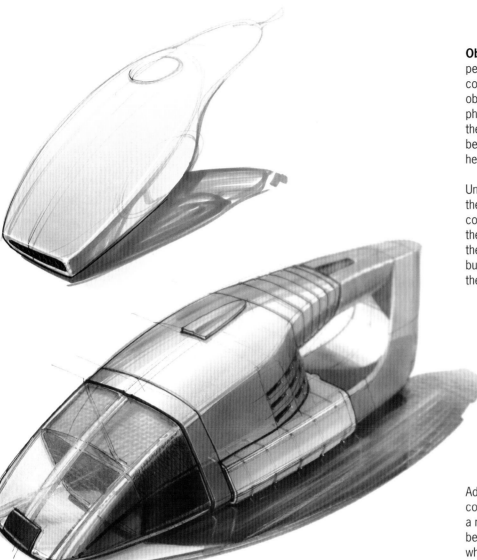

Objects that are further away are perceived with less contrast, less saturated colour, and cooler colour than nearer objects. In architecture this is a normal phenomenon because of the large scale of the designs, but the phenomenon can also be applied to smaller objects, as is done here. In car design it is quite common.

Unlike the first examples in this section, there is no clearly added focal point. The colour contrast gradually fades out towards the back. This exaggerates the spatiality of the drawing and the object may look bigger, but it combines efficiency in drawing with the out-of-focus effect of reality.

Adding a digital blur to a sketch is a common effect in photography. It is actually a natural phenomenon to the human eye, because we can only focus on part of what we see. The rest is only perceived indirectly, from the corner of our eye.

With the aid of digital photo editing, a blur can be added to create a point of focus and add depth to a sketch. Of course the smaller the object, the more exaggerated this phenomenon will be.

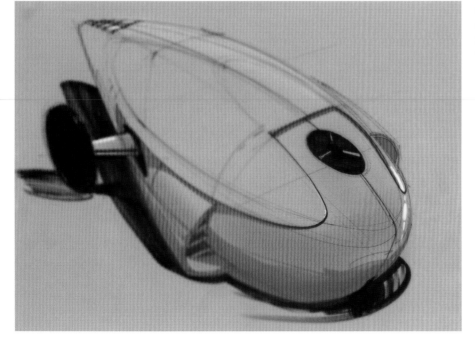

195

7.7 HOW TO PRACTICE

This exercise starts with an image of an insect such as a dragonfly. It consists of a shape analysis and two products: one at a small scale, one at a large building scale.

Start by analysing the shape of the insect in a line drawing. Use side view and perspective line drawing, and try to read its shape structure and form language.

Then simplify its shape to, say, a robot-like shape. Simplify it so much that you are able to reproduce it in another viewpoint. Here you see the result on the right.

Now use the robot-like shape as an inspiration for a handheld product. Express its size by viewpoint and level of detail.

Finally, use the robot-like shape as an inspiration for a huge building-like shape. Again, use viewpoint and level of detail to express size. Add elements that convey scale, like the sky or people.

CASE

PININFARINA S.P.A., ITALY

Snowgroomer 'Beast' for Prinoth. 2008
Designer: Doeke de Walle

After the design analysis, we presented
three concepts to Prinoth. Here you see one
of these concepts. The client chose elements
from two different renderings, which we were
able to combine in one homogeneous design.

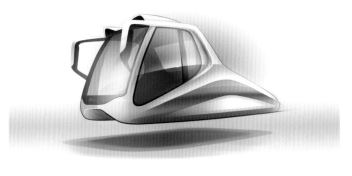

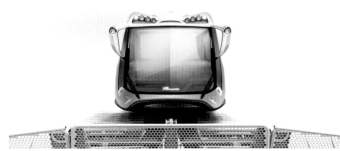

The drawings you see here were started
in blue pencil (Faber-Castell Polychromos)
on paper. The drawings were scanned
and imported into Adobe Photoshop for
colouring, and the final touches were
added in Corel Painter. In order to keep
the sketch lines visible but not dominant,
their layer opacity was set at 50%. On top
of that, several layers with shading were
added. The layer blending mode of these
layers was set at 'multiply', allowing the
shading to blend in with the different layers
underneath.

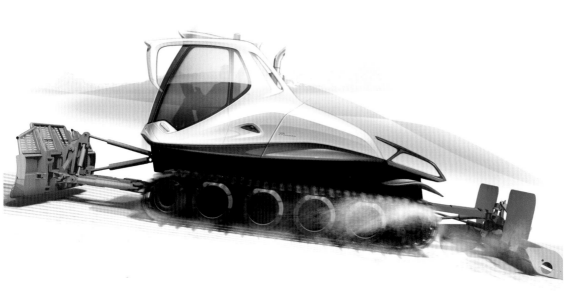

Setting the layer blending mode to 'multiply' keeps underlying layers such as sketch lines visible. It also allows you to literally multiply the shading onto underlying layers, such as here, for the caterpillar elements and snow environment.

Some blurring and snow were added on top of the tracks to give an impression of movement. The snow effect is created with a combination of a few standard scatter brushes in Photoshop. The carbon fibre texture on the lower black body side was created by applying the 'Sketch - Halftone Pattern' filter on a light grey layer, which was then set to 'multiply'.

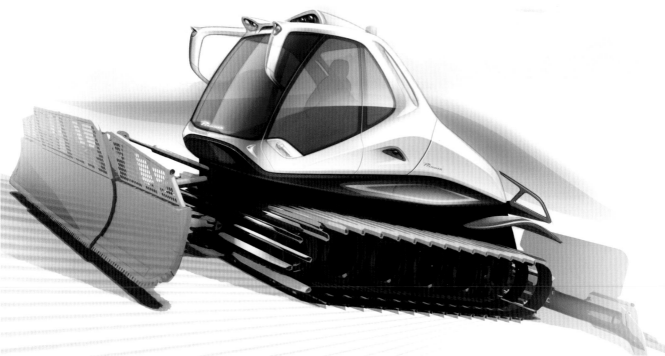

The groomer's tracks and blade are copied from a CAD model and modified with the 'Sketch-Stamp' filter in Photoshop to integrate the computer image with the drawing. This preserves the hand-sketched character of the drawing.

ACKNOWLEDGEMENTS

Broek, Jos van den, Willem Koetsenruijter, Jaap de Jong en Laetitia Smit, *Beeldtaal Perspectieven voor makers en gebruikers*, Boom uitgevers, Den Haag, The Netherlands, 2010.

Eissen, Koos, Erik van Kuijk, Peter de Wolf, *Product presentatietekenen*, Delftse Universitaire Pers, Delft, The Netherlands, 1984.

Eissen, Koos and Roselien Steur, *Sketching Drawing Techniques for Product Designers*, BISPublishers, Amsterdam, The Netherlands, 2007.

Gerritsen, Frans, *Evolution in Color*, Schiffer Publishing, Atglen, USA, 1988.

Gill, Robert W., *Rendering with pen and ink*, Thames and Hudson Ltd, London, UK, Reprinted 1979.

IDSA (Industrial Designers Society of America), *Design Secrets: Products*, Rockport Publishers, Inc, Gloucester, USA, 2001.

IDSA (Industrial Designers Society of America), Lynn Haller and Cheryl Dangel Cullen, *Design Secrets: Products 2*, Rockport Publishers Inc, Gloucester, USA, 2001.

Itten, Johannes, *The Art of Color*, John Wiley and Sons, Hoboken USA, 1974; also as a version in Dutch, Cantecleer, Baarn, The Netherlands, 2000.

Lewin, Tony and Ryan Borroff, *How to: Design cars like a pro*, Motorbooks International, St. Paul, USA, 2003.

Lidwell, William, Kritina Holden, Jill Butler, *Universal Principles of Design*, Rockport Publishers, Gloucester, USA, 2003.

Olofsson, Erik and Klara Sjölen, *Design Sketching*, KEEOS Design Books, Sundsvall, Sweden, 2005.

Samara, Timothy, *Design Elements : A Graphic Style Manual*, Rockport Publishers, Inc., Beverly, USA, 2007.

Shimizu, Yosmiharu, *Quick & easy solutions to marker techniques*, Graphic-Sha Publishing Co., Ltd., Tokyo, Japan, 1995.

Versluis, Ari and Ellie Uyttenbroek, *Exactitudes*, 010 Publishers, Rotterdam, The Netherlands, 4th revised edition, 2010.

Objectified, a documentary film by Gary Hustwit, UK, 2009.
Auto&Design Magazine, Torino, Italy.

Items Magazine, Amsterdam, The Netherlands.

Wired Magazine, New York, USA.

www.dutchdesignweek.nl

www.coroflot.com

www.wikipedia.com

FEATURED DESIGNERS

BEESTUDIO INDIA, Pune, India.
www.beestudio.it
Design Director: Emanuele Nicosia
Case study, Chapter 3

BMW Group DesignworksUSA, Singapore
www.designworksusa.com
Design team: Sonny Lim, Joe Tan, Nils Uellendahl
Case study, Chapter 5

Daimler AG, Mercedes-Benz Design, Sindelfingen, Germany
www.mercedes-benz.com
Designer: Sarkis Benliyan
Case study, Chapter 6

Ducati Motor Holding S.p.A., Bologna, Italy
www.ducati.com
Ducati Design Team, Senior Designer: Bart Janssen Groesbeek
Case study, Chapter 6

FLEX/the INNOVATIONLAB®, Delft, The Netherlands
www.flex.nl
Case study, Chapter 1
Case study, Chapter 5

Roy Gilsing Design, Rotterdam, The Netherlands
www.roygilsing.com
Designers: Roy Gilsing, Jorrit Schoonhoven, Angelo Jansen
Case study, Chapter 4

Idea Dao Design, Shanghai, China
www.ideadao.com
Design Director: Carl Liu
Case study, Chapter 7

JAM visual thinking, Amsterdam, The Netherlands
www.jam-holland.com
Sketches by Jan Selen and Jeroen Meijer
Case study, Chapter 7

Art. Lebedev Studio, Moscow, Russia
www.artlebedev.com
Art Director: Timur Burbayev
Designers: Benoit Patoureaux, Alexei Sharshakov, Maxim Chashchin and Maxim Shkinder.
Case study, Chapter 1
Case study, Chapter 3

Carl Liu – Industrial Designer, Shanghai, China
www.carlliu.com
Case study, Chapter 2

Pininfarina S.p.A., Torino, Italy
www.pininfarina.it
Designer: Doeke de Walle
Case study, Chapter 7

SMOOL, Amsterdam, The Netherlands
www.smool.nl
Designer: Robert Bronwasser
Case study, Chapter 2

TurnKey Design BV, Utrecht, The Netherlands
www.turnkeydesign.eu
Senior Designer: Imre Verhoeven
Case study, Chapter 1

Van der Veer Designers, Geldermalsen, The Netherlands
www.vanderveerdesigners.nl
Designer: Joep Trappenburg
Photography: Van der Veer Designers
Case study, Chapter 4

IMAGE CREDITS

Page 26
– Sketch Furniture by FRONT, Sweden, www.frontdesign.se

Page 32
– Monorail rendering by Tomasz Bitel

Page 54
– Dog flies, For Jakpetz, Advertising Agency: Saatchi & Saatchi Jakarta, Indonesia, Photographer: Heret Frasthio, 2009

Page 86
– The mega-passenger aircraft Megalodon, by Colani, 1977. www.colani.ch
Photography: Colani Trading AG

Page 128
– BK Conical pan coat and BK Silicon flan form: copyright BK Cookware bv
– LaCie Rugged XL Desktop Hard Drive: copyright LaCie.

Page 129
– Iittala Sarpaneva castiron casserole: copyright Iittala
– Garlic cutter: copyright Rosti Mepal
– LaCie Little Disk 1.3 and LaCie Little Disk White Mobile Hard drive: copyright LaCie

Page 130
– Iittala Verna glass 22cl clear and Iittala Kartio glass 21cl lightblue: copyright Iittala

Page 132
– Bodum Electric Coffe Grinder and Bodum Ice jar: copyright BODUM®
– Tesla Model S: copyright Tesla Motors, Inc.

Page 133
– Tesla Model S: copyright Tesla Motors, Inc.

Page 134
– Iittala CollectiveTools mill: copyright Iittala
– car image: copyright Ford Motor Company

Page 135
– LaCie D2 quadra Hard Disks and LaCie Starck Mobile Hard Drive: copyright LaCie
– Iittala Piilo: copyright Iittala

Page 138
– Bodum Electric Hand Mixer and Bodum Electric Juicer: copyright BODUM®
– JBL Roxy Reference 430 headphone: copyright Harman International Industries, Inc.

Page 139
– LaCie Skwarim mobile HD: copyright LaCie

Page 148
– AP/Reporters, Frank Augstein

Page 154
– the Im Perfect furniture collection, design: Studio JSPR, photography: Floor Knapen

Page 170
– Courtesy Joe Baran, www.joebaran.net

All images on the Case Study pages are supplied by the featured design offices.
All other images are courtesy of the authors.